SPLENDOURS OF THE
SUBCONTINENT

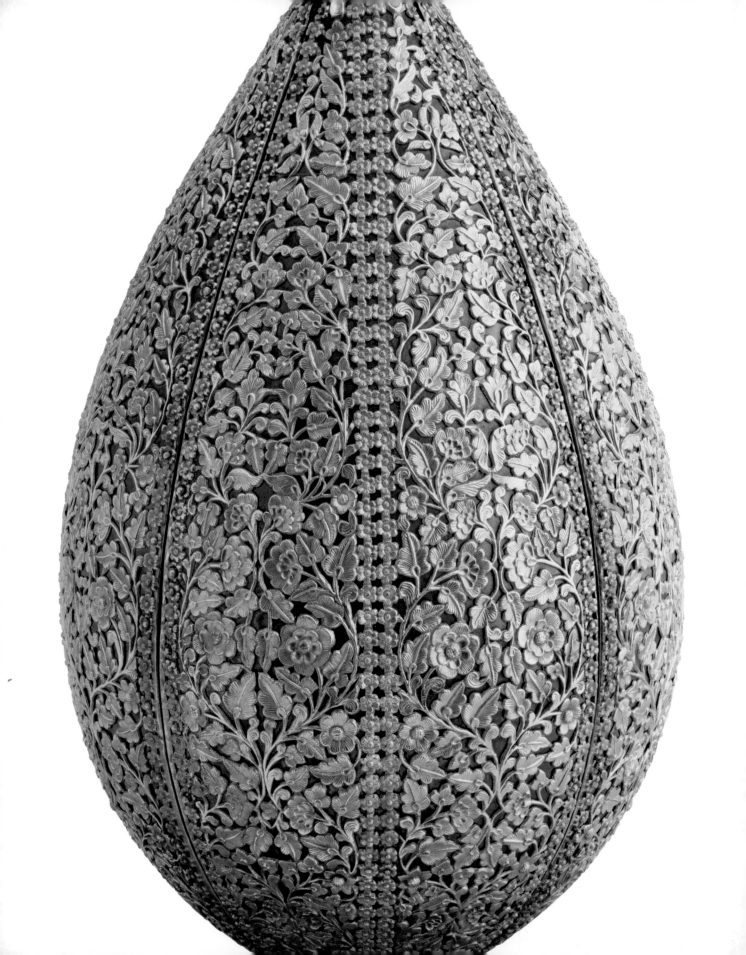

SPLENDOURS OF THE

SUBCONTINENT

A PRINCE'S TOUR OF INDIA 1875–6

ROYAL COLLECTION TRUST

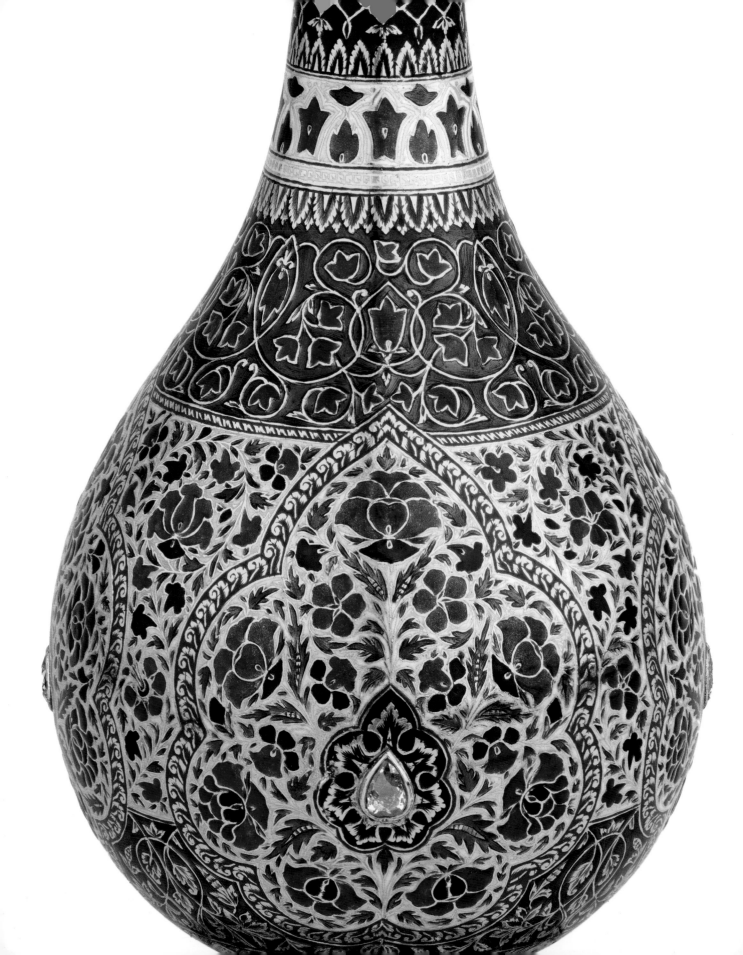

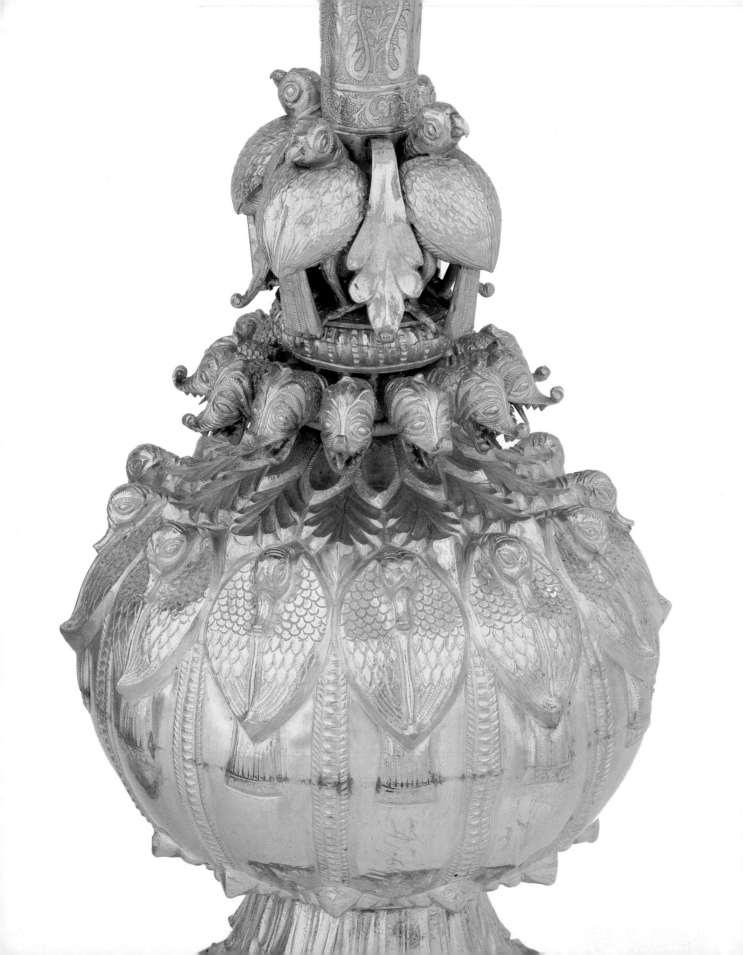

INTRODUCTION

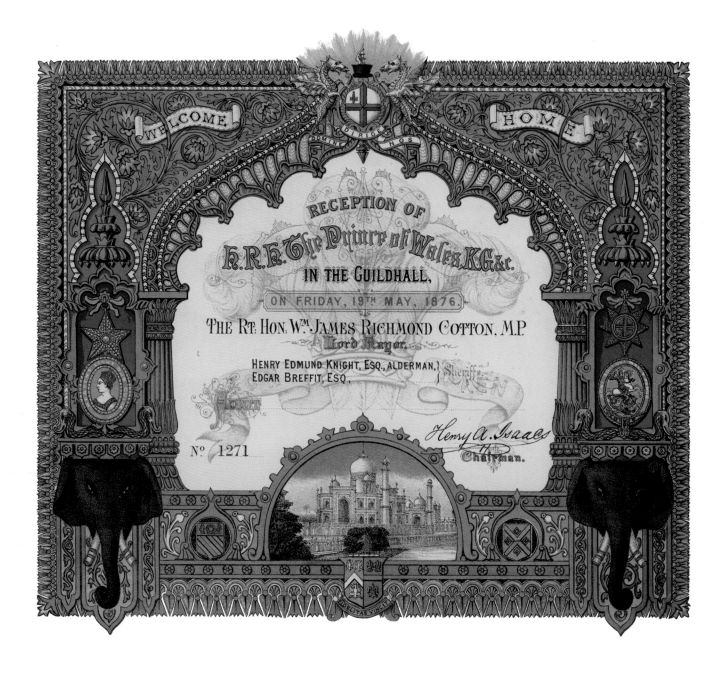

WELCOME HOME

RECEPTION OF
H.R.H. The Prince of Wales, K.G. &c.
IN THE GUILDHALL,
ON FRIDAY, 19TH MAY, 1876.

THE RT. HON. WM. JAMES RICHMOND COTTON, M.P.
Lord Mayor.

HENRY EDMUND KNIGHT, ESQ., ALDERMAN,} Sheriffs.
EDGAR BREFFIT, ESQ,

Nº 1271

Henry A. Isaacs
Chairman.

I n June 1876 the upper galleries of the India Museum at South
Kensington were transformed into what was described as 'a scene
from the Arabian Nights'.[1] Albert Edward, Prince of Wales (1841–
1910), had only just returned to Britain from his four-month tour
of the Indian subcontinent and, eager to share his experiences,
arranged for all of his sumptuous gifts to be exhibited for the wider
public to enjoy. Row upon row of cabinets glittered with opulent
jewellery, gold and silverware, arms and armour, furniture and textiles.

The gifts, which came from many regions of modern-day India, Pakistan,
Nepal and Sri Lanka, are tangible reminders of the encounters and connec-
tions that the Prince of Wales made with the Indian rulers. The Prince hosted
six receptions in Bombay, Madras, Calcutta, Delhi, Lahore and Agra, where
he followed Indian ceremonial customs to welcome his guests. Visits to the
royal courts of Baroda, Benares, Kashmir, Gwalior, Jaipur and Indore gave
the Prince opportunities to see courtly performances, to hear Indian music
and to visit historical palaces. The Prince also went hunting at many of these
courts, as well as in Ceylon and Nepal. By the end of the trip Sir William
Howard Russell (1820–1907), writer of the official tour diary, noted that
since arriving in India the Prince had 'travelled nearly 7,600 miles by land and
2,300 miles by sea, knows more Chiefs than all the Viceroys and Governors
together', adding, with a touch of hyperbole, that he had 'seen more of the
country in the time than any living man'.[2]

The subsequent display of these gifts at ten venues in Britain, Paris and
Copenhagen also played an instrumental role in the narrative of British
and Indian design and their intertwined histories. Given the extensive jour-
ney undertaken by the Prince, the collection of gifts provided an intriguing
snapshot of the spectacular range of Indian craftsmanship. Recognising the
merits of the collection, the Prince of Wales lent it to be exhibited at a fur-
ther nine venues after the initial display at South Kensington. For two years
the collection was shown at the Bethnal Green Museum before being sent to
Paris, where it formed most of the British Indian display for the International

Fig. 1 Invitation to the reception of
the Prince of Wales at the Guildhall,
London, 19 May 1876.

Exhibition of 1878. From Paris the gifts travelled on to Edinburgh, Glasgow, Aberdeen, York, Nottingham, Copenhagen and Penzance; it was estimated that over two million people saw the collection in Britain alone.[3]

Rationale for the tour

The royal tour played an integral role in the meticulously planned educational programme developed by Queen Victoria (1819–1901) and Prince Albert (1819–61) for the Prince of Wales. They felt that travel, coupled with intensive tuition, would encourage the Prince to take an avid interest in the wider world. Although the Prince was less academically inclined than his younger brothers, he enjoyed travelling and collecting objects from tours, and, like his father, he developed a taste for displaying these souvenirs. By October 1875, Albert Edward had already undertaken major tours to Canada and the United States (1860), and to Egypt and the Middle East (1862). Both tours had been devised to provide the Prince with the opportunity to learn about the culture, history and religions of these countries as well as to establish diplomatic links.[4]

Prince Albert wanted the Prince of Wales, as heir apparent, to visit India and he discussed the idea of a tour with Lord Charles Canning (1812–62), then Viceroy and Governor-General of India.[5] The British East India Company had ruled over parts of India until 1857, when Indian sepoys employed in the Company's armies revolted. This led the British Crown to assume rule in 1858, following the Government of India Act. A tour of India would allow the Prince of Wales to learn more about a country he would eventually rule and to establish a personal and visible link between the two countries.

However, the prospect of a tour diminished due to concerns over the Prince's health and this, coupled with news of the assassination of Richard Bourke, 6th Earl of Mayo and Viceroy of India (1822–72), raised questions over whether the Prince should make the trip at all. Early in 1875, however, the Prince revisited the idea, expressing his continuing desire to visit India. The Queen recorded in her journal that it made her 'anxious', but her anxieties appear to have been assuaged by meetings with the Prime Minister, Benjamin

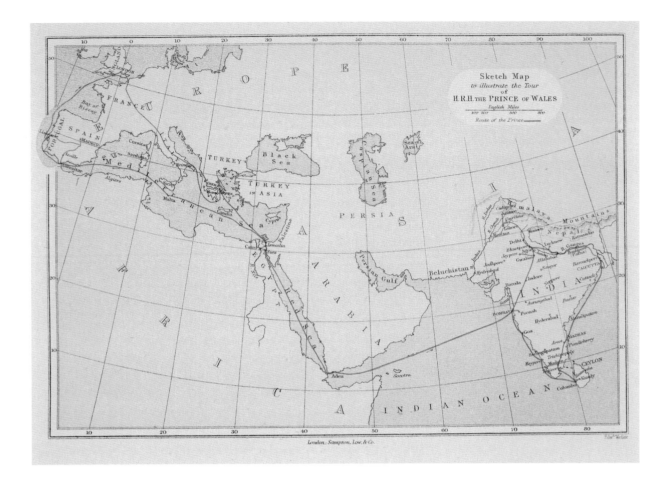

Disraeli (1804–81), and Lord Salisbury (1830–1903), Secretary of State for India, who were both in favour of the trip.[6]

Lord Northbrook (1826–1904), Viceroy of India, also supported the proposal for the Prince's tour. A significant portion of India remained independent of the Crown and was ruled over by Indian rulers, many of whose lineages had been established for centuries. These rulers had supported the British against the so-called 'Indian Mutiny' (1857), and from the perspective of Lord Northbrook a tour would acknowledge their loyalty to the British Crown.

On 23 March 1875, the Prince's intention to travel to India was publicly announced in *The Times* newspaper, which reported that 'the greatest necessity, after all, in the government of a vast and various Empire like that of England is mutual intelligence, mutual respect, a sense of unity, and increasing sympathy. The growth of all these will be promoted by the PRINCE's visit; and it is not impossible both countries may hereafter look back upon the event as a new starting point in their strange and momentous destiny'.[7]

Fig. 2 Map showing the route taken by the Prince of Wales, from the diary of William Howard Russell, 1877. RCIN 1054593

Preparations

The logistics of the tour were discussed at what William Howard Russell would later describe as an 'Indian Council', held at Marlborough House.[8] The route was largely dictated by the climate of the country, and it was decided that the period between November and March would be the ideal time for the tour. Albert Edward instructed his librarian to obtain books on India for the library at Sandringham, as well as visiting the India Museum in South Kensington in preparation. The museum's curator, Sir George Birdwood (1832–1917), took the Prince around the displays and 'went carefully over the natural history, and raw products and manufactures collections'.[9] Birdwood, who had become an authority on Indian art by the late nineteenth century through his work for the India Office and its museum, would be instrumental in the interpretation and display of the Prince of Wales's gifts on his return from India.

Wider discussions regarding the financing of the tour and, in particular, the exchange of gifts, an important aspect of Indian diplomacy, were debated in Parliament and at the India Office. It was initially suggested that the Prince of Wales should adopt a policy that had been used by the East India Company to recover some of the cost of the tour, whereby the gifts received through diplomatic exchange were deposited in the Company's *toshakhana*. The *toshakhana* (a term borrowed from the Indian courts) was a storehouse in which objects of value or curiosities were kept. Once an object had entered the Company's *toshakhana* it could be auctioned to recoup the cost of the return gift that the East India Company presented to the ruler. However, the idea of continuing the practice during this particular tour was met with great resistance by both the Prince and Sir Owen Tudor Burnes (1837–1909), Private Secretary of two previous Viceroys, who considered it to be in poor taste.[10]

Furthermore, it was acknowledged that the monetary value of the gifts that the Prince was advised to present in India may not equal the value of the gifts that he was likely to receive. To counteract this, Lord Northbrook suggested that the Indian rulers should only present 'curiosities, ancient arms, and specimens of local manufacture' to the Prince.[11] Lord

Fig. 3 Garrard and Co., Gold bracelet, set with a coloured photographic portrait on paper of the Prince of Wales, 1875. British Museum 2012, 8004.1.

Northbrook sent out a circular to the British residents attached to Indian courts to clarify this. It reiterated several times that a 'ceremonial Durbar' would not be held and 'the exchange of presents which is usual at Durbars will consequently not be made'.[12] However, the circular was open to interpretation by the Indian rulers and as a result the gifts received by the Prince included many examples of works of both great value and historical importance.

With the debate regarding gifts settled, at least in the minds of the Prince and his advisors, the gifts for the Prince to present to the Indian rulers were commissioned. These were based on the type of gifts historically given by the East India Company officials to the Mughal emperors. For the Prince's tour, gold and silver rings, badges, bracelets, watches and lockets were commissioned from the crown jewellers, Garrard and Co. (fig. 3). Gold and silver medals, depicting the Prince of Wales, were struck by Phillips, designed to be presented as gifts to present to the rulers (fig. 4). Lavishly illustrated books such as Joseph Nash's *Windsor Castle* and Louis Rousselet's *India and its Native Princes* were ordered. Engravings, miniatures and lithographs of Queen Victoria and the Prince and Princess of Wales were also prepared, and rifles from the leading gun makers, Purdey and Sons, and presentation swords and daggers from distinguished sword makers, the Wilkinson Sword Company, were purchased.[13] Queen Victoria also issued a warrant that authorised the Prince of Wales to hold a reception to bestow the Order of the Star of India in Calcutta on New Year's Day 1876. This Order had been established in 1861 to reward and strengthen bonds between Queen Victoria and the Indian rulers in the wake of the 1857 'Indian Mutiny'.

Journey to India

The journey to India began on 11 October 1875. The Prince left Marlborough House and travelled to the port of Brindisi to board HMS *Serapis* on 16 October (fig. 5). HMS *Serapis*, which had originally been a Royal Navy

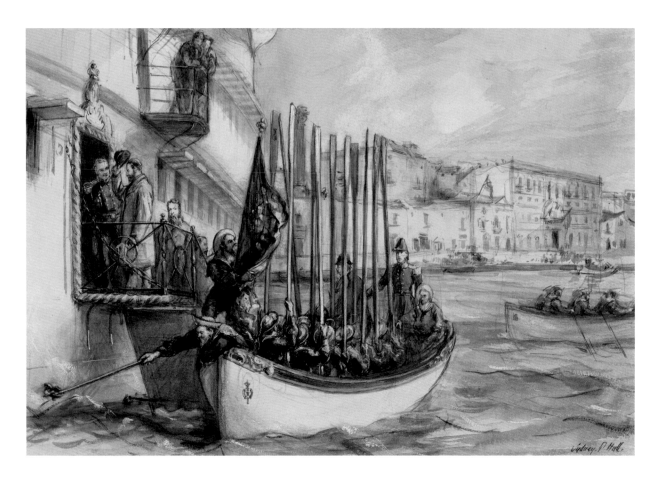

troopship, was transformed for its royal passenger. The crest and motto of the Star of India, 'Heaven's Light Our Guide', was applied to its bow in gilt. The saloon had 'heavy bronze-yellow curtains of Indian Pattern' to divide it into three compartments creating a reception room, dining room and drawing room (fig. 6).[14] Most of the furniture had been manufactured in the Portsmouth dockyard and was embellished with a gilded badge depicting the Star of India. Fond memories of the voyage led the Prince to later name a room at Sandringham House the 'Serapis Room', and the furniture and dinner service from the ship were later given to the Prince of Wales and subsequently used at Sandringham.

The Prince was accompanied on the tour by a number of advisors, as well as some of his closest friends and members of his household. William Howard Russell, reporter for *The Times*, was asked by the Prince to be honorary Private Secretary and later published the official tour diary in 1877. Sydney Prior Hall (1842–1922), artist for *The Graphic*, whose 'sympathetic and skilful pencil had gained him high reputation', joined the party as the Royal Artist, and his drawings were used to illustrate Russell's vivid accounts.[15] Sir Bartle

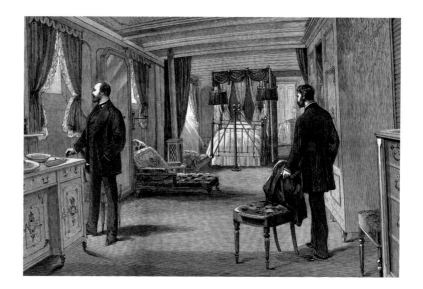

Fig. 6 The bedroom of the Prince of Wales on HMS Serapis, *8 October 1875.*
Illustrated London News

Frere (1815–44), who had served as the Governor of Bombay until 1867, joined to advise the Prince on Indian ceremonial procedures.

Other members of the tour party with experience of India included Lord Charles Beresford (1846–1919) and the physician Sir Joseph Fayrer (1824–1907), both of whom had previously accompanied the Prince's brother, the Duke of Edinburgh, to India in 1869. Fayrer later published an account of both tours. Prince Louis of Battenberg (1854–1921), joined as *aide-de-camp*. The Prince's suite also included the botanist Christopher Mudd (1852–1920), zoologist Clarence Bartlett (1848–1903) and his French cook, Monsieur Bonnemain (*fl.*1875–6).

The tour was also widely reported in publications such as the *Illustrated London News*, which periodically issued 'Special' supplements, and despatched reporters and artists to record the tour for their readers. To cater for those who were inspired to travel to India as a result of the Prince's tour, the *Times of India* produced *The Prince's Guide Book: The Times of India Handbook of Hindustan*. This provided an overview of the geography, history and places of interest in India for the 'influx of visitors to the East'.[16] Other accounts of the tour include those by George Pearson Wheeler, correspondent for the *Central News*, who published *India in 1875–76: The Visit of the Prince of Wales* and J. Drew Gay, correspondent for the *Daily Telegraph* who wrote *The Prince of Wales in India; or, From Pall Mall to the Punjab* in 1877. Mary Elizabeth Corbet (b. 1830), wife of an army officer, also published *A pleasure trip to India, during the visit of the Prince of Wales and afterwards to Ceylon* in 1880.

The tour of the Indian subcontinent

On 8 November, a month after the *Serapis* had left Brindisi, the Prince of Wales arrived in Bombay where he was greeted by crowds 'glittering with gems' and 'swaying to and fro' in an attempt to catch a glimpse of him (fig. 7).[17] The students of the Jamsetjee Jheejebhoy School of Art had

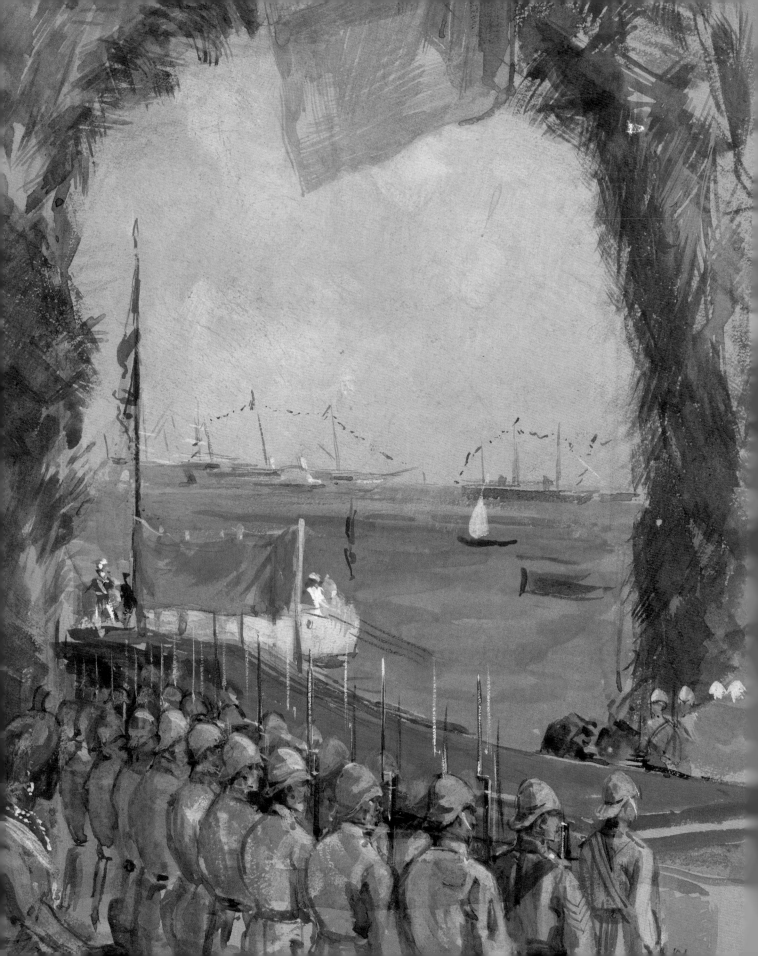

extravagantly decorated the city of Bombay (fig. 8).[18] Lanterns that had been set up for the Hindu festival of Diwali (celebrated just a few days prior to the Prince's visit) were left in place to commemorate the Prince's birthday on 9 September.[19] As the Prince's carriage proceeded to Government House, where he was due to be staying, Russell wrote that 'new effects continually opened up, and fresh surprise came upon one, from point to point, 'til it was relief to close the eyes out of sheer satiety and to refuse to be surprised anymore'.[20]

(Opposite) *Fig. 7* Sydney Prior Hall, *Landing at the dockyard, Bombay, 8 November, 1876.* RCIN 923295

(Above) *Fig. 8 Students of the Jamsetjee Jheejebhoy School of Art putting up decorations in Bombay,* 4 December 1875. *Illustrated London News*

The Prince's three-week stay in Bombay was punctuated by visits to Poona and the court of Baroda, where he enjoyed his first experience of riding an elephant. The elephant was painted yellow with saffron, covered in sumptuous cloth, and harnessed with a silver gilt howdah 'surpassing splendour, which shone like burnished gold in the morning sun' (fig. 9).[21] Whilst in Baroda, the itinerary for the tour had to be changed when news of a cholera outbreak in parts of southern India reached the tour party. The original journey was altered to avoid the affected areas and as a result visits to the courts of Hyderabad, Travancore and Mysore were cancelled.

On 25 November, the Prince left Bombay to set sail for Ceylon. On his arrival he was presented with a gift of an ivory casket containing spices grown in Ceylon (RCIN 11398, pp. 66–7). Here the Prince visited the Royal Botanical Gardens in Peradeniya, an exhibition on the agriculture and horticulture of Ceylon and cocoa and coffee factories in Colombo.

Departing Ceylon from the port of Colombo on 8 December, HMS *Serapis* sailed to Tuticorin in Tamil Nadu, the southern tip of India. From here the Prince travelled by train to see the monumental temples of Madurai and Trichinopoly. Although Trichinopoly had been removed from the tour itinerary due to the cholera outbreak, when the Prince heard that the outbreak had been contained he insisted on visiting the town.[22] The Prince visited the

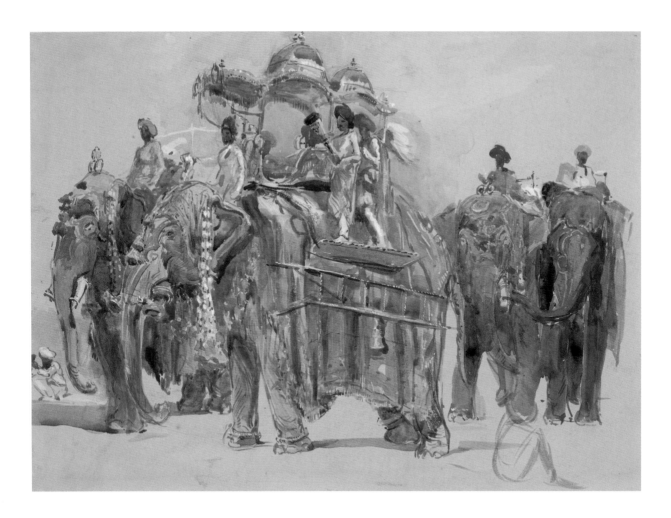

(Above) *Fig. 9* Sydney Prior Hall, *State elephants at Baroda, 19 November, 1875.* RCIN 923308

(Opposite) *Fig. 10* Sydney Prior Hall, *The Prince investing Jashwant Singh (?), Maharaja of Jodhpur, with the Star of India on New Year's Day, 1 January, 1876.* RCIN 923341

famed rock fort that housed two Hindu temples, and from a pavilion erected near the base of the fort he watched the illuminations and fireworks arranged in honour of his visit. These were described by Russell as 'pouring [like] lava, like floods, now blue, now orange, now green, from some overwelling [*sic*] fountain'.[23]

From southern India, the Prince sailed to Calcutta, reaching the British capital on 23 December. On Christmas Day, the crew of the *Serapis* were keen to get into the festive spirit and decorated the ship with holly and ivy wreaths sprinkled with white powder and cotton wool to mimic snow.[24] On New Year's Day, the Prince hosted an investiture to confer the Star of India upon three Indian rulers (fig. 10).

The Prince left Calcutta on 4 January and travelled by rail further inland. He had received many invitations from the Indian rulers to visit their palaces and states, and one such invitation was from Maharaja Ishwari Narayan

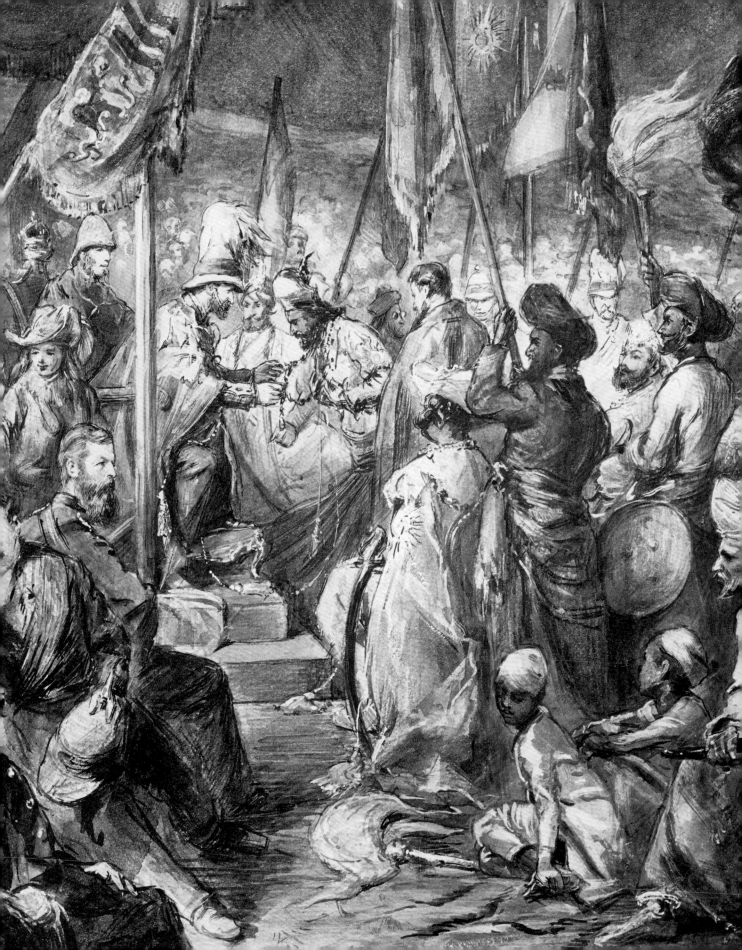

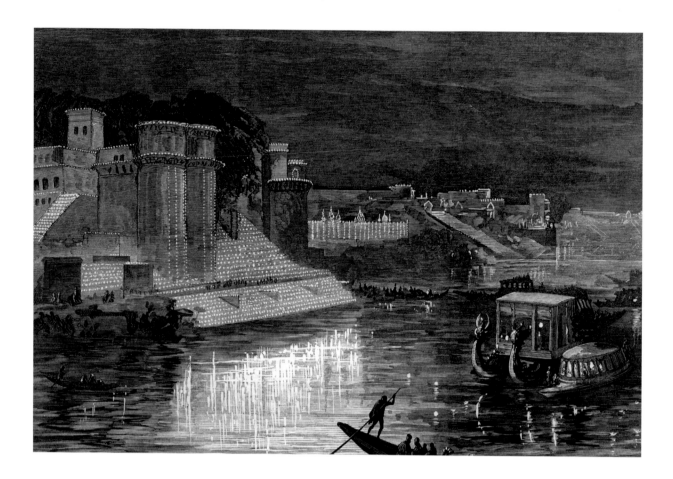

Fig. 11 *The Prince's boat ride along the river Ganges, 5 January, 1876. Illustrated London News*

Prasad Singh of Benares (1822–99). Here, the Prince travelled along the River Ganges on the Maharaja's state barge to visit Ramnagar Palace. Looking out from the palace, Russell described the surface of the river 'covered with tiny lamps […] little earthen vessels, bearing their cargoes of oil and wick, sparkled and glittered quite wonderfully. It seemed as though a starry sky were passing between banks of gold' (fig. 11).[25]

Leaving Benares on 6 January, the Prince and his suite visited Lucknow, Cawnpore and Delhi. They visited monuments built by the Mughal emperors and the Kings of Awadh, as well as visiting sites associated with the 1857 'mutiny'. At Lucknow, the Prince laid the foundation stone for the memorial to the Indian soldiers who had helped the East India Company army defend the British Residency at Lucknow against the Indian 'mutineers'. Here he also met some of the survivors (fig. 12).

The Prince and his party then travelled along the Grand Trunk Road into the Punjab, where they spent two days in Lahore, a seat of the Mughal emperors and, later, the capital of the Sikh Empire. Here the Prince hosted

Fig. 12 William Simpson, *The Prince receiving the survivors of the Defence of Lucknow, 7 January, 1876.*
RCIN 921112

a reception for the rulers of the Punjab and attended an evening fete at the Shalimar Gardens built by the Mughal emperor Shah Jahan (1596–1666). The Prince also visited the Golden Temple at Amritsar and was presented with an address casket from the inhabitants of the city (RCIN 11230, pp. 76–7).

Arriving at Agra on 25 January, the Prince visited the Taj Mahal, the famous seventeenth-century tomb built by Shah Jahan for his wife Mumtaz Mahal (1593–1631). Russell wrote that 'entering the tomb itself – the culminating glory – the party stood and gazed, almost trembling with admiration'.[26] The tomb evidently impressed the Prince so much that he returned again later during the tour to see the marble monument lit by moonlight (fig. 13).[27]

From Agra, the Prince travelled to Gwalior, where he stayed at Jai Vilas Mahal, the palace of Maharaja Jayajirao Scindia of Gwalior (1835–86). Built in 1874, the palace was furnished with chandeliers, mirrors, furniture and tapestries from Europe, and the room in which the Prince was to stay was fitted with a bedstead, washing service and bath all made of solid silver.[28]

The Prince's next stop was Jaipur, where he arrived on 4 February. Russell was particularly struck by the architecture, which had earned Jaipur the title of the 'Pink City', and likened it to 'solid strawberry creams streaked in white

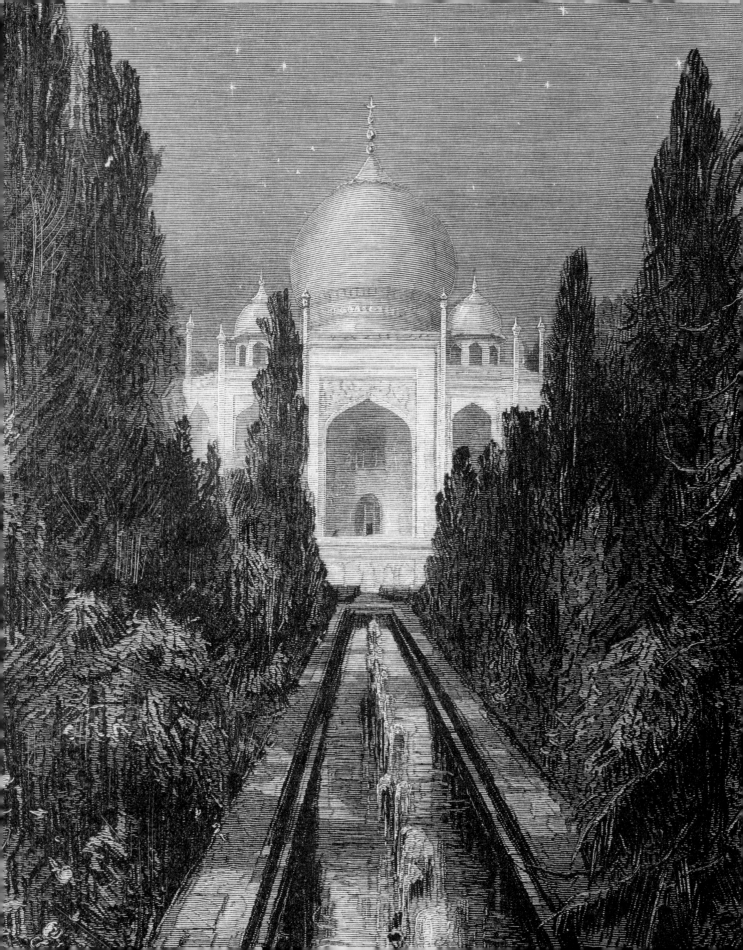

arabesque, stating that he had 'never beheld any street architecture of this kind'.[29] Here, Maharaja Ram Singh II (1835–80) (fig. 14) presented the Prince with a plaster model based on an eighteenth-century *haveli* (townhouse) made by the students of the Jaipur School of Art (RCIN 42376, pp. 210–11).

The Prince's final weeks on the subcontinent were spent on a hunting excursion on the frontiers of Nepal as a guest of Bir Narsingh Kunwar (1816–77), Prime Minister of Nepal. Travelling up to Nepal, the Prince was able to see 'the range of the Himalayas lighted up by the setting sun' and watch the 'rose hue steal up from the darkening base over the pure white summits'.[30] Finally the Prince made a brief visit to Indore, before returning to Bombay where he rejoined HMS *Serapis*.

By the time of his departure on 13 March, the Prince had travelled the length and breadth of the Indian subcontinent and had met more than 90 Indian rulers. On his return to England on 11 May 1876, crowds of well-wishers greeted him at Portsmouth.

The gifts

From the start of the tour, gifts from the rulers that the Prince had met began to arrive at Government House, Bombay. Russell noted that 'groups of Native Police are constantly on duty, watching porters carrying cases and boxes'.[31] Many of the gifts were connected to Indian courtly customs. In Bombay, during the first reception on 9 November 1875, for example, Russell recorded that, at the end of the meeting between the Raja of Kolhapur and the Prince of

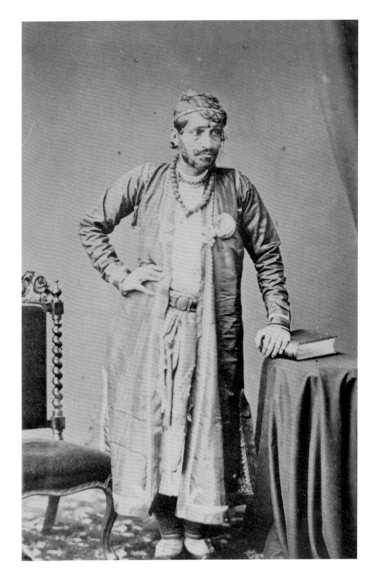

(Opposite) *Fig. 13* After Sydney Prior Hall, *The Taj Mahal by moonlight*, in Russell 1877, p. 443.

(Above) *Fig. 14* Bourne and Shepherd, *Ram Singh II, Maharaja of Jaipur* (1835–80), 1875–6. RCIN 2114186

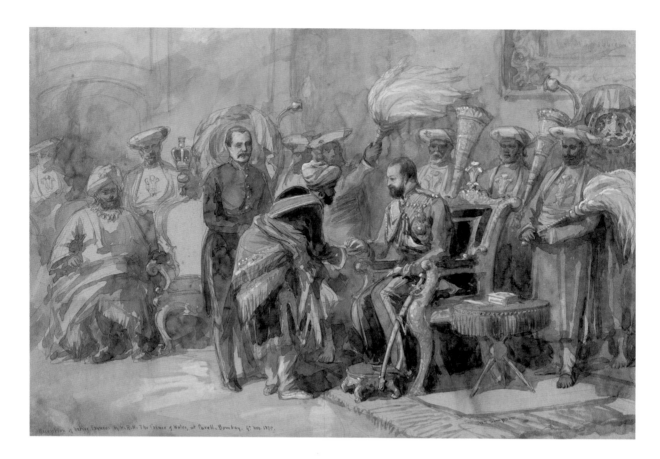

Wales, the Prince 'shook a few drops of perfume (*uttur*) on the Rajah's pocket handkerchief, and then from another rich casket took the betel-nut (*paan*), wrapped in fresh green leaf covered with gold foil, which he place[d] in the Raja's hand'.[32] The Prince followed the same practice with each of the rulers he met throughout the tour during the formal receptions (fig. 15) and returned to Britain with many gifts that related to this welcoming etiquette such as *paan* boxes, bottles and perfume holders (RCINS 11212, 11362 and 11381, pp. 98–9, 104–5 and 106–7).

Arms and armour formed the largest category of gifts received by the Prince, and ranged from rudimentary arrows to jewel-encrusted daggers and ceremonial shields. Some of the arms had particular historic importance, for example the seventeenth-century spearhead given by Zamindar of Ettayapuram (RCIN 37537, pp. 156–7) and a sword presented by the Maharaja of Jaipur, which had belonged to a former ruler of Amber (RCIN 11421, pp. 162–3).

A departure from Indian courtly custom was the presentation of elaborate caskets containing formal addresses. These addresses were usually read out to

the Prince and he would make a short speech in reply (fig. 16). The Prince also
bought presents for his family from *boxwallah*, or peddlers. From Trichinopoly,
for example, he bought a bangle for Queen Victoria (RCIN 11522, pp. 44–5).

The predilection for jewels demonstrated by the Indian rulers ensured that
the Prince came away with an abundance of jewel-encrusted gifts. During the
Prince's first meeting with Maharaja Sayajirao, Gaekwar of Baroda, for exam-
ple, Russell described the Maharaja as 'a crystallised rainbow […] weighted,
head, neck, chest, arms, fingers, ankles, with such a sight and wonder of vast
diamonds, emeralds, rubies, and pearls' (fig. 17).[33]

Some gifts, as Lord Northbrook suggested in his circular, represented
objects and techniques that were unique to specific regions. Enamelled jew-
ellery and vessels were a popular gift from Jaipur, for example, and such items
were highly sought after by European visitors to the region. Enamelled gifts
presented to the Prince included RCINS 11409, 11423 and 11421 (pp. 82–3,
84–5 and 162–3).

*Fig. 16 Dosabhai Framji, chairman
of the Bombay Corporation, reading
a welcome address to the Prince,
4 December 1875. Illustrated
London News*

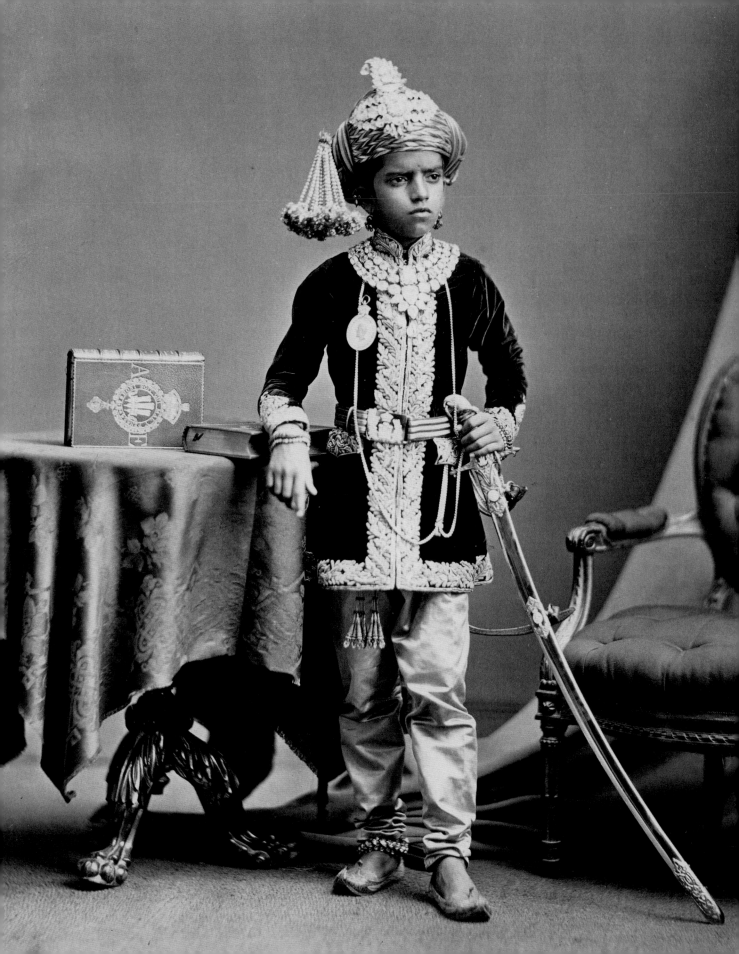

Tour of the gifts

As HMS *Serapis* crossed the Channel and neared Portsmouth, the Prince of Wales telegrammed George Birdwood requesting that he board the ship and take charge of the gifts.[34] Birdwood had been assistant surgeon in the Bombay medical service, as well as curator of the Bombay Government Museum until 1868 when ill health forced him to retire to England. He had developed a keen interest in the arts and culture of India, and, in 1868, was appointed by the India Office as Keeper of the India Museum.

At the initial exhibition of the gifts at the South Kensington Museum, the objects were displayed in the upper galleries alongside Sydney Prior Hall's sketches and watercolours, offering a vivid account of the Prince's time in India. The scale of the display was impressive, filling more than 40 cases. According to a contemporary account:

> '[T]he visitor would probably feel absolutely dazzled by the splendour of the scene, and it was not until this feeling had time to wear off, and he had leisure to realize that he was not dreaming of a scene from the Arabian Nights, that he was able to settle down to the contemplation of individual objects'.[35]

The first week of the exhibition saw nearly 30,000 visitors pour into the South Kensington Museum.[36] The admission fees from the display generated ample funds and from this the Prince reserved £3,000 'for the purpose of promoting the interests of Indian art'.[37] Subsequently, in October 1880, Sir Caspar Purdon Clarke (1846–1911) was sent to India with a total of £5,000, partly funded through the Prince's display of gifts, to expand the Indian collections of the museum.[38] Clarke sent to the South Kensington Museum over 3,000 items from India including architectural fragments, sculpture, paintings, manuscripts, metalwork, jewellery and 16 life-sized models of Indian craft workers.

(Opposite) *Fig. 17* Bourne and Shepherd, *Sayajirao III, Gaekwar of Baroda* (1863–1939). The Gaekwar wears a medal given by the Prince during the tour. A book tooled with the Prince's feathers on the table beside the Maharaja was probably another gift from the Prince, 1875–6. RCIN 2701622

(Above) *Fig. 18 A selection of the gifts given to the Prince of Wales during his tour of India*, 1 July 1876. *Illustrated London News*

Many national and regional newspapers published weekly features on the collection. The newspapers, and a later handbook written by George Birdwood, reviewed the design and workmanship of the Prince's presents. Objects that appeared 'traditionally Indian', with motifs that pre-dated British rule, were particularly commended by Birdwood, and many of the subsequent reports or guides produced for the various exhibitions echoed such sentiments. Similarly, those objects that displayed strong 'local character' (such as RCIN 11270, pp. 116–19) were highly praised. By contrast, objects that included motifs associated with Europe (RCINS 11487 and 11251, pp. 132–3 and 140–41) were often criticised as not representing 'true' Indian design. Such opinions were based on the idea of 'authentic' Indian design expressed by, amongst others, Sir Henry Cole (1808–82), founder of the Victoria and Albert Museum, and Owen Jones (1809–74) architect and author of *The Grammar of Ornament* (1856), who had looked to countries such as India to readdress ideas on design within Britain.[39]

The success and enthusiastic reception of the exhibition at the South Kensington Museum led to the gifts to being exhibited at the Bethnal Green Museum from 1876 to 1878. The Prince himself believed that it was important for the 'industrious classes' of East London to examine the collection.[40] The exhibition generated £450 through entrance fees, with entry to the museum costing sixpence on Wednesday to Friday and free on all other days.[41] By the close of the exhibition in 1878, it had been visited by 1,220,000 people.[42]

In 1878, the Prince's gifts travelled to Paris for display at the International Exhibition (fig. 19). From late 1876 parts of India had been devastated by a famine and the Prince of Wales felt that 'due to the distressing circumstances in India [it would be] inexpedient to charge the Revenue of India with the cost of making a new Collection' for the exhibition.[43] He wrote to the South Kensington Museum in March 1877 asking for the museum to loan the cases and fittings, and to administer the display in Paris as part of the British Indian section, to which they agreed.[44] The foreword in the British Indian section handbook by Purdon Clarke, who had designed the Indian pavilion for the

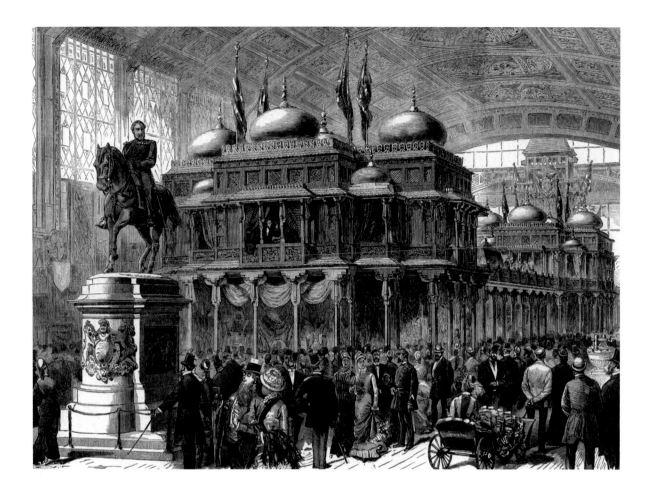

exhibition, commented that the Prince's collection 'more than sufficiently represents the higher Art manufactures of India'.[45] These pieces were to be supplemented with 'peasant' jewellery, pottery from Bombay, Sindh, Madras, Punjab and Azamghar, as well as chintz from Masulipatam.[46] To secure these for the exhibition, the Prince wrote to Robert Bulwer-Lytton (1831–91), the new Viceroy of India, and to the respective Governors of the Indian Provinces.[47] As the number of objects to be displayed grew larger, the Prince asked the exhibition authorities for a larger space for visitors to see the British Indian display, which he was granted.[48]

On their return from Paris, the gifts travelled to Scotland where they were exhibited at the Edinburgh Museum of Science and Art in March 1879, the Corporation of Glasgow in October 1879, and at the Town and Country Hall in Aberdeen in October 1880. Here surplus funds from admission fees were put towards the construction of Aberdeen Art Gallery and Museum, which opened in 1883.

Fig. 19 Prince of Wales's Pavilion,
Paris International Exhibition, 1878.
Illustrated London News

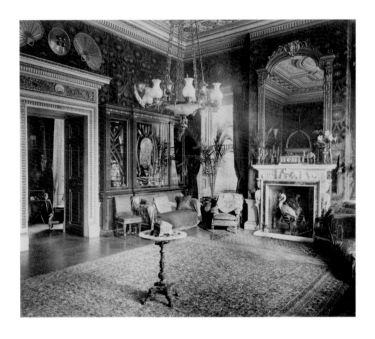

Fig. 20 The 'Indian Room' at Marlborough House, London, c.1890.

The popularity of the exhibition encouraged the Yorkshire Fine Art and Industrial Institution to ask the Prince if they might display a selection of the gifts. The Prince agreed and they were subsequently shown in York in May 1881. George Birdwood wrote a revised publication for this smaller display, suggesting that the Indian works of art 'may serve to bring home to Englishmen in this city, the natural capital of all the great manufacturing industries of Central and North-Eastern England [...] an intelligent sense of their shortcomings as manufacturers, and of the ways and means for their correction'.[49] Over a quarter of a million visitors went to see the exhibition and it raised £2,754.[50] An 'Oriental Bazaar' was also set up in the gallery alongside the display to give visitors the 'opportunity of purchasing appropriate mementoes'.[51] From York, the gifts were displayed at the Castle Museum, Nottingham from December 1881 to March 1882, with extended opening hours and reduced admission fees to ensure that more visitors were able to visit.[52] From there they travelled to the Amalienborg Palace in Copenhagen and, in January 1883, a small selection of the gifts were lent to Penzance School of Art to assist with raising funds in setting up a permanent museum.[53]

The display of the Prince's gifts from India appears to have encouraged firms in Britain to capitalise on their popularity. The Birmingham-based firm Elkington and Co., which had developed the process of silver-plating, had begun to produce copies of Indian silver from 1872. They increased the production of 'shawl' patterned silverware, similar to the design seen on the bottles given by the Maharaja of Kashmir (RCIN 11446; pp. 102–3).[54] Liberty of London and Proctor and Co. also began to stock tea sets and dinner services from Cutch displaying scrolling foliage similar to that seen on the scabbard presented by the Rao of Cutch (RCIN 11350, pp. 152–3).[55] The company P. Orr and Sons in Madras, who had produced gifts for the Maharajas of Cochin and

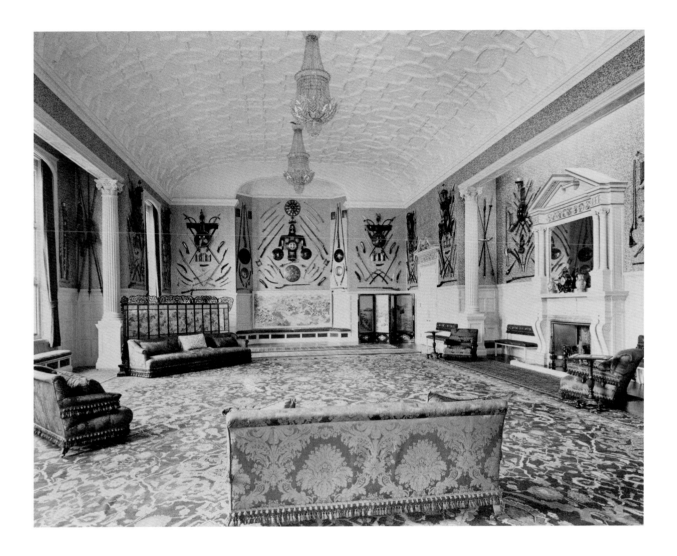

Indore and the Gaekwar of Baroda to present to the Prince of Wales, began to advertise themselves as 'Manufacturing Jewellers, Gold and Silversmiths to His Royal Highness the Prince of Wales'.[56]

Fig. 21 The Prince's gifts displayed in the Ballroom at Sandringham House, Norfolk, 1934.

A lasting impression of India

Following the tour and subsequent exhibitions of the gifts, the Prince's interest in Indian art manifested itself both within his residences and in his continued involvement with exhibitions and institutions linked with the Indian subcontinent.

Following the exhibition tour of the gifts, the collection was returned to the Prince. At Marlborough House the Prince had the library converted into an 'Indian Room' so that he could display a selection of the gifts (fig. 20).

Cabinetmakers Holland and Sons created built-in cabinets fitted with electric lighting to house them.[57] The room was further decorated with wallpapers and curtains inspired by Indian motifs, and on the floor were Indian carpets and rugs. Carved chairs were upholstered in gold cloth brought back by the Prince from India; sofas were covered with Indian textiles and a gold and green elephant trapping was used to cover a divan, which created 'a distinctly Oriental effect'.[58] Other gifts from the tour were displayed at Sandringham House in the Ballroom, the Ballroom Corridor and Dining Room (fig. 21).

Inspired by the positive reception the gifts received at the Paris International Exhibition (1878), the Prince served as Executive President for the Colonial and Indian Exhibition (1886). In 1887, the Prince became the President of the Imperial Institute, which was created to mark the Queen's Golden Jubilee by providing 'an enduring representation of the Colonies and India' and to 'be an emblem of Imperial unity'.[59]

The Prince valued his gifts from the Indian subcontinent as objects of scholarly study. In 1898, he asked Purdon Clarke to produce a catalogue of the gifts kept in the Indian Room at Marlborough House and, in 1910, Purdon Clarke produced another catalogue of the Indian arms and armour at Sandringham House which also formed part of the gift. Two beautiful catalogues were printed by William Griggs (1832–1911), the inventor of photo- and chromo-lithography, who also produced the lavish polychrome *Journal of Indian Art* (later *Journal of Indian Art and Industry*), published from 1884 to 1916. In 1902, when the Prince of Wales had been crowned King Edward VII, the cabinets and contents of the Indian Room at Marlborough House were transferred to Buckingham Palace and installed by Holland and Sons.

Notes

1. London 1877, p. 117.
2. Russell 1877, p. 521.
3. *York Herald*, 6 May 1881.
4. London 2013, p. 15.
5. Russell 1877, p. viii.
6. RA VIC/MAIN/QVJ (W) 18 April 1875 (Princess Beatrice's copies).
7. *The Times*, 23 March 1875.
8. Russell 1877, p. xvii.
9. *The Times*, 21 July 1875.
10. IOR/C/138 f.66.
11. Ibid.
12. IOR/R/2/167/258: 1875.
13. RA VIC/ADDA5/503.
14. *ILN*, 2 October 1875.
15. Russell 1877, p. xv.
16. Aberigh-Mackay 1875, p. iii.
17. Russell 1877, p. 115.
18. *ILN*, 4 December 1875.
19. Ibid.
20. Russell 1877, p. 122.
21. Ibid., p. 187.
22. Wheeler 1876, p. 358.
23. Russell 1877, p. 313.
24. Ibid., p. 361.
25. Ibid., p. 390.
26. Ibid., p. 443.
27. Ibid., p. 462.
28. Ibid., p. 448.
29. Ibid., p. 456.
30. Ibid., p. 466.
31. Ibid., p. 152.
32. Ibid., p. 134.
33. Ibid., p. 138.
34. Ibid., p. 571.
35. London, 1877, p. 117.
36. *ILN*, 1 July 1876.
37. *ILN*, 2 October 1880.
38. Ibid.
39. See Dehejia et al. 2008, pp. 54–6.
40. MA/1/R1940.
41. London 1879, p. xvii.
42. *York Herald*, 6 May 1881.
43. MA/1/R1940.
44. Ibid.
45. Clarke 1978, p. iii.
46. Ibid., pp. iii–iv.
47. Ibid., p. iv.
48. Ibid.
49. Birdwood 1881, p. 62.
50. *York Herald*, 29 December 1881.
51. *York Herald*, 4 June 1881.
52. *Nottinghamshire Guardian*, 10 March 1882.
53. *The Morning Post*, 22 December 1882.
54. Dehejia et al. 2008, p. 13.
55. Ibid., pp. 127–8.
56. See Orr and Sons 1877 and Stronge 1995, pp. 113–25.
57. Beavan 1896, p. 32.
58. Ibid., p. 30.
59. *ILN*, 9 July 1887.

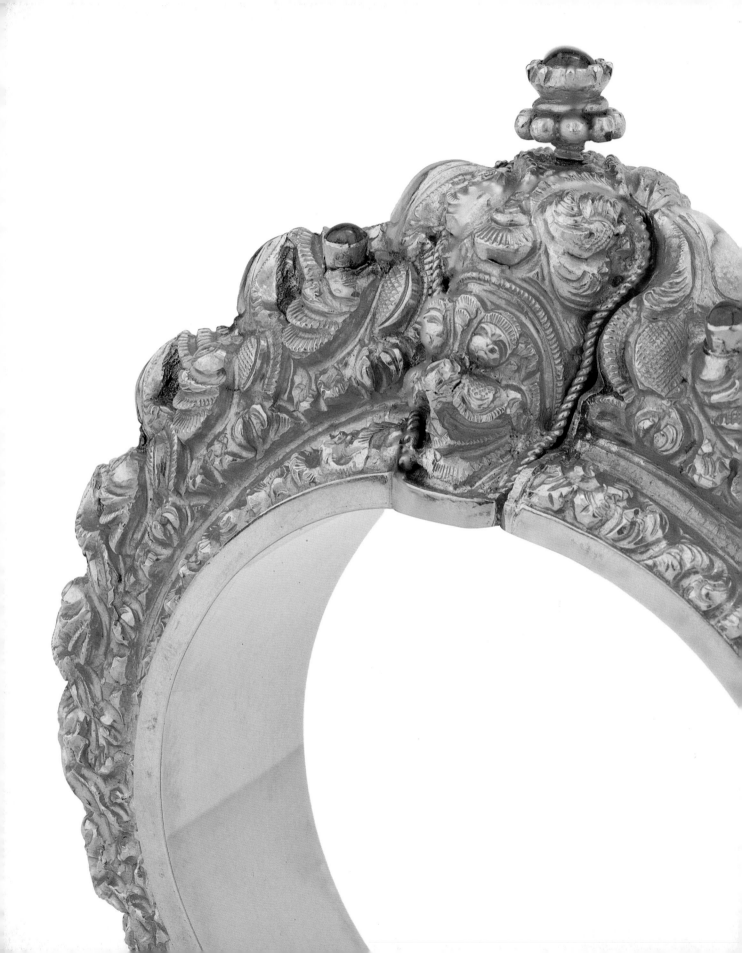

JEWELLERY

TURBAN ORNAMENT

Udaipur, mid-nineteenth century
RCIN 11286
Gold, enamel, emeralds, diamonds and pearls
15.6 × 13.5 × 1.9 cm
EXHIBITED: Bradford 1988; Edinburgh 2012
LITERATURE: Stronge, Smith and Harle 1988, cat. no. 42

This turban ornament was one of the first gifts that the Prince of Wales received when he reached India and was presented by Sajjan Singh (1859–84), Maharana of Udaipur (fig. 22). During the Prince's meeting with the Maharana, William Howard Russell noted in the official tour diary that he too 'wore an aigrette [turban ornament] of magnificent diamonds'.[1] The design of this turban ornament developed out of early eighteenth-century examples, and, typical of turban ornaments from northern India, it is enamelled on the reverse. At the time of presentation it was valued at 3,500 imperial rupees.[2]

By the end of the seventeenth century, turban ornaments had been established as an emblem of royalty in India. This arose from Mughal links with the Iranian courts, where the *kalgi*, a stem used to hold a heron feather, would symbolise the power of a ruler. From the *kalgi*, the turban ornament became more ornate with its stylised feather composed of precious stones. Many of the Hindu Rajput rulers from nearby courts adopted elements of Mughal styles and fashions.

The gemstones have been set using the Indian technique known as *kundan* (pure gold), which secures the gemstone through pressure created by the application of thin layers of sheet gold. The emerald set on the right with a drill hole running through the centre has been reused.

When the Prince's gifts were exhibited at the India Museum at South Kensington, the turban ornament was depicted in the *Illustrated London News* as one of the highlights of the Prince's gift.[3]

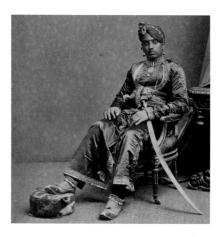

Fig. 22 Bourne and Shepherd, *Sajjan Singh, Maharana of Udaipur (1859–84)*, 1875–6. RCIN 2114233

1 Russell 1877, p. 136.
2 IOR/R/2/167/258: 1875.
3 *ILN*, 12 August 1876.

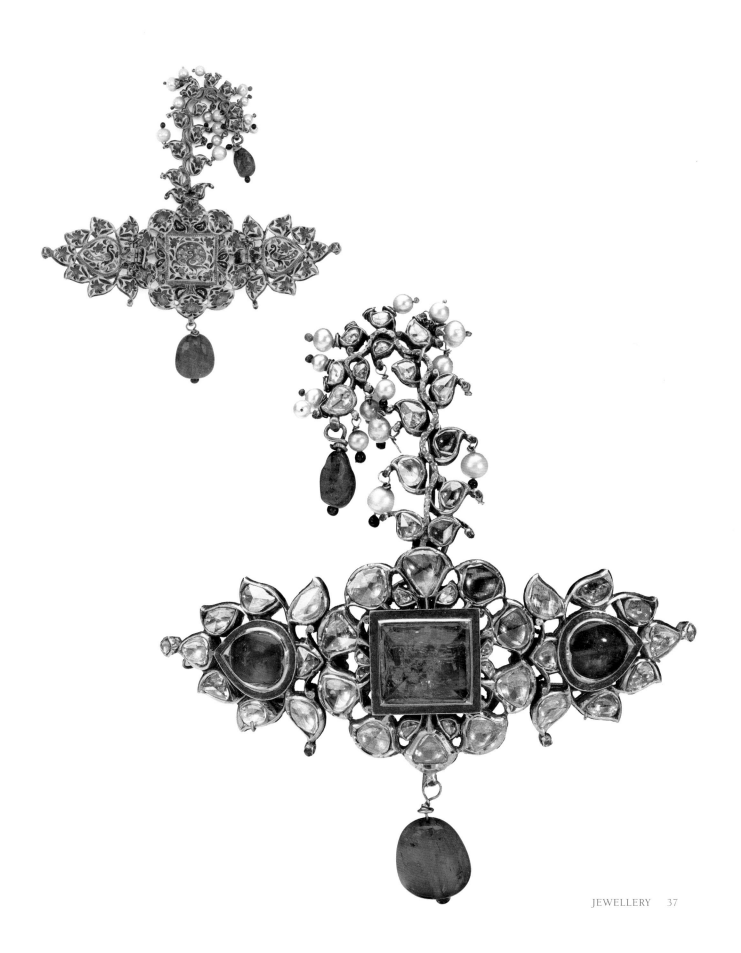

TURBAN AND EAR ORNAMENTS

South India, mid-nineteenth century
RCINS 11463, 11282.1–2
Gold, diamonds, rubies, emeralds and pearls
Turban ornament 12.0 × 24.6 × 0.8 cm;
ear ornaments 6.5 × 4.2 × 2.2 cm each
LITERATURE: Untracht 1997, cat. no. 420

These turban and ear ornaments were presented to the Prince of Wales by Ramachandra Deo III, Maharaja of Jaypore (1843–89), from Vizagapatam, Madras.[1] The Prince of Wales met the Maharaja at the Guindy Park racecourse, Madras, on 15 December 1875, where the latter was presenting a trophy.

The turban ornament has a large inset ruby encircled by diamonds. A stem of emeralds rises above the ruby to create the feather shape. The headband is held in place with a red cord, which allows it to be adjusted to fit the shape of the head. The engraved back and open-work setting of the gems is characteristic of turban ornaments produced in South India.[2] Although originally catalogued together by Caspar Purdon Clarke in *Indian Art at Marlborough House* (1898), the ear ornaments differ from the turban ornament in design, and in the use of seed pearls, suggesting that they do not belong together. Ear ornaments of this type would be worn by women, while the turban ornament would only have been worn by men.

1 Lethbridge 1900, p. 571. The Raja of Jaypore was granted the title of 'Maharaja' on 2 December 1875 for 'personal use'.
2 Scherbina et al. 2014, p. 133.

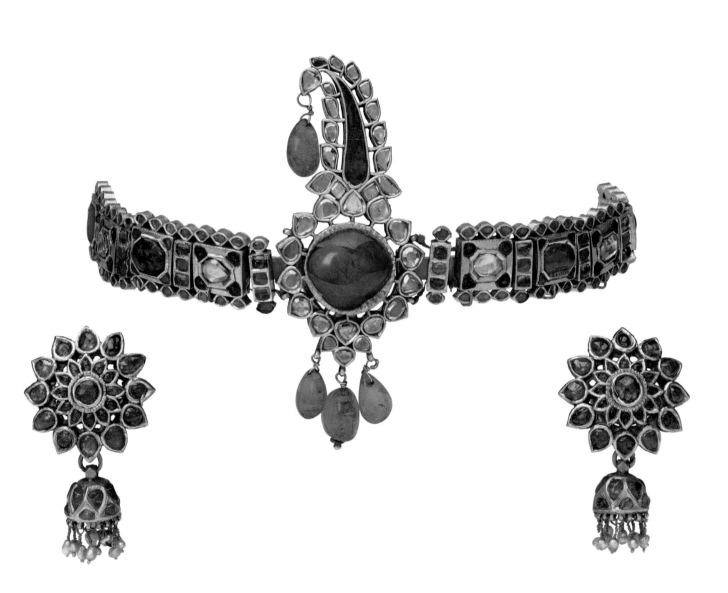

CROWN

Lucknow and possibly Jaipur, c.1875
RCIN 11358.a
Gold, enamel, velvet, cotton, pearls, emeralds and diamonds
17.5 × 32.0 × 32.0 cm
EXHIBITED: London 2002; London 2005
LITERATURE: London 2002, cat. no. 301
MARKS: '*ICH DIEN*' and '*HONI SOIT QUI MAL Y PENSE*'
embroidered in silver-gilt thread on the front of the crown

This crown was a gift to the Prince of Wales from the Taluqdars of Awadh. It was presented at Kaiserbagh, the garden complex built by the last King of Awadh, Wajid Ali Shah (1822–87), on 7 January 1876. Wajid Ali Shah's kingdom had been annexed by the East India Company in 1856 and the Taluqdars, holders of estates in Awadh, had benefited from this act and sought to elevate their status within the hierarchy outlined by the British Indian Government.

A crown of this form had been adapted by Ghazi-al-Din Haider (c.1769–1827), the first King of Awadh, and was designed by Robert Home (1752–1834), a British artist employed at the court of Awadh. The crown worn by Haider was made using a blend of European and Iranian emblems (fig. 23) and this type of crown was also used by later Kings of Awadh.[1]

The crown presented to the Prince includes a three-pronged jewel aigrette of diamonds and emeralds to represent the Prince of Wales's feathers. Behind the aigrette, a lion and unicorn from the Royal Arms can be seen along with the Prince of Wales's motto, 'Ich Dien'.

The deposition of the Awadhi court did not appear to displace the court artisans, who found patronage amongst the Taluqdars and Europeans living in Lucknow. By the mid-nineteenth century two thirds of the population of Lucknow, a city renowned for its luxurious craftsmanship, were estimated to be artisans. William Howard Russell noted that 'there are still a few of the artificers who abounded here in the days of the Native Court when Lucknow was like Paris under the Empire workers in gold and silver, makers of curious jewellery, enamellers and pipe stick embroiderers [...] these exhibited their wares every morning at the Commissioner's, and found many purchasers'.[2]

The crown presented to the Prince displays a mix of craftsmanship from Lucknow and possibly Jaipur. Red, green and white enamelling, depicting floral patterns on the reverse of the visible portions of the circlet and aigrette, suggests that the gold components of the crown were made in Jaipur. The embroidered textile of the crown is characteristic of Lucknow embroidery.[3]

When the crown was displayed at South Kensington in 1876, the combination of the European and Indian symbols of kingship had rendered the crown 'far too theatrical and tinselly to be pleasing'.[4]

1 Trivedi 2010, p. 3.
2 Russell 1877, p. 399.
3 Markel et al. 2010, p. 199; Crill 2010, p. 239.
4 London 1877, p. 131.

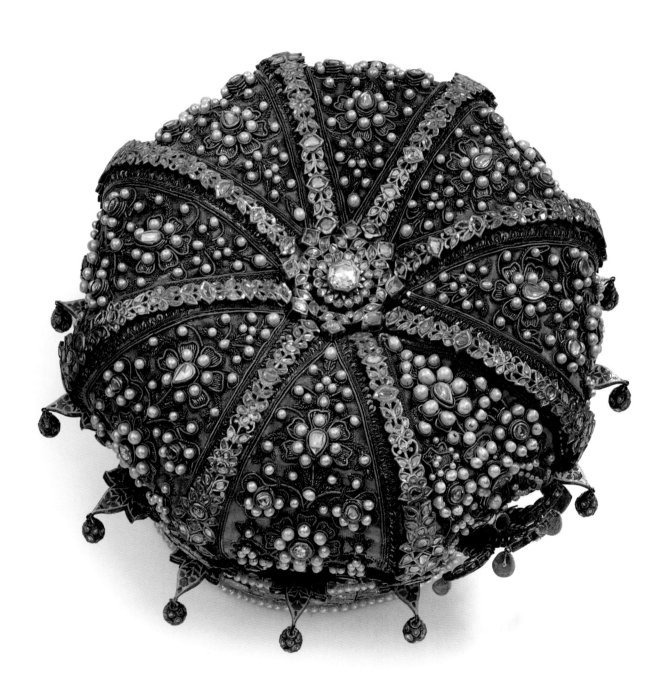

Fig. 23 Wajid Ali Shah's *Ishqnama*, fol. 357, 1849–50.
RCIN 1005035

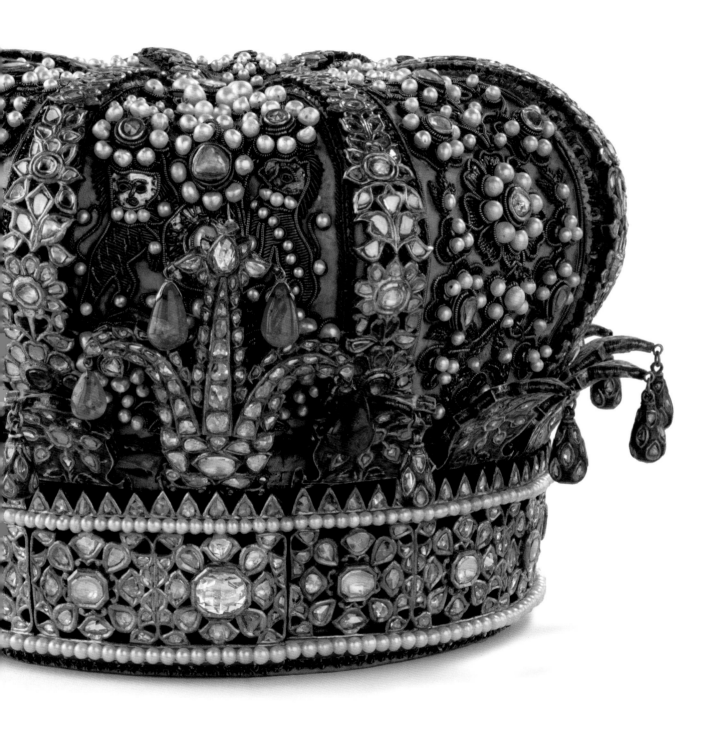

BANGLE

South India, c.1850–75
RCIN 11522
Gold and rubies
3.1 × 9.1 × 8.9 cm

On 24 May 1876 Albert Edward presented his mother, Queen Victoria, with a golden bangle for her 57th birthday. In her journal she recorded: 'I received a number of lovely things. Arthur gave me a charming old Spanish fan from Seville & Bertie 2 beautiful Indian bracelets from Trinchinopoli & Jeypore'.[1]

Indian peddlers, referred to as *boxwallah* in William Howard Russell's diary, were a frequent sight throughout the Prince's tour. On 12 December 1875, Russell wrote that 'there was a heavenly repose in the early part of the day. Divine service in the drawing-room at headquarters at 11 AM. Then came irruptions [*sic*] of workers in gold and silver, in brass and ebony, and in all the things for which Trichinopoly is famous. There was no more peace, but there was much bargaining for bangles and

jewellery' (fig. 24).[2] The wares of the *boxwallah* enticed the Prince to purchase this bangle as a souvenir.

The repoussé bangle is made of sheet gold that has been beaten in the form of *makara* heads, fantastical Hindu creatures, ascending in size from the hinge at the base. The two sides of the bangle terminate with two large *makara* heads set with ruby eyes. The hinged bangle is held together by a screw topped with a larger cabochon ruby.

Sculptural bangles such as this were filled with lac, a resin used to fill hollow jewellery in India. This allowed Indian goldsmiths to create jewellery that gave 'the flimsiest and cheapest Indian jewelry [*sic*] its wonderful look of reality'.[3]

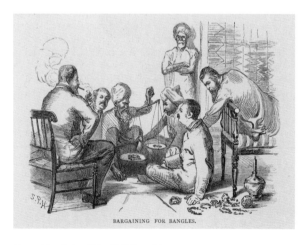

Fig. 24 After Sydney Prior Hall, *Bargaining for Bangles*, in Russell 1877, p. 315.

1 RA VIC/MAIN/QVJ (W) 24 May 1876 (Princess Beatrice's copies).
2 Russell 1877, p. 314.
3 Birdwood 1884, p. 190.

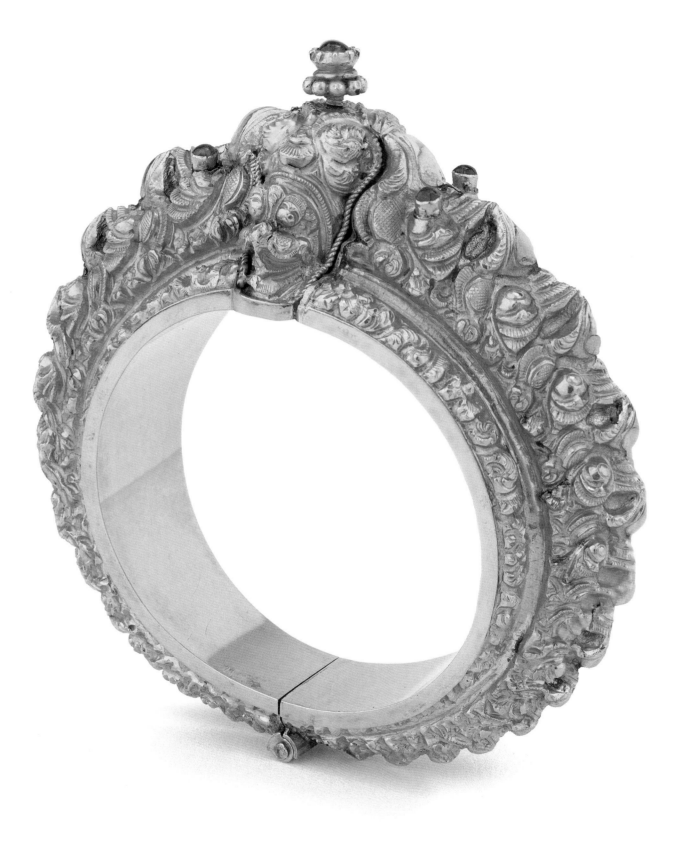

PAIR OF BANGLES

Jaipur, *c.*1850–75
RCIN 11290.1–2
Gold, enamel, diamonds and pearls
1.6 × 8.1 cm each

The predominant use of dark blue, white and ruby red enamel is typical of Jaipur enamelled jewellery. It is possible that the Prince purchased this pair of bangles while visiting Ram Singh II, Maharaja of Jaipur (1833–80), in early February 1876. As with the gold bangle purchased at Trichinopoly (RCIN 11522, pp. 44–5), Russell's diary makes references to *boxwallah*. On the last day of the Prince's stay in Jaipur he noted that they were 'hovering around with articles for sale'.[1]

1 Russell 1877, p. 408.

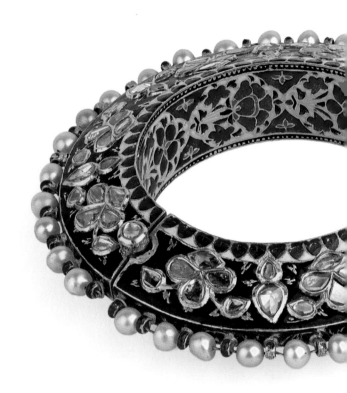

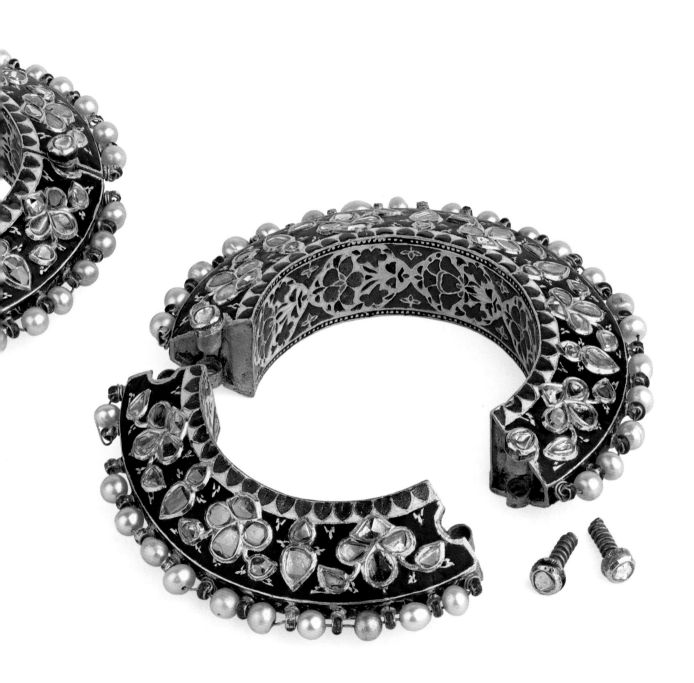

WAIST BELT

Mysore, mid-nineteenth century or earlier
RCIN 61971
Gold, diamonds, emeralds and rubies
6.9 × 26.5 cm
LITERATURE: Untracht 1997, cat. no. 524

This jewel-encrusted waist belt was presented as a gift to the Princess of Wales by Chamarajendra Wadiyar X (1863–94), Maharaja of Mysore. The belt is made of a gold, openwork frame, set with diamonds, emeralds and rubies emulating patterns of open lotuses and peacocks, and the inner surface is engraved with designs that echo the outer patterns. What appears to be a buckle is actually a decorative element and the belt is in fact fastened by a small hook.

J. Drew Gay, reporting for *The Daily Telegraph* from India during the Prince's tour, claimed that 'the most beautiful present of all is a belt of gold which is placed on a little table by itself. Long years it has been in the treasury of Mysore, highly valued, much admired, and now it sees light only to leave Mysore forever [...] it is one of the most resplendent ornaments that could be designed. Its intrinsic cost was many thousands of pounds, but as a work of art it is still more valuable'.[1]

Rigid belts such as this would have been worn by women, and George Pearson Wheeler, who reported on the tour for *Central News*, remarked on the *nautch* (dancing) girls at Madras who wore on their waists 'belts of solid gold'.[2]

The Princess of Wales lent the belt to be included in the exhibition of gifts; however, it received mixed reviews, one reviewer commenting that 'you see a necklace or girdle of gems, which you would say is priceless; but it is all mere glamour of colouring'.[3]

1 Gay 1877, p. 43.
2 Wheeler 1876, p. 178.
3 *ILN*, 12 August 1876.

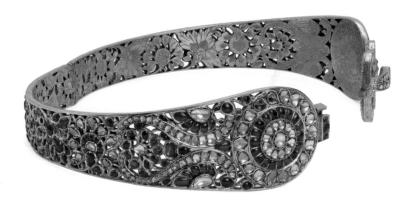

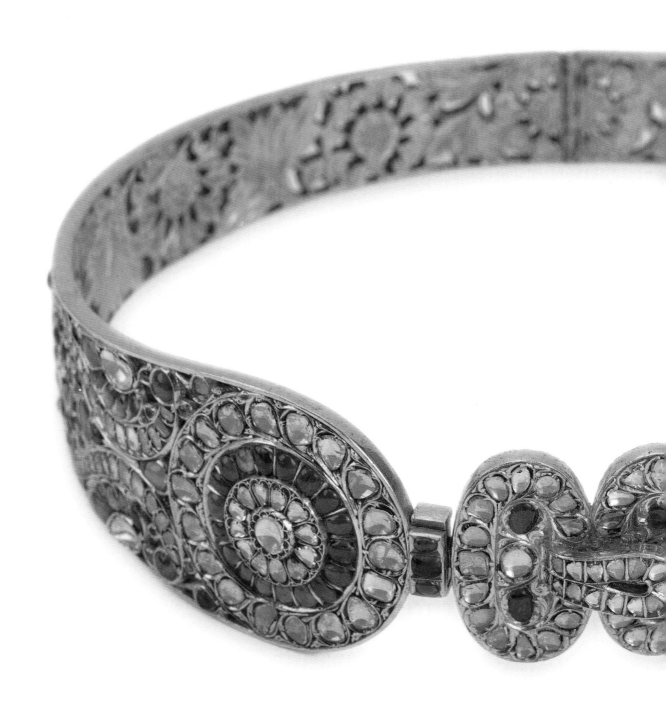

TIGER CLAW BROOCH

South India, *c.*1870
RCINS 11493, 11533
Gold and tiger claws
11.3 × 10.2 × 1.4 cm (overall)
EXHIBITED: London 1982; Bradford 1988
LITERATURE: Stronge, Smith and Harle 1988, cat. no. 77

This tiger claw amulet, adapted to be worn as a brooch, was presented by Ayilyam Thirunal Rama Varma IV Kulasekhara (1832–80), Maharaja of Travancore, in Madras, in December 1875.

The brooch is comprised of three tiger claws with gold mounts. The mount forming the top section of the brooch depicts the Hindu goddess of wealth, Lakshmi, seated in a lotus with an elephant at either side. This popular depiction of the goddess with elephants is known as *gaja-lakshmi*. A smaller figure on the single claw, whose palms are facing up and down, is flanked by two peacocks. This possibly represents Subramanya, the Hindu god of war.

In many parts of India tiger claws were traditionally worn as charms against malevolent spirits and to instil courage. However, by the nineteenth century tiger claws had also become popular with the burgeoning European tourist market and were worn as exotic charms or set in brooches, necklaces and bracelets.[1]

1 Untracht 1997, p. 95.

BROOCH

Ratlam, *c.*1875
RCIN 11497
Gold and glass
5.5 × 5.5 × 0.8 cm
MARKS: '*H.R.H. PRINCE OF WALES HER R.H. PRINCESS
OF WALES RUTLAM 1876*' inlaid in gold encircling the two busts
EXHIBITED: Bradford 1988
LITERATURE: Stronge, Smith and Harle 1988, cat. no. 121

This scallop-edged brooch was presented by Ranjit Singh (1860–93), Raja of Ratlam, who met the Prince of Wales at Indore. The two figures within the arch supposedly depict the Prince and Princess of Wales.

The glass plaque for the brooch was produced using a process known as *thewa* (setting), which involved etching a design on a thin sheet of gold. These designs often depict secular scenes of courtly life or hunting, as well as scenes from the life of the Hindu deity Krishna, or occasionally a commissioned portrait, as with this gift.[1] Once the desired image has been etched onto the sheet, the design is cut out removing the excess gold.

The pierced design is then fused onto the coloured glass by heating it. Silver or tinfoil is often added beneath the plaque to enhance the colour of the glass.

This process was described by European commentators as quasi-enamelling in the late nineteenth century due to a lack of understanding of the technique. It remained a closely guarded secret by the few families that created it (fig. 25). *Thewa* work was popular in India and abroad due to its versatility, and was used for the embellishment of jewellery, boxes, swords and daggers.[2]

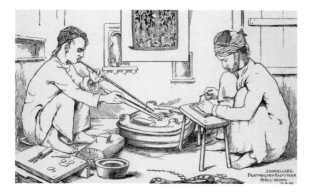

Fig. 25 Percy Brown, *Enamellers. Pertabgarh Rajputana,
17 August 1902*, in Watt 1903, plate 7.

1 Untracht 1997, p. 302.
2 *JIA* 1894.

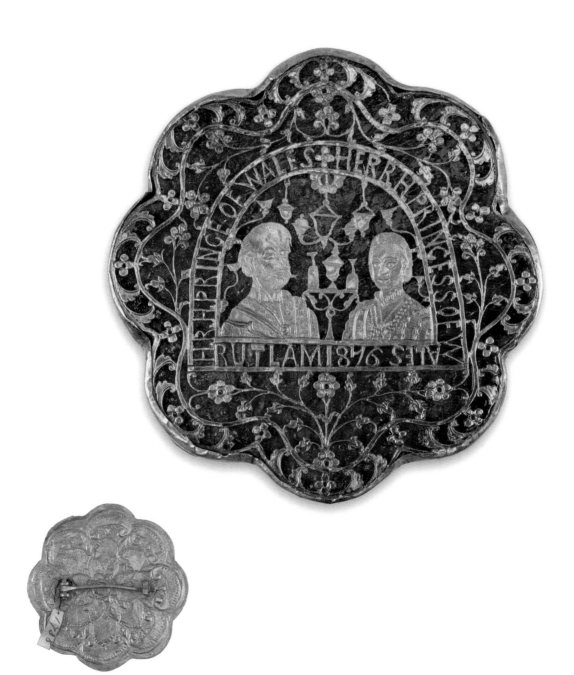

OPIUM BOX

Ratlam or Pratapgarh, *c.*1875
RCIN 11537
Silver-gilt, gold and glass
6.2 × 5.8 × 2.8 cm

As the Prince and his entourage arrived at Indore, William Howard Russell described the fields of poppies as being 'spread out like carpets of Turkestan, as far as the eyes could reach'.[1] At his meeting with Ranjit Singh, Raja of Ratlam, the Prince was presented with this silver and silver-gilt hinged opium box. Like other gifts from the ruler, this box has a plaque of green glass, fused with pierced sheet gold depicting the Hindu deity Krishna, with the *gopis* (cowherds). This technique was known as *thewa*.

The use of both silver and silver-gilt in parts of North India was poetically described as *Ganga-Jumna*, after the River Ganges and River Yamuna, and in reference to the contrasting colours of the two rivers.

By the early nineteenth century Ratlam had become a thriving centre for trading opium, and tobacco containers such as this were especially designed for carrying opium powder. A silver-gilt poppy head, affixed to the underside of the box, gives an indication of the box's purpose.

1 Russell 1877, p. 515.

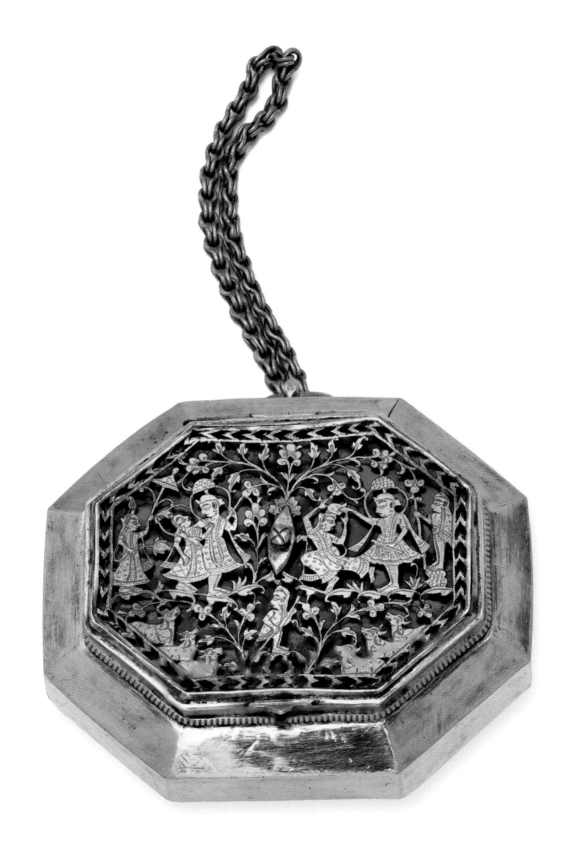

NECKLACE

Ratlam, *c.*1875
RCIN 11499
Gold, glass and emerald
35 cm
MARKS: '*H.R.H. PRINCE OF WALES HER R.H. PRINCESS OF WALES*'
inlaid bordering the heart-shaped plaque, and '*RUTLAM 1876*'
inlaid horizontally below the two busts

The heart-shaped pendant of the necklace features a depiction of the Prince and Princess of Wales similar to that found on the brooch (RCIN 11497, p. 53). Beneath them, a small Indian figure in courtly dress stands in profile and a cabochon emerald is suspended below. The other plaques of the necklace show animals in combat, another popular theme depicted using *thewa*. The reverse of the necklace is decorated with etched designs of animal scale patterning and floral motifs and the reverse of the pendant is etched with the image of two peacocks.

This necklace was undoubtedy a special commission and the goldsmith appears to have based the portraits of the Prince and Princess of Wales on printed ephemera produced in anticipation of the tour.

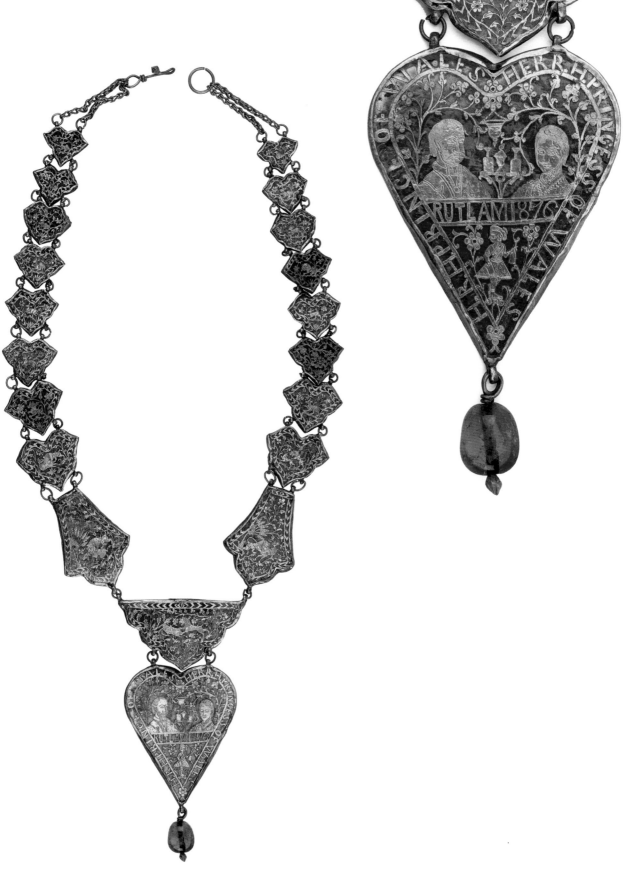

NECKLACE

Pendant from Gwalior, probably first half of nineteenth century, reset by Phillips Brothers and Sons, London, c.1878

RCIN 11355

Gold, enamel, diamonds, rubies, pearls and emeralds

22.6 × 15.5 × 0.7 cm

The Prince of Wales received a necklace from Jayajirao Scindia, Maharaja of Gwalior (1835–86), on behalf of his mother, Queen Victoria. Shortly after receiving the gift, the Queen had the necklace remounted by the jewellers Phillips Brothers and Sons.

A reference to the original necklace is made in Queen Victoria's jewellery inventory, where it is described as 'a neck ornament in the shape of a demi circle with enamelled back, composed of five large & four smaller lask Diamonds surmounted by nine Pearls; pendant from it four Pearls & five heart shaped lask Diamonds with an Emerald drop & two Pearls attached to three of the Diamonds & a Ruby drop & two pearls attached to the two others. On each end of the ornament five short rows of Pearls, each row containing nine Pearls. A gold cord with two gold tassels attached to it'.[1]

The new setting was later recorded in the inventory as 'almost the original style, a few ornaments in red enamel & a snap fastening of Rubies added to it. The snap made out of a large ring presented to the Queen with other jewellery by the Maharajah of Mysore in 1862'.[2]

Phillips Brothers were admirers of Indian enamelling and salvaged the original Indian enamelled panels behind the *kundan*-set diamonds, riveting them to the gold frame that they had created to hold the diamonds. Phillips had created jewellery inspired by Indian enamelling and exhibited a Mughal crystal bowl at the Paris International Exhibition (1867) mounted in an Indian-inspired enamelled and gem-set gold stand (now part of the collection at the Victoria and Albert Museum).[3] Phillips's Indian-inspired jewellery usually featured enamelling on the front instead of the back, as was usual with Indian jewellery. With the necklace for Queen Victoria, Phillips made four crescent-shaped 'ornaments' enamelled with green flowers.

Although the inventory does not note a specific date for the resetting of the necklace, it was returned to Queen Victoria by the end of February 1878, when she remarked in her journal that 'a number of congratulatory Indian addresses, on the assumption of the title of "Empress", have arrived [...] wore Scindia's splendid necklace which has been reset, but just in the same style'.[4]

1 'List of jewellery belonging to Her Majesty The Queen Victoria, 1819–1901', vol. 3, c.1917–27. RCIN 1170221, pp. 1–4.

2 Ibid.; Krishnavaja Wadiyar III, Maharaja of Mysore (1794–1868), 'by a spirit of loyalty and deep sense of sincere attachment to Her Majesty's Government', had presented necklaces, armlets and rings of rubies, diamonds and pearls to Queen Victoria in 1862 (IOR/L/P45/6/511 ff.4–5).

3 See IM.328-1920 in the collection at the Victoria and Albert Museum. Barnard 2008, pp. 103–4; Untracht 1997, p. 395.

4 RA VIC/MAIN/QVJ (W) 28 February 1878 (Princess Beatrice's copies).

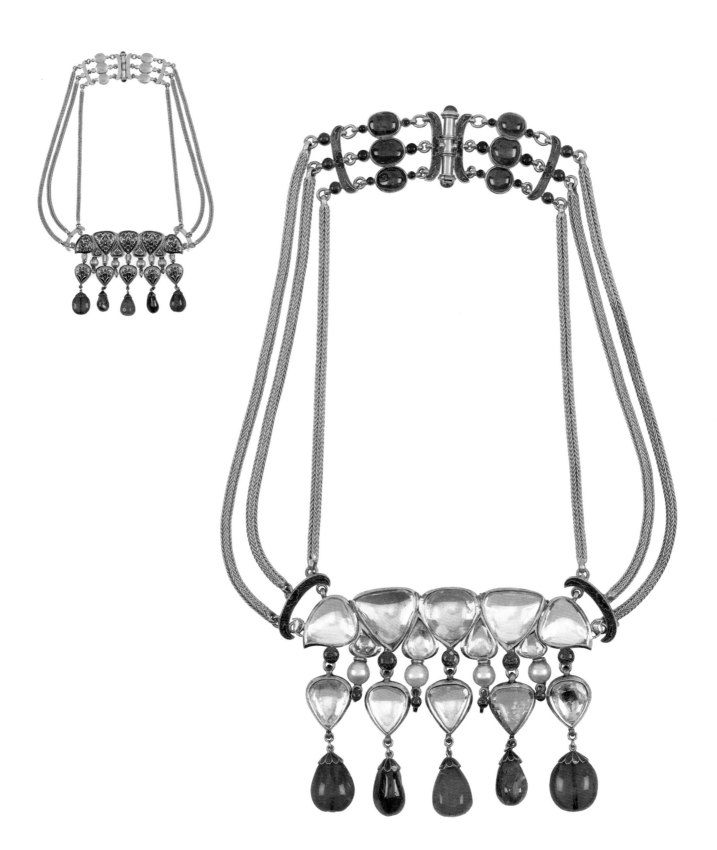

POCKET WATCH AND CHAINS

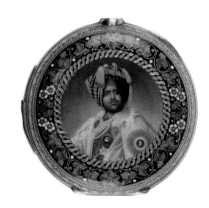

H. Grandjean and Co., Switzerland, 1870
RCINS 11476, 11477, 11478
Gold, enamel, diamonds and emeralds
Key and chain 33.0 × 2.3 × 1.6 cm; chain 67.0 × 2.5 × 0.7 cm;
watch 8.0 × 5.6 × 2.0 cm
MARKS: inscribed inside case '*Made only for H. H. the Maharaja
of Puttiala G.C.S.I.*'
EXHIBITED: Bradford 1991; London 1999
LITERATURE: Bradford 1991, cat. no. 82; London 1999, cat. no. 203

Based on its inscriptions, it appears that this double half
hunter watch was part of Maharaja Mahendra Singh of
Patiala's personal collection before he presented it to the
Prince of Wales at Lahore, in January 1876.

Pocket watches featuring enamelled portraits of the
rulers of India, popularly known as 'Maharaja watches',
became fashionable with Indian rulers from the last
quarter of the nineteenth century. This example has
an enamelled portrait of Maharaja Mahendra Singh
(1852–76) wearing the insignia of a Knight Grand
Commander of the Order of the Star of India, which
he received in 1870, indicating that this was a relatively
recent commission at the time of presentation. The
watch does not require a key, suggesting that the chain
was not designed for it.

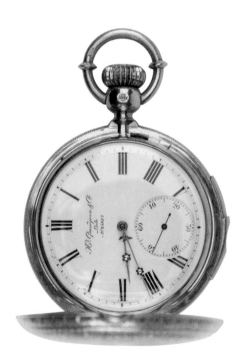

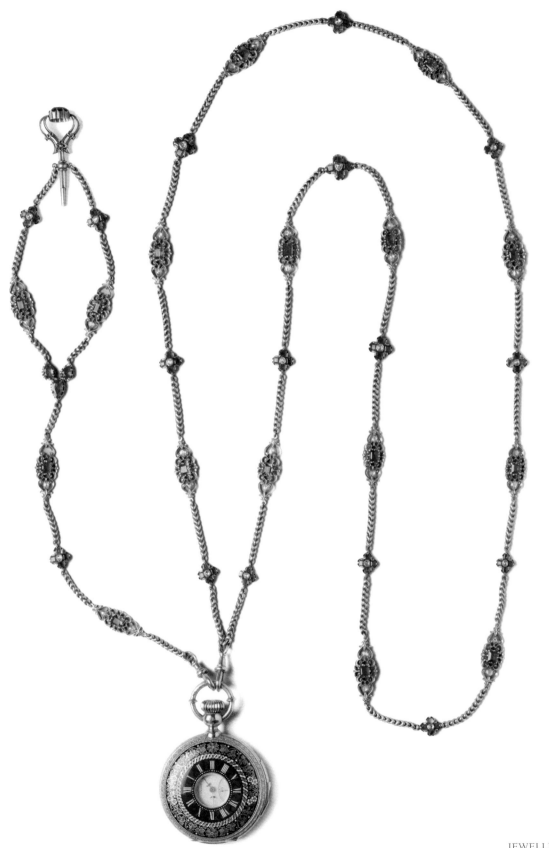

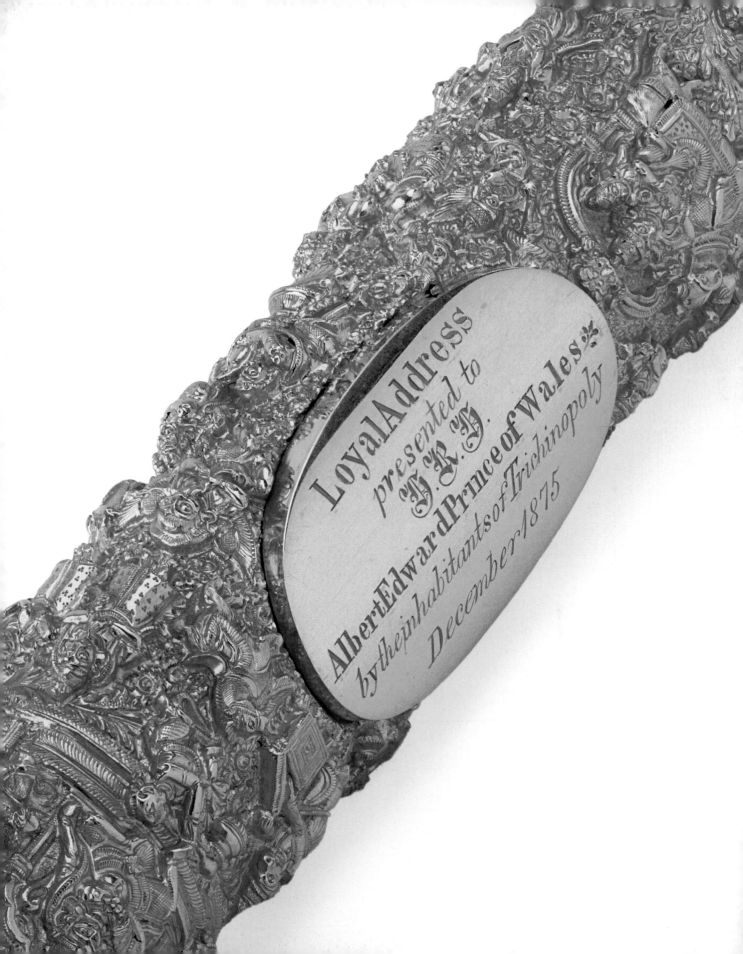

Loyal Address
presented to
H. R. H.
Albert Edward Prince of Wales
by the inhabitants of Trichinopoly
December 1875

ADDRESSES

ADDRESS CASE

Jaffna, *c.1875*

RCIN 11217.a–b

Gold, silk habotai, rubies and a diamond

Case 2.7 × 11.7 × 6.7 cm; address 44.5 × 30.3 cm

MARKS: '*ICH DIEN*' engraved on lid

This hinged gold case containing an ivory-coloured silk address was presented to the Prince by the inhabitants of the Northern and Eastern Provinces of Ceylon. The address, printed in gold leaf, is further embellished with 96 gold flowers together with the Prince of Wales's crest of three ostrich feathers and the motto *Ich Dien* ('I serve').

The address states that gifts for the Princess of Wales of 'Jaffna jewellery, both as a souvenir of Your Royal Highness's visit to Ceylon and as specimens of the handiwork of Tamil craftsmen', were also presented,

but these no longer survive in the collection. The filigree work and granulated borders seen on this box were typical of the techniques used by Tamil goldsmiths working in Ceylon.

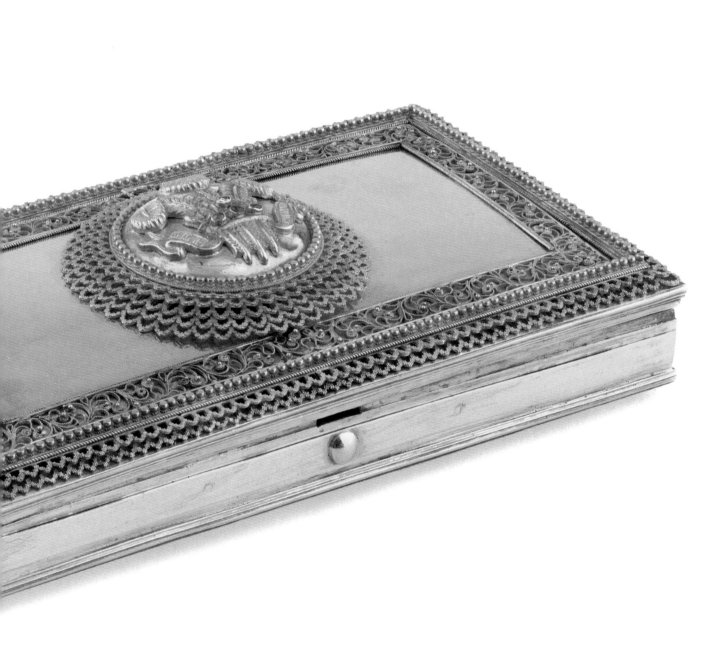

ADDRESS CASKET

J.B. Gomes Mudaliyar, Colombo, *c.*1875

RCIN 11398.a–o

Ivory, gold, sapphires, garnets, chrysoberyls, amethyst
and pearls

9.8 × 20.2 × 11.7 cm

MARKS: '*NON NOBIS*' on garter, '*ICH DIEN*' carved
on ivory underneath the Prince of Wales's feathers and
Royal Crest, and '*Made by J.B. Gomes Mudaliyar Ceylon*'
inscribed on the gold plaque fixed to the base

This casket was presented to the Prince by the municipal council of Colombo on 1 December 1876, just as he disembarked HMS *Serapis* (fig. 26). The ivory casket bordered with gemstones set in gold is carved with both the armorial and crest of the Prince of Wales. It contains an address in English, Tamil and Sinhalese engraved onto a gold plaque. The casket also contains gold-mounted spices including areca nut, cinnamon, coffee, vanilla and pepper, typically grown on the island of Ceylon.

Ivory carvers across Ceylon had been producing presentation items such as address caskets from the sixteenth century, mainly for the European market.[1]

J.B. Gomes Mudaliyar was probably the maker of the gold and gemstone mounts, and shortly after the tour exhibited a range of cut and uncut stones at the Melbourne International Exhibition (1880).[2]

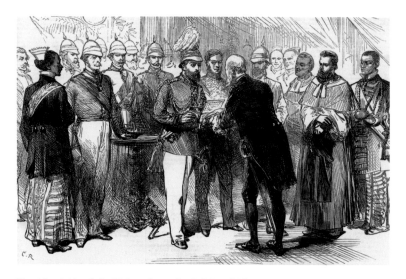

*Fig. 26 Royal visit to India: Mr Layard presenting the Prince of Wales
with the address of the municipal council at Colombo, Ceylon, 1876.
Illustrated London News*

1 Jaffer 2002, p. 14; Harle and Topsfield
 1987, p. 92.
2 Ferguson 1888, p. 184.

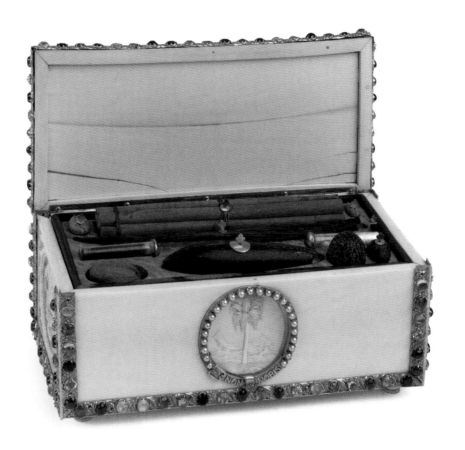

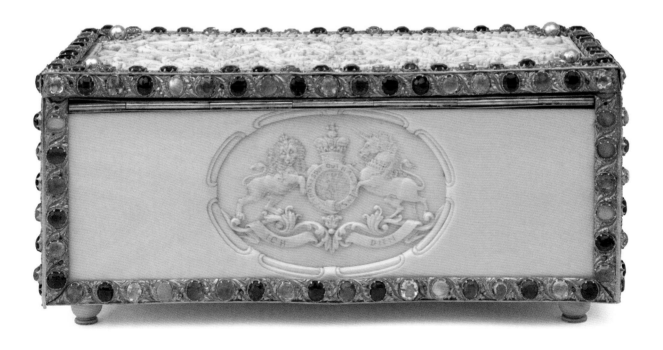

ADDRESS CASKET

South India, c.1875
RCIN 11313
Gold and sandalwood
17.6 × 28.7 × 18.7 cm
MARKS: '*MADURA, 1875*' embossed on lid

This address casket was presented to the Prince by the inhabitants of Madura (Madurai) in Thirumalai Nayakar Mahal, the palace built by the seventeenth-century Nayaka ruler, Thirumalai Nayak (r.1621–57). The address itself is no longer in the Royal Collection. Mythical elephant-headed lions, known as *yali*, at the corners of the casket seem to hold up the cover, echoing local architectural forms. The use of *yali* as pillars in South Indian temple sculpture became prominent in the sixteenth century, the most renowned example being the 'Hall of a Thousand Pillars' at the Meenakshi Amman Temple, which the Prince and his suite visited on 12 December. Carved out of single blocks of stone and standing at 25 feet high, William Howard Russell wrote that 'the figures are elaborated with extraordinary richness and abundant fancy'.[1]

The sandalwood casket is covered in panels of sheet gold all worked in repoussé with Hindu deities set within arcaded panels of floral borders. This type of embellishment using temple architecture, religious processions and Hindu iconography was known as *swami* decoration and was designed for Europeans in India and abroad. European objects such as boxes, caskets, mugs and tea sets became common objects for South Indian metalworkers to embellish with these motifs.[2]

1 Russell 1877, p. 305.
2 Stronge 1995, pp. 117–32.

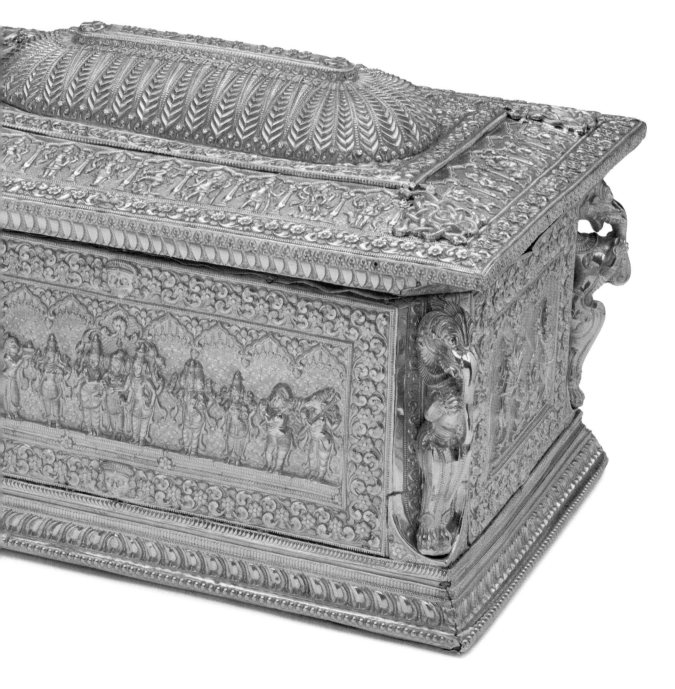

ADDRESS CASE

Trichinopoly, 1875
RCIN 11213.a–b
Gold, parchment, opaque watercolours and inks
Case 4.8 × 30.0 cm; address 60.5 × 24.6 cm
MARKS: engraved on oval plaque on scroll case '*Loyal Address presented to H.R.H. Albert Edward Prince of Wales by the inhabitants of Trichinopoly December 1875*'; plaque within finial lid engraved '*Vithelingum assary* [sic] JEWELLER'

On 11 December 1875, the Prince of Wales observed the Trichinopoly illuminations from a pavilion near the base of the 'Rock', a seventh-century temple dedicated to the Hindu deity Ganesh in the form of Vinayaka. To commemorate the event the Prince received an address from the inhabitants of the city.

The address was contained in this scroll case, made of sheet gold with Hindu deities Ganesh, Shiva, Krishna and Saraswati worked in high repoussé.[1] The sculptural cap of the scroll case depicts the Hindu deity Vishnu, reclining on a five-headed serpent, Adishesha and Vishnu's consort, Lakshmi massaging his feet. The

cap at the other end shows an unidentified figure on horseback.

Vithelingum, a jeweller based in Trichinopoly, exhibited bracelets, necklaces, earrings and vessels featuring *swami* decoration at the Vienna International Exhibition (1873), earning him an 'Honorable Mention' within the Metal Industry group.[2] Like the address casket from the inhabitants of Madura (p. 69), this casket, with its highly sculptural metalwork featuring Hindu deities, was described as *swami* decoration, and was produced primarily for European patrons. Trichinopoly was particularly known for producing *swami* ornamented in gold.[3]

1 *Repoussé* is a metal-working technique where designs are hammered into the metal sheet in reverse to create a relief.
2 *London Gazette*, 2 September 1873.
3 Dehejia et al. 2008, p. 119.

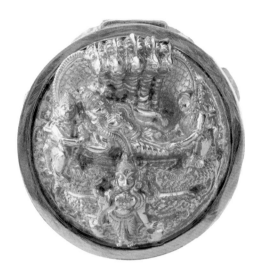

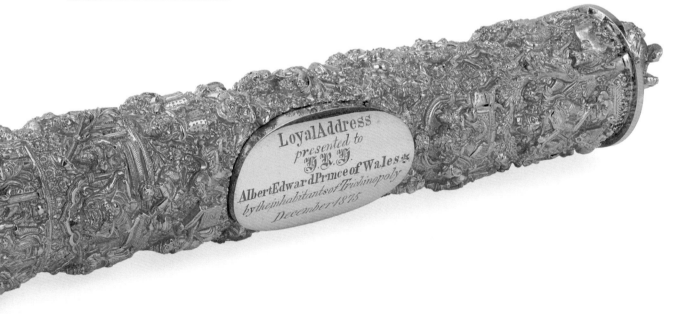

Loyal Address presented to H.R.H. Albert Edward Prince of Wales by the inhabitants of Trichinopoly December 1875

ADDRESS POUCH

Benares, *c.*1875

RCIN 11428.*a–b*

Silk, gold sequin, silver-gilt thread, gold, pearls, emeralds and rubies

Pouch 31.0 × 13.6 cm; address 61.0 × 21.0 cm

This silk address and its embroidered pouch were presented to the Prince of Wales by the Maharaja of Benares on 5 January 1876 when he laid the foundation stone for a new hospital in Benares. The hospital was named in his honour when it was finally opened in 1877. Embroidered using couched silver-gilt wire, a technique known as *zardozi*, the pink silk pouch shows the Royal Arms on one side and two fish, the emblem of Benares, on the other.

The embroidered pouch is based on the *kharita*, which was used by Indian rulers and nobles to enclose letters.

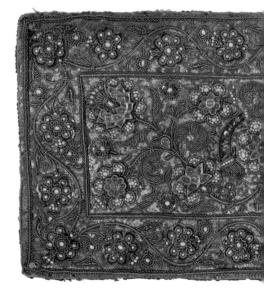

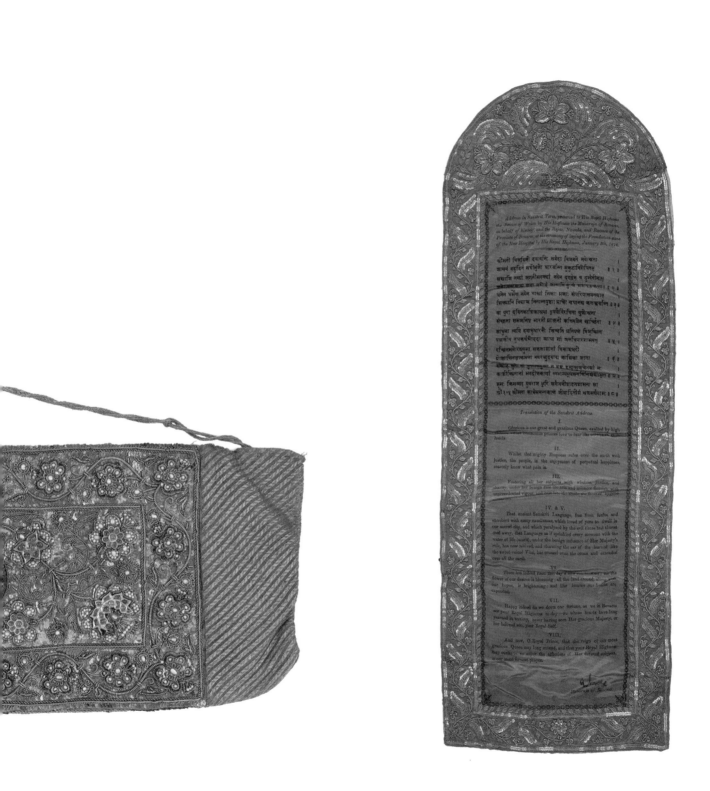

Address in Sanskrit Verse, presented to His Royal Highness the Prince of Wales by His Highness the Maharajah of Benares, on behalf of himself, and the Rajas, Nawabs, and Zemindars of the Province of Benares, at the ceremony of laying the Foundation stone of the New Hospital by His Royal Highness, January 5th, 1876.

श्रीमती विश्वशक्ती दयवानि: सर्वेषा विजयते भवेकता
ग्रामन बहुविन सवीभूमो मारवन्ना मकुटासितोगिनश्च ॥ १ ॥
सर्वाणि सन्ता आसतीस्त्रत्या लोकेन दृयवेम च दुरमेणेन्द्रय
तस्मादनि भमीर्व आत्माणि कुर्वे महराजस्पन्दनुना ॥ २ ॥
धलेन धर्मेण मवेन चाया निका: प्रजा: कंपरिपालयन्त्या
विद्याधानि विद्याश्व निस्वलनवृत्या: प्राचेन वचानस्य करत्सद्गति ॥ ३ ॥
वा प्रुपा दयिनका्रिकाकाच्या हुयविरितिता सुधीयाणाम
संस्थात समलनिष्ठ भारनी प्रालनी कच्चिदमेन क्त्सिंद्या ॥ ४ ॥
याथुना त्यावि दशाप्रुधारमे: सिख्यसि प्रसिपले प्रिप्रमिलते
पव्यकोन नुपक्रमेधेददा आच्या मो कलत्सिपारमामवण ॥ ५ ॥
रक्तिसमभेगमेराधमस: सकलागानां विकमामारी
एकासिनिमलानां मरनवुदयाय कांशिका आता ॥ ६ ॥
ग्रमेक श्रुता का कलत्सित्वमत्सते रा रहासाव्वोजेनसा न
कामोग्मिलनानो भारतीचनकार्या लभत्सरण्यमकन्विननावधधप्रकर्णा ॥ ७ ॥
प्रम: किमन्वस् युकराज भूरि कलेनवीयोतहतनामस्मा का
श्री १७५ श्रीमला साधेमनकाले श्रीयाहिनोगी अयसर्वीयाम ॥ ८ ॥

Translation of the Sanskrit Address.

I.
Glorious is our great and gracious Queen, exalted by high
and measureless princes love to bear like clusters of flower
beads.

II.
Whilst that mighty Empress rules over the earth with
justice, the people, in the enjoyment of perpetual happiness,
scarcely know what pain is.

III.
Fostering all her subjects with wisdom, justice, and
charity, under her benign rule the arts and science flourish with
unprecedented vigour, and bear into the minds we thirst cigarne

IV. & V.
That ancient Sanskrit Language, free from faults and
abounding with every excellence, which loved of yore to dwell in
our sacred city, and which paralysed by the evil times had almost
died away, that Language as if sprinkled every moment with the
water of life (amrit), under the benign influence of Her Majesty's
rule, has now revived, and charming the ear of the learned like
the sweet-voiced Vind, has crossed even the ocean and extended
over all the earth.

VI.
There has indeed risen that day of our enlightenment; on the
flower of our desires is blooming; all the land around, along with
our hopes, is brightening; and like temples our souls are
expanded.

VII.
So happy indeed do we deem our fortune, as we in Benares
see your Royal Highness to-day—we whose hearts have long
yearned in anxiety, never having seen Her gracious Majesty, or
her beloved son, your Royal Self.

VIII.
And now, O Royal Prince, that the reign of our most
gracious Queen may long extend, and that your Royal Highness
may remain—to enjoy the affections of Her throned subjects,
is our most fervent prayer.

Maharajah of Benares.

ADDRESS CASKET AND HAMMER

Possibly Sialkot, c.1875
RCIN 11248.a–e
Steel, gold, wood, silk and bronze
Casket 11.9 × 39.8 × 15.6 cm; hammer 33.2 × 10.3 × 3.2 cm
MARKS: inscribed on hammer 'THE ALEXANDRA BRIDGE 64 Spans 9,300 Ft long foundations 70 Ft deep carries the PUNJAB NORTHERN STATE RAILWAY over the river CHENAB olim ACESINES Engineer in Chief Alex. Grant M.I.C.E Executive Engineer H. Lambert COMMENCED Nov 1. 1871 this BRIDGE was opened Jany 22nd 1876 by Albert Edward Prince of Wales K.G. & THOMAS GEORGE BARING BARON NORTHBROOK G.M.S.I. Viceroy of India' and 'PNSR'

On 22 January 1876, Albert Edward hammered in the last rivet of the bridge crossing the River Chenab in Wazirabad (fig. 27). The bridge was named 'Alexandra' in honour of the Princess of Wales. The steel hammer he used was presented to him in this casket, together with an address, by Alexander Grant, Chief Engineer of the Punjab Northern State Railway. Construction work on the bridge began in November 1871 and, spanning 9,300 feet, it became the longest bridge in the world once complete.[1]

The casket and mounts on the hammer have been blued by intense heating of the steel. The surface has then been cross-hatched to allow for the gold pattern and inscription to be overlaid. This method of overlaying is known as *kuftkari* and was generally used to decorate arms and armour, although, following the annexation of Punjab in 1849, the technique was also used to embellish objects for the European market such as caskets, boxes and jewellery.[2]

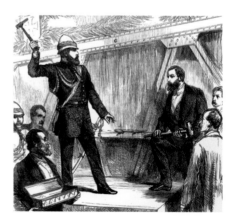

Fig. 27 Royal tour of India: The Prince of Wales riveting the last bolt of the Alexandra Railway Bridge in the Punjab, 1876. Illustrated London News

1 *ILN*, 26 February 1876.
2 London 1999, p. 89; Barnard 2008, p. 80.

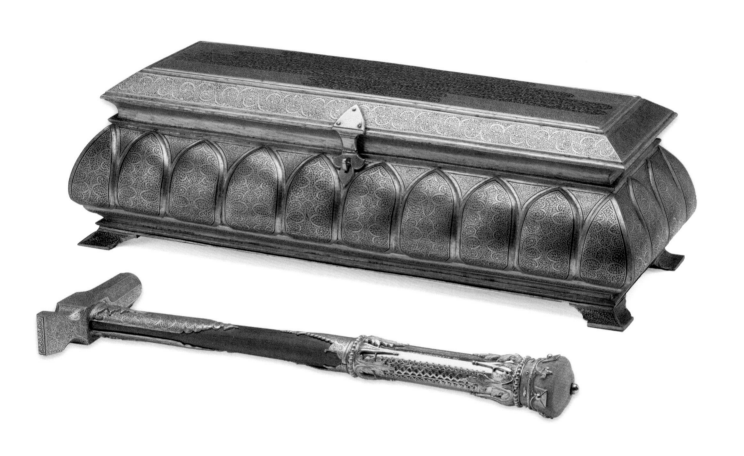

ADDRESS CASKET

Amritsar, *c.1875*

RCIN 11230.a–d

Gold, diamonds, rubies, emeralds, turquoise, velvet, gold thread
and silver thread

Casket 7.6 × 32.5 × 13.3 cm; address 119.0 × 29.3 cm

EXHIBITED: Bradford 1991; London 1999

LITERATURE: Bradford 1991, cat. no. 79; London 1999, cat. no. 204

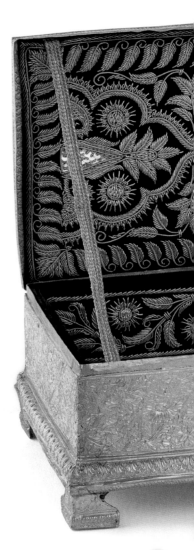

This ornate address casket, finely chased with birds and
floral motifs, and inlaid with gemstones, was presented
to the Prince of Wales by the community of Amritsar.
The Prince visited Amritsar on 24 January 1876. His
route to the reception, at which this casket was pre-
sented, was lined with artificial cypress trees with gilded
branches and garlands.[1]

The purple velvet lining of the box is profusely
embroidered with flowers and vines in silver and gold
thread, a technique known as *zardozi*. Amritsar was one
of the leading centres for this type of embroidery.

The address is beautifully illuminated reflecting local
traditions of court painting, another art form for which
this region of the Punjab was particularly renowned.

1 Russell 1877, p. 435.

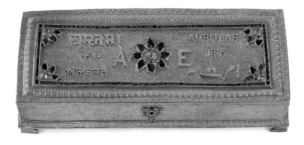

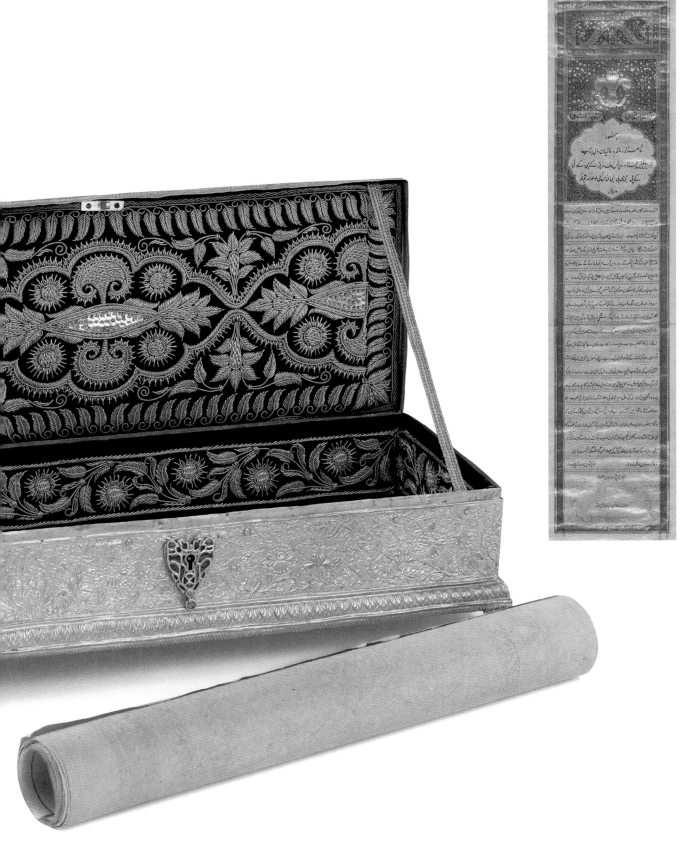

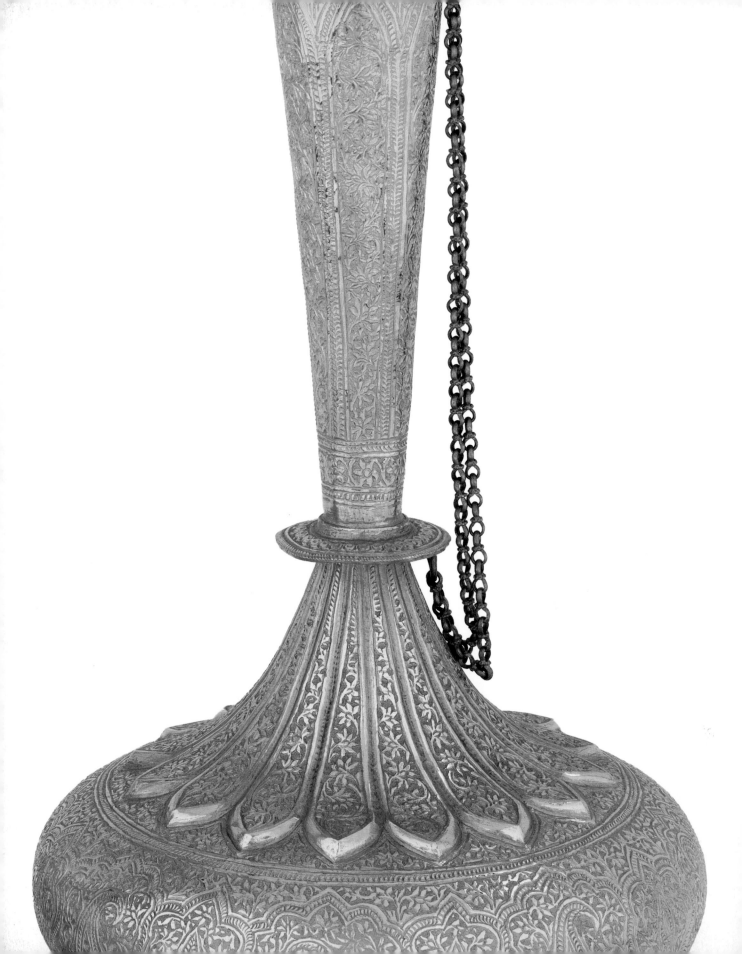

COURTLY OBJECTS

PAIR OF CEREMONIAL STAFFS

Probably South India, *c.*1875
RCIN 11341.1–2
Ivory, silver and red glass
59.4 × 5.7 × 4.8 cm each

This pair of ivory ceremonial staffs, known as *chobs* or *chottas*, are carved in the form of lion heads. They were presented to the Prince of Wales by Ramachandra Tondaiman (1829–86), Raja of Pudukottai, during the Prince's visit to Madura on 10 December 1875. It appears that the eyes of the lions, which consist of red glass over silver foil, are replacements for the original rubies.

Ceremonial staffs were held by court officials standing guard, and usually depicted the head of a tiger or lion. The British Indian Government had adopted many of the courtly customs associated with Indian *durbar* (court) ceremonies and, during the Prince's tour, the Viceroy Lord Northbrook employed court attendants known as *chobdars* at Government House in Calcutta. On 24 December 1875, William Howard Russell recalled 'mace-bearers, or chobdars, in scarlet and gold liveries, guarded the entrances […] in the handsome liveries of the Governor-General, bearing chotas and silver maces'.[1]

1 Russell 1877, p. 353.

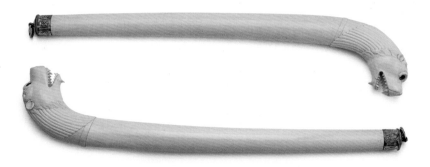

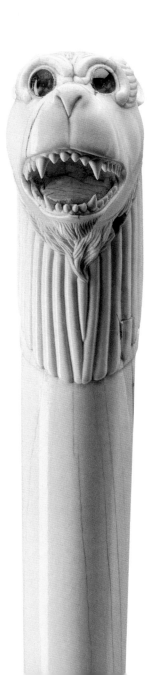
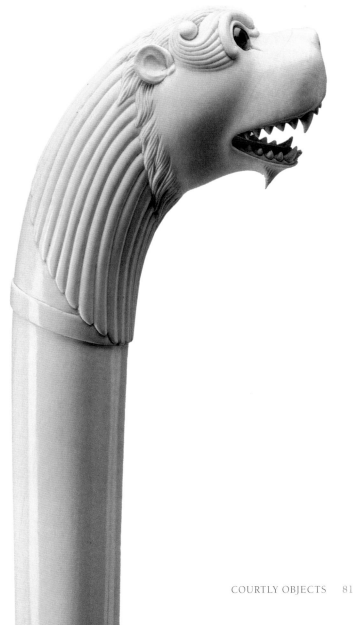

PAIR OF PEACOCK FEATHER FANS

Jaipur, *c*.1850–75
RCIN 11409.1–2
Peacock feathers, gold, enamel, turquoise, pearls and diamonds
94.0 × 18.0 cm each
EXHIBITED: London 2009

Mounted on an elephant and riding alongside Maharaja Ram Singh II of Jaipur, the Prince of Wales entered the city of Jaipur on 5 February, fanned by two courtiers holding large peacock feathers (fig. 28). Fans such as these played an important role in the spectacle of Indian court and procession, attendants using them to keep the ruler cool.

These fans captured the imagination of visitors to the touring exhibition of the Prince's gifts. George Birdwood likened the addition of gems and enamel to the feathers as 'adding another hue to the rainbow'.[1] He praised the way in which the peacock feathers were masterfully set with precious stones to accentuate the colours.[1] Thomas Holbein Hendley (1847–1917), a British Residency Surgeon based at Jaipur, took great interest in enamel production, and also noted the exceptional beauty of these fans, stating that they represented some of the most exquisite enamelling ever produced.[2]

1 Birdwood 1884, p. 182.
2 Hendley 1895, p. 3.

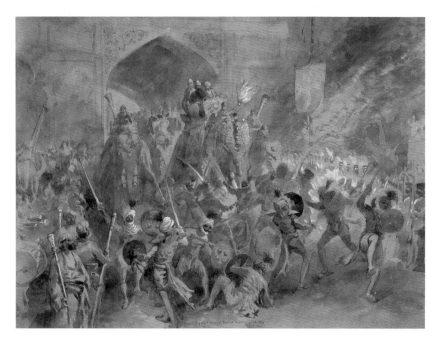

Fig. 28 William Simpson, *Arrival of the Prince at Jaipur, 4 February 1876*, 1876. RCIN 921120

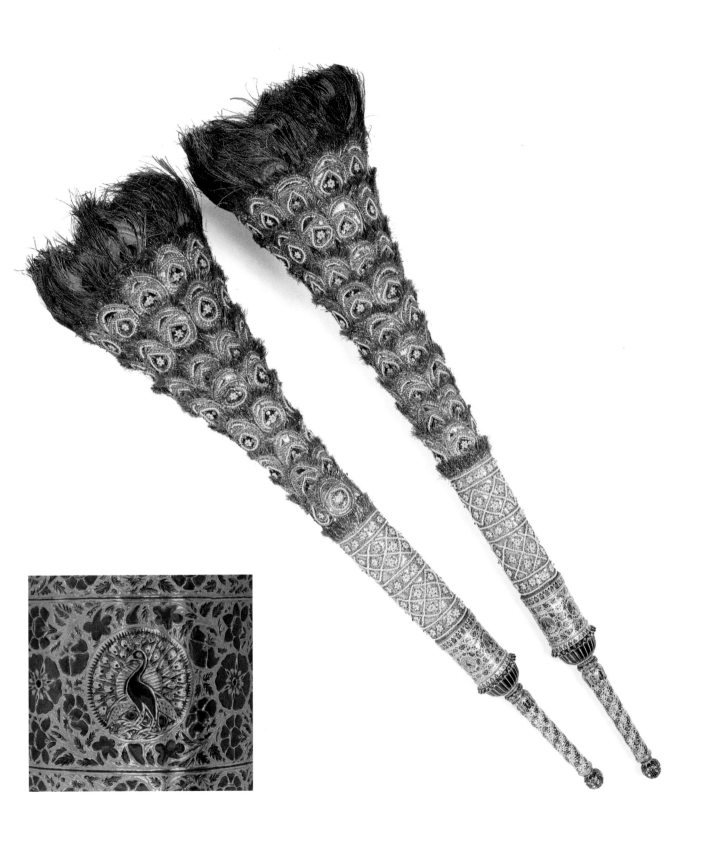

PERFUME HOLDER

Enamelled by Hira Singh, Jaipur, *c*.1870–5
RCIN 11423.a–c
Gold, enamel, diamonds and pearls
15.6 × 20.3 cm (open); 14.4 × 20.3 cm (closed)
EXHIBITED: London 1982; Cardiff 1998; London 2002
LITERATURE: Cardiff 1998, cat. no. 164

This perfume holder was a gift from Ram Singh II, Maharaja of Jaipur. When pressure is applied to the rod beneath the tray, the 'leaves' of the perfume holder open to reveal a yellow enamelled cup and cover. The feet of the tray are in the form of elephant-like animals with curled up trunks that rest on green enamelled circular feet with *kundan*-set diamonds.

The circular tray is enamelled with eight oval medallions depicting hunting scenes, the Chandra Mahal and Amber Fort, and floral designs similar to the salver (RCIN 11469, pp. 108–9). Thomas Holbein Hendley recorded that this perfume holder was enamelled by Hira Singh and that it cost 10,000 rupees to produce.[1] The enamelled holder underwent five firings and took five years to complete.[2]

1 Hendley and Jacob 1886, Appendix.
2 Ibid.

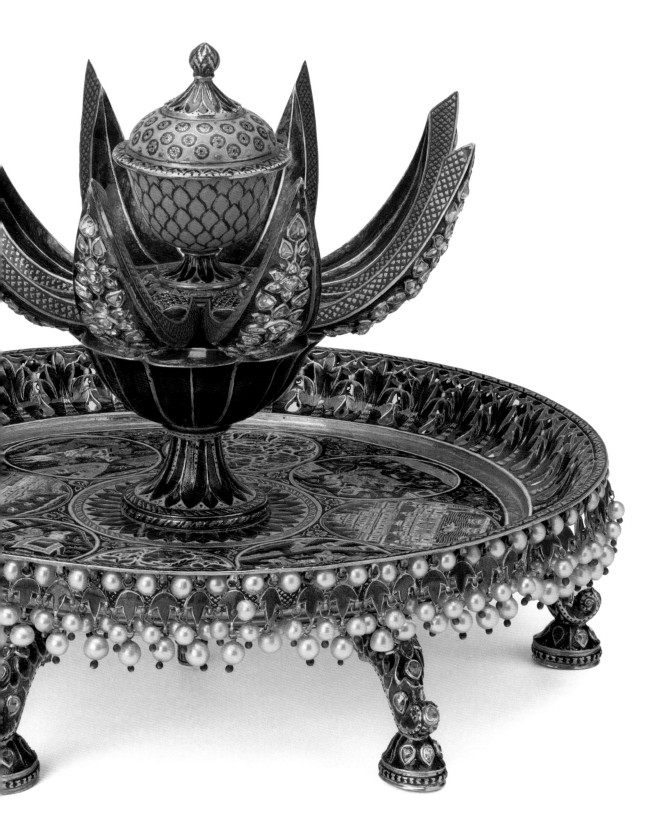

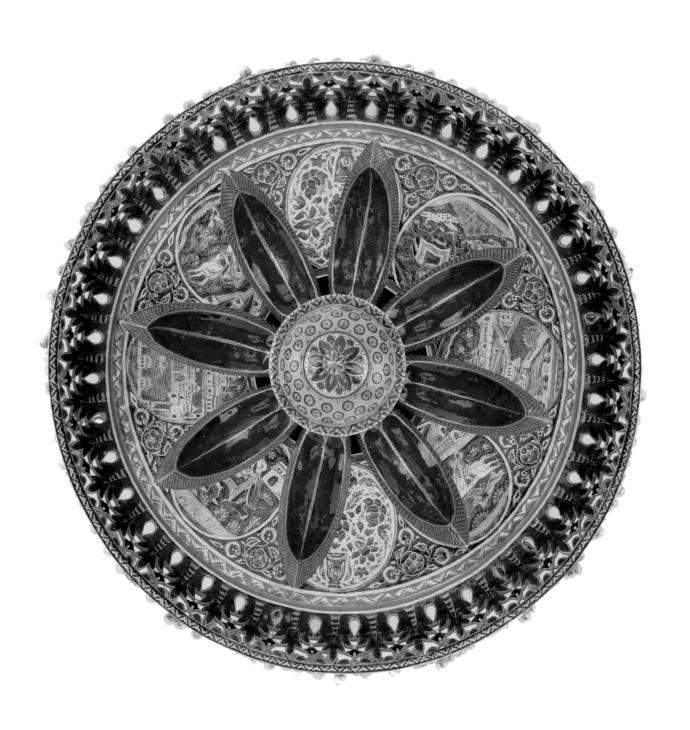

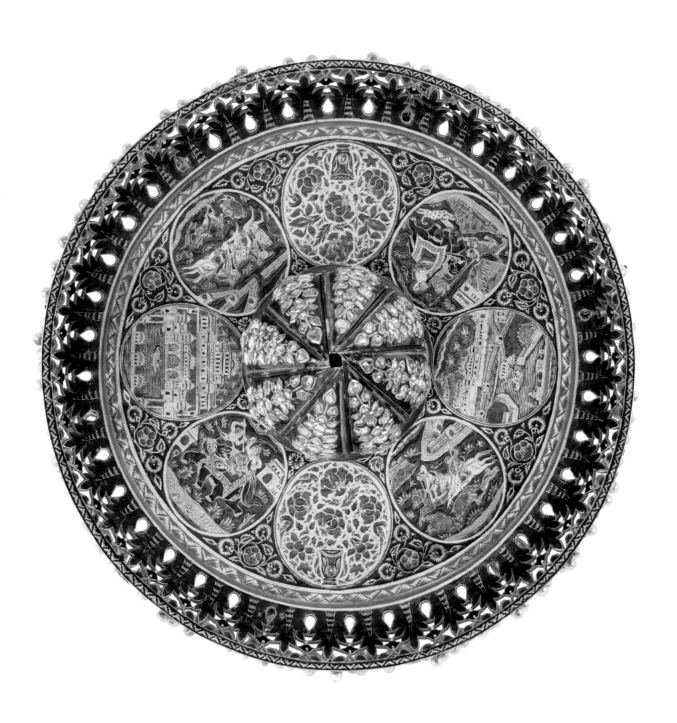

PERFUME HOLDER

Possibly Madras and Orissa, *c*.1870–5
RCIN 28692
Gold, silver, wood and rubies
27.0 × 19.0 × 15.5 cm

This perfume holder was presented to the Prince of Wales by Jashwant Singh II, Maharaja of Jodhpur (1838–95). The Prince first met the Maharaja at the Madras Racecourse on 15 December, and later at Calcutta, where the Maharaja was made a Knight Commander of the Order of the Star of India on New Year's Day 1876 (fig. 10).

The bud-shaped holder opens up when the finial is pressed to reveal five perfume holders held by silver filigree brackets. The openwork floral designs on the outside 'leaves' of the bud, the gold bottles and the silver filigree suggest that it was produced in different parts of India and later brought together. The gold scrolling foliage on the outer 'leaves', the ruby-inlaid perfume bottles and the fluted base are similar in style to metalwork from Madras, and the interior silver filigree work is similar to that produced in Orissa.[1]

1 Watt 1903, pp. 37–8; Dehejia et al. 2008, p. 81.

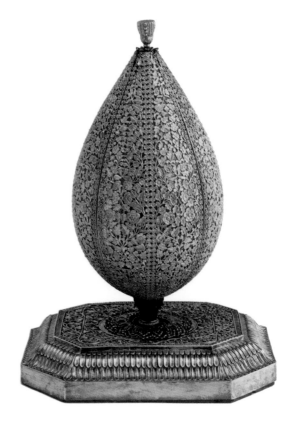

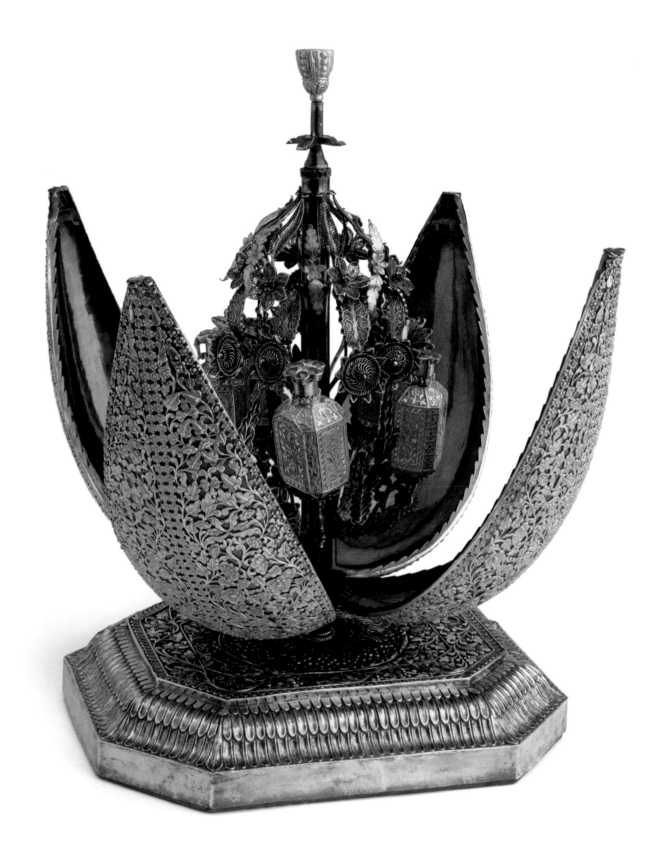

PERFUME HOLDER

Probably western India, *c.1870–5*
RCIN 11479.a–b
Gold, rubies, diamonds and emeralds
9.0 × 12.0 × 10.0 cm
MARKS: encircled inside the tray base is the inscription
'*WANKANER*' and '*RAJ SHAHIB BANESHUNGJEE*'

This perfume holder was presented by Banesinhji
Jaswantsinghji, Raj Sahib of Wankaner (1842–81), and
was probably designed to store solid perfume. The
inscription in Gujarati on the lower tray is obscured
from view by the upper tray and bottle, indicating that
they were made separately and then attached together
at a later date, probably to make a more impressive gift.
The screws holding both the trays together unscrew
anticlockwise. This is unusual in Indian metalwork and
implies this perfume holder was assembled by a non-
Indian craftsman possibly working in Bombay, where
this gift was presented.[1]

1 Birdwood 1884, p. 175.

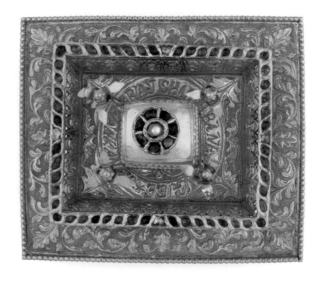

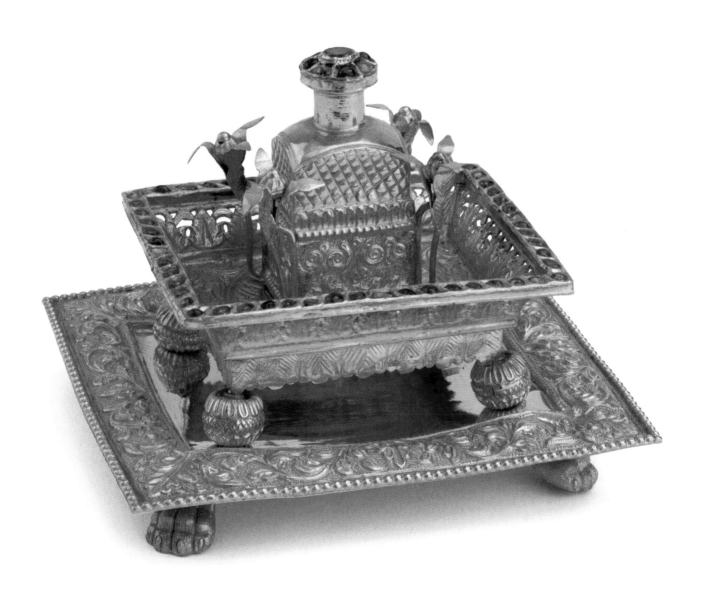

FOUR PERFUME HOLDERS

Kapurthala, *c*.1870–5
RCIN 11317.1–4
Gold
13.1 × 8.2 × 5.3 cm each
EXHIBITED: Bradford 1991; London 1999
LITERATURE: Bradford 1991, cat. no. 80; London 1999, cat. no. 202

The Prince of Wales met Kharak Singh (1850–77), Raja of Kapurthala, during the reception he held for the rulers of Punjab in Lahore on 18 January 1876. Here the Raja presented him with this set of four perfume holders, cast as seated lions with articulated tongues.

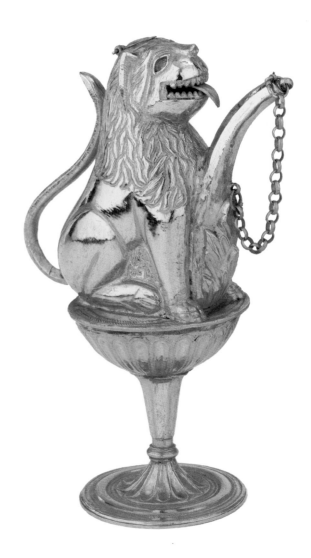

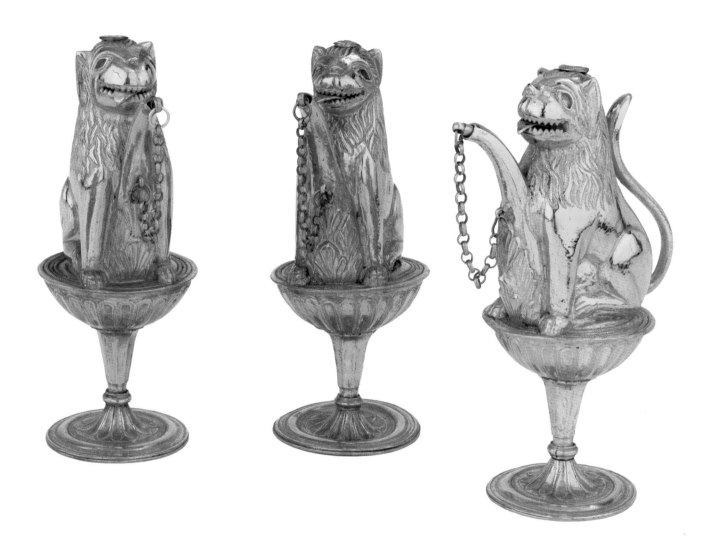

CUP AND SAUCER

Possibly enamelled by Ghuma Singh, Jaipur, *c.*1870–5
RCIN 11424.a–c
Gold, enamel and diamond
10.2 × 14.7 × 14.7 cm (overall)
EXHIBITED: London 2001

This covered cup and saucer was presented by Maharaja Ram Singh 11 of Jaipur. It is likely to have been enamelled by Ghuma Singh, who is recorded to have made a similar covered cup and saucer found in the collection of the Albert Hall Museum, in Jaipur, in 1895.[1]

Although intended as a Western drinking vessel, it follows the same form as covered cups and salvers traditionally used as perfume holders in India. This adaptation reflected the demand from the European market for Jaipur enamelling; in the 1880s a third of annual sales of Jaipur enamelled wares were made for Europeans.[2] From the early twentieth century onwards, covered cups and saucers were often accompanied by similarly enamelled spoons.

1 Hendley 1895, p. 13.
2 Hendley and Jacob 1886, p. 7.

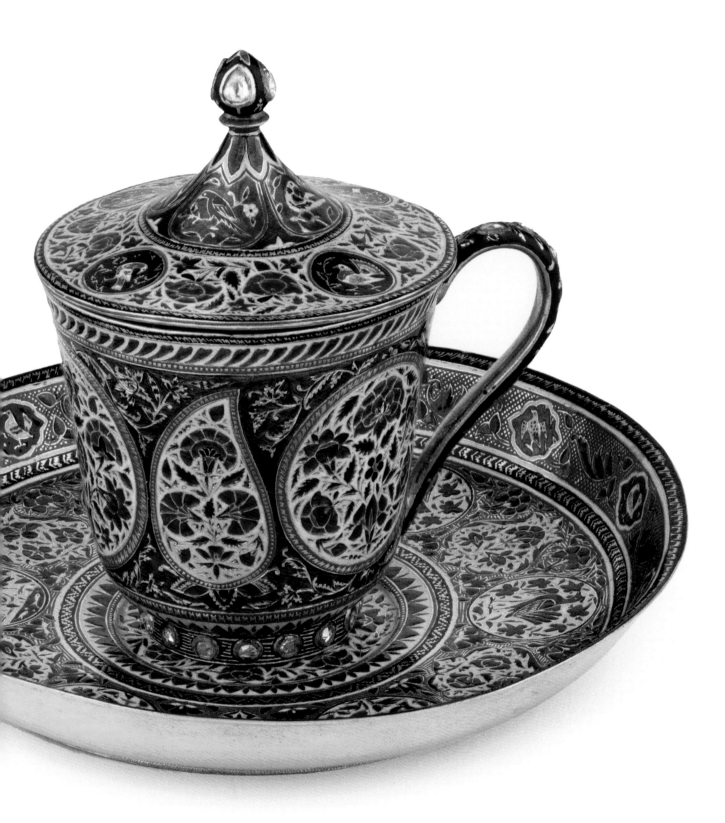

PAIR OF ROSEWATER SPRINKLERS

Cutch, *c.*1870–5
RCIN 11475.1–2
Gold
28.2 × 6.7 × 5.4 cm each

The Prince of Wales met Pragmalji II, Rao of Cutch (1832–75), at Bombay, in November 1875. Here he was presented with this pair of rosewater sprinklers in the form of cranes holding a fish in their beaks. The fish have a bouquet of flowers issuing from their mouths, which have been perforated with holes to allow for the rosewater to be sprinkled.

The strange iconography of the sprinkler may be linked with the legend of the two rival goldsmiths, Gangu and Nandu, working in the court of Anhilpur Patan, in modern-day Gujarat. The legend recalls that both goldsmiths were invited to take part in a contest of

skill by the Solanki ruler, Jayasimha Siddharaja (*c.*1094–1143). Gangu produced a gold fish, which could float and move in water. In response, Nandu produced a crane that pecked at the fish causing it to drown and thus won the contest. However, Nandu later incurred the wrath of the ruler and was banished from Patan, taking refuge in Cutch, where this tale inspired later metalworkers in the state.[1]

Silver versions of these sprinklers in other collections suggest that this pair, made from gold, were produced as unique presentation pieces for the tour.[2]

1 *JIA* 1894.
2 Ibid.

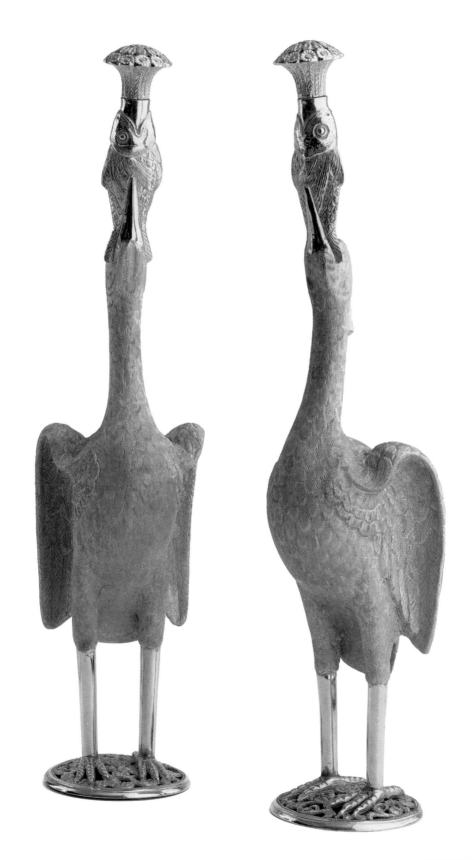

PAIR OF ROSEWATER SPRINKLERS

Nahan Foundry, Nahan, *c.1873–6*

RCIN 11212.1–2

Silver

37. 0 × 10.7 cm each

MARKS: on the base of each, inscribed '*FROM NAHAN FOUNDRY*'

EXHIBITED: London 1982; Bradford 1991

LITERATURE: Bradford 1991, cat. no. 81

Shamsher Prakash, Raja of Nahan (1856–98), presented this pair of silver rosewater sprinklers when he met the Prince in Calcutta in December 1875. The Raja of Nahan established the Nahan Foundry in *c.*1873, where these sprinklers were made. Managed by Frederick Robert Jones, an Austrian engineer, the foundry predominantly produced industrial items such as sugar-cane crushers and railings.

The bulbous body of the sprinkler is decorated with eight embossed and chased European baroque-style medallions. One of the medallions has been left blank, where a presentation inscription may have been intended to be added. Although catalogued as 'automatic' in the *Indian Art at Marlborough House* catalogue, it doesn't appear to have a pump mechanism. A number of the Prince's gifts were recorded as having signs of being produced in haste, as 'everything has to be made to order in India; nothing is kept ready made', and this perhaps explains the missing mechanism.[1]

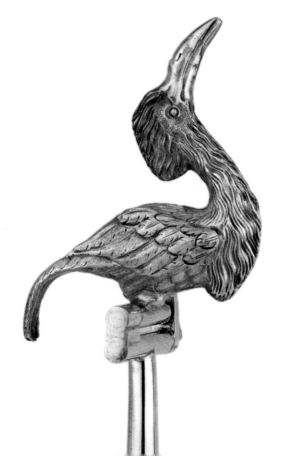

1 *ILN*, 1 July 1876.

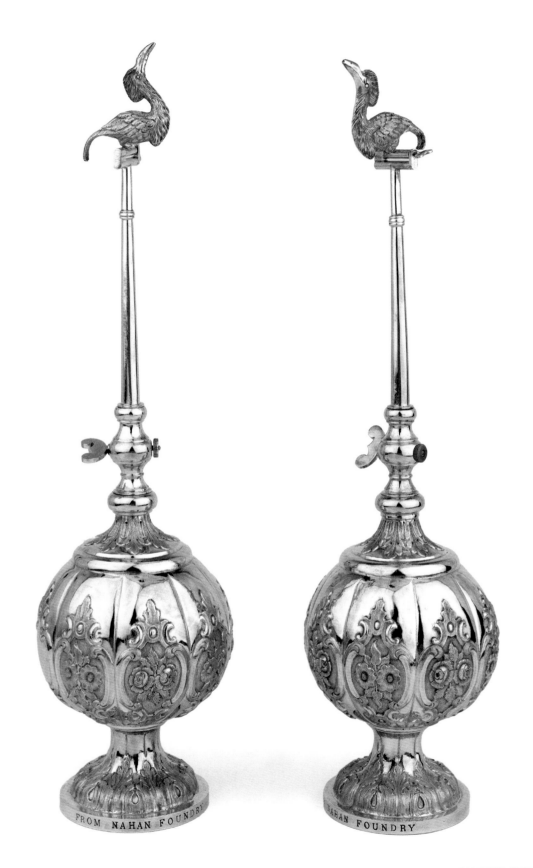

FROM NAHAN FOUNDRY

BOTTLE AND SALVER

Jaipur, *c*.1870–5
RCIN 11427.a–c
Gold, enamel, diamonds and ruby
Bottle 21.6 × 9.8 × 9.8 cm; salver 5.9 × 18.8 cm
EXHIBITED: London 1982

Presented to the Prince of Wales by Ram Singh II, Maharaja of Jaipur, this enamelled bottle and salver are of exceptional quality. They were illustrated in the review of the Prince's gifts, where they were described as displaying 'an exquisite example' of Jaipur enamelling.[1]

1 *ILN*, 12 August 1876.

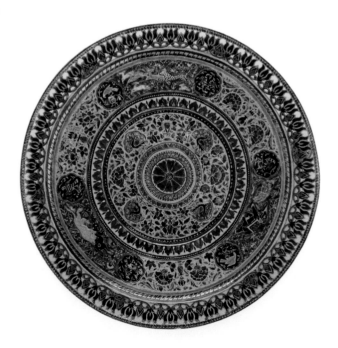

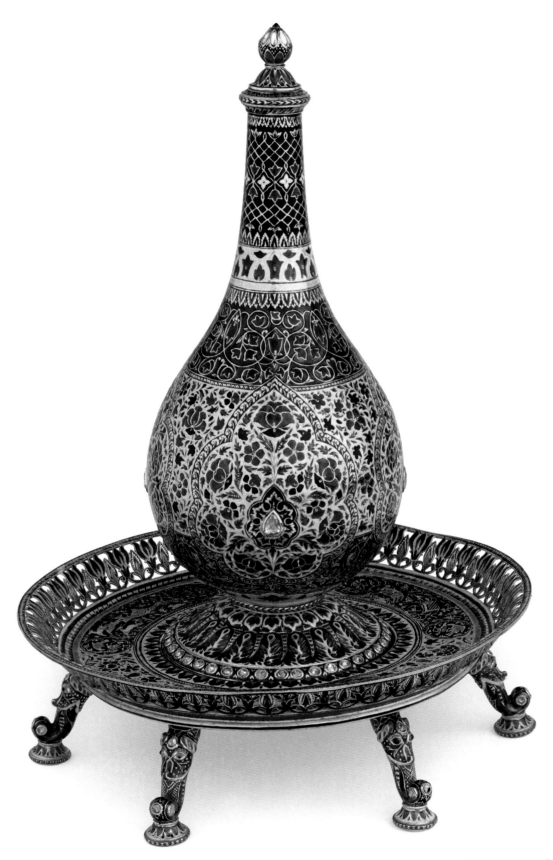

PAIR OF BOTTLES

Kashmir, c.1870–5
RCIN 11446.1–2
Gold
28.2 × 11.2 cm each

The surface of these bottles, presented by Ranbir Singh, Maharaja of Kashmir (1830–35), is engraved with stylised poppy flowers and overhanging cypress trees. This design became known as 'shawl patterning' in reference to the famed Kashmir shawls, which feature similar motifs.

From 1887, increasing numbers of European visitors chose to spend their summers in Kashmir rather than Simla, and the silversmiths began to use 'shawl' patterning to embellish tea caddies, cigarette cases, trophies, beakers and tea sets for these new customers.[1] In Britain, the Birmingham-based firm Elkington and Co. sold Kashmir-inspired silverware and electroplates of copperwares from Kashmir.[2]

1 Dehejia et al. 2008, p. 153.
2 Ibid., p. 154.

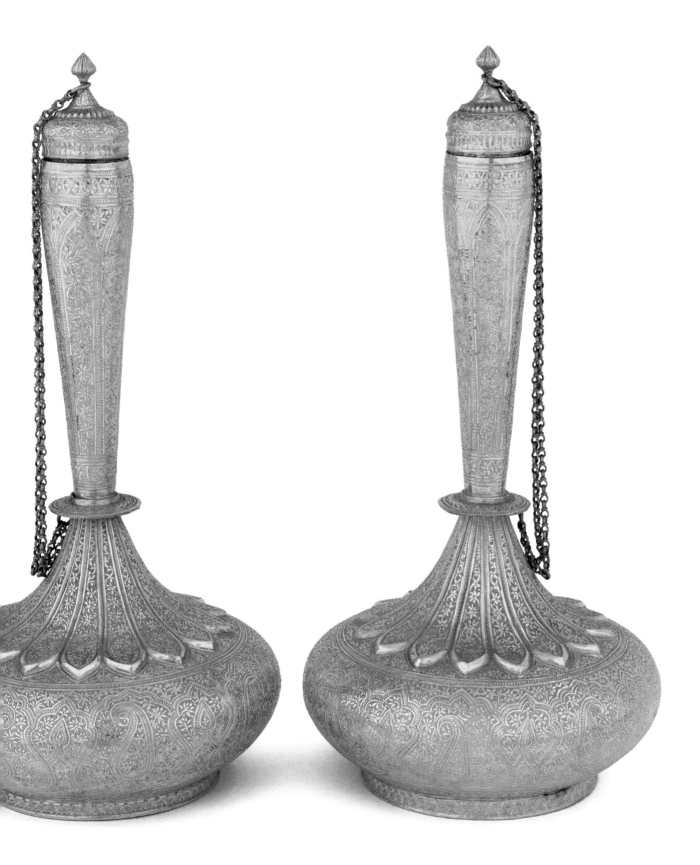

WATER BOTTLES

Kapurthala, *c.*1870–5
RCIN 11362.1–2
Gold
26.5 × 13.0 cm each
MARKS: on the bulbous section of each bottle, engraved in
Persian *Estate of Ahluwalia*
EXHIBITED: London 1982; Cardiff 1998

This pair of gold bottles was presented to the Prince of
Wales on 18 January, 1876, in Lahore by Kharak Singh,
Raja of Kapurthala. The birds cast on the lower section
of the bottles represent land and water-based animals.
Perched at the base of the bottleneck are four parrots
above a row of 12 *makara*, mythical Hindu creatures,
which have a combination of features associated with
terrestrial and aquatic animals. The bulbous body is cast
in low relief with a series of 12 ducks. The inscription on
both bottles refers to the Ahluwalia dynasty of rulers, to
which the Rajas of Kapurthala belonged.

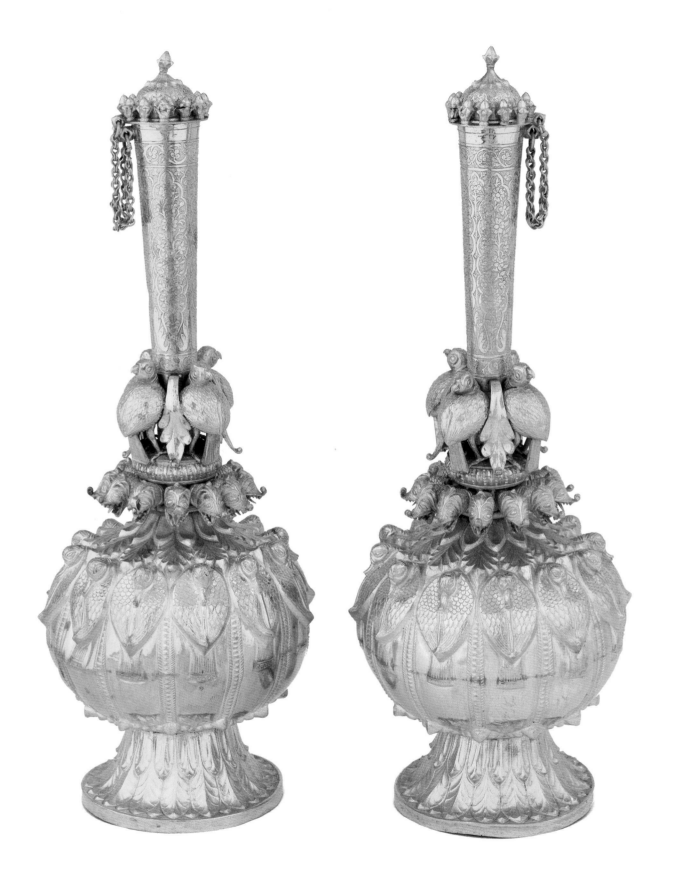

PAIR OF *PAAN* BOXES

India, *c.*1870–5
RCIN 11381.1–2
Silver, silver-gilt and gold
11.5 × 12.2 × 12.2 cm (each when closed);
5.7 × 22.3 × 22.3 cm (each when open)
EXHIBITED: London 1982; London 2001

Indore was the Prince of Wales's final stop in India before he returned to Bombay to board HMS *Serapis* for England. Here he was presented with a pair of silver and silver-gilt *paandan* (*paan* holders) by Tukoji II Holkar, Maharaja of Indore (1835–86). The *paandan* rest on six circular feet and have separate hinged covers to store the individual ingredients used to prepare *paan*, such as shavings of areca nut, various seeds and spices. The compartments are shaped like the betel leaves that wrapped the ingredients. The presentation of *paan*, a mild stimulant, signified the end of formal assemblies, and the Prince adopted the same practice when meeting with the Indian rulers.

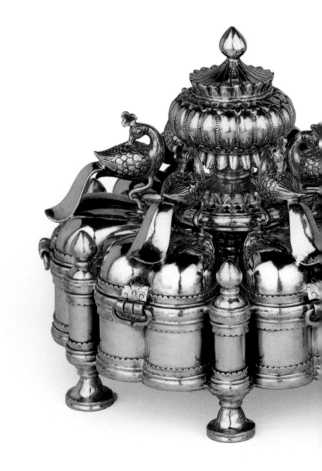

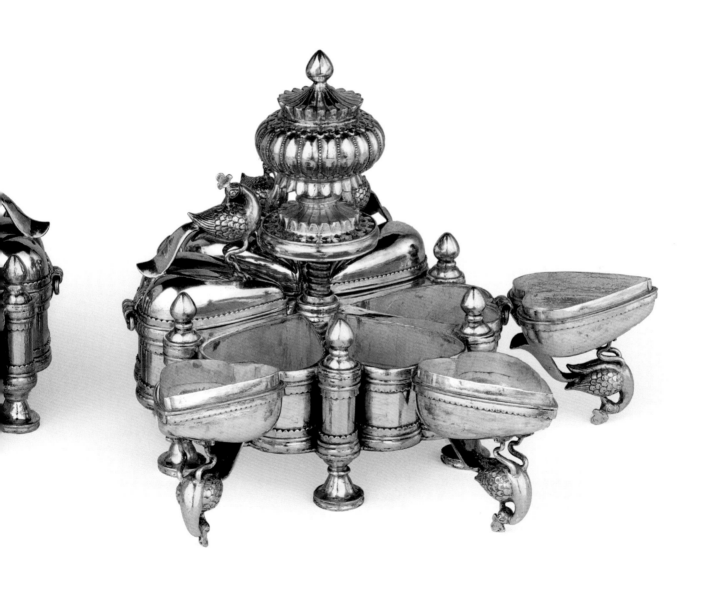

SALVER

Enamelled by Ram Singh, Jaipur, *c*.1870–5
RCIN 11469
Gold and enamel
2.0 × 32 cm
EXHIBITED: Cardiff 1998

This enamelled salver, presented by Ram Singh II, was highly praised during the exhibitions of the Prince of Wales's gifts and was described as a 'monument of the Indian enameller's art'.[1] Thomas Holbein Hendley, the Jaipur Residency Surgeon who took an avid interest in the arts of Jaipur, recorded that this salver had been produced by Ram Singh, whom he considered to be one of the most skilful craftsmen in this technique.[2]

The amount of time reportedly taken to produce this salver varies from two to six years.[3] Hendley, writing a decade after the gift's presentation, states that 'the plate was put ten times into the fire,

3,000 rupees worth of gold were used'.[4] This salver is spectacular in its design and colour range. Designed as a presentation piece and a memento of Jaipur, it depicts two of Jaipur's palaces, the Chandra Mahal and the Jal Mahal. Unlike other enamels presented to the Prince from Jaipur, the underside of the salver also has enamelled decoration.

1 Birdwood 1878, p. 64.
2 Hendley and Jacob 1886, pp. 5–6.
3 It is given as 4 years in Birdwood 1884, p. 165,
 6 years in Hendley and Jacob 1886, p. 6 and
 2 years in Hendley 1895, p. 13.
4 Hendley and Jacob 1886, p. 5.

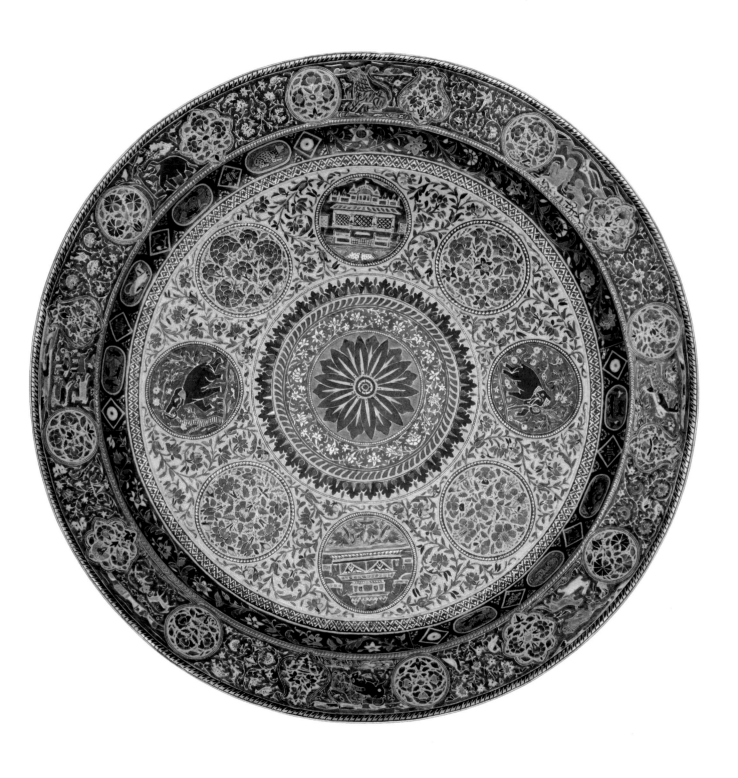

ANTIMONY HOLDER

Tonk, c.1875
RCIN 11231
Silver, silver-gilt, red seeds and rock crystal
13.0 × 4.4 × 5.1 cm

Antimony was used in parts of India as an eyeliner for cosmetic purposes, but it was also regarded as a coolant that strengthened and protected the eyes from the sun.

This articulated holder in the form of a fish was presented to the Prince of Wales by Mohammad Ibrahim Ali Khan, Nawab of Tonk (1867–1930), in Agra on 26 January 1876. The silver-gilt rod would have been used to apply the antimony through the stopper that unscrews from the mouth of the fish.

The Nawab of Tonk exhibited silverware that included a similarly designed antimony holder at the Jaipur Exhibition (1883), where it was awarded first prize for its 'purely Indian work'.[1] Articulated fish-shaped vessels were also used as containers for perfume or addresses, the latter produced primarily by metalworkers in the Monghyr District in Bengal.[2]

1 *JIA* 1886b.
2 Watt 1903, p. 39.

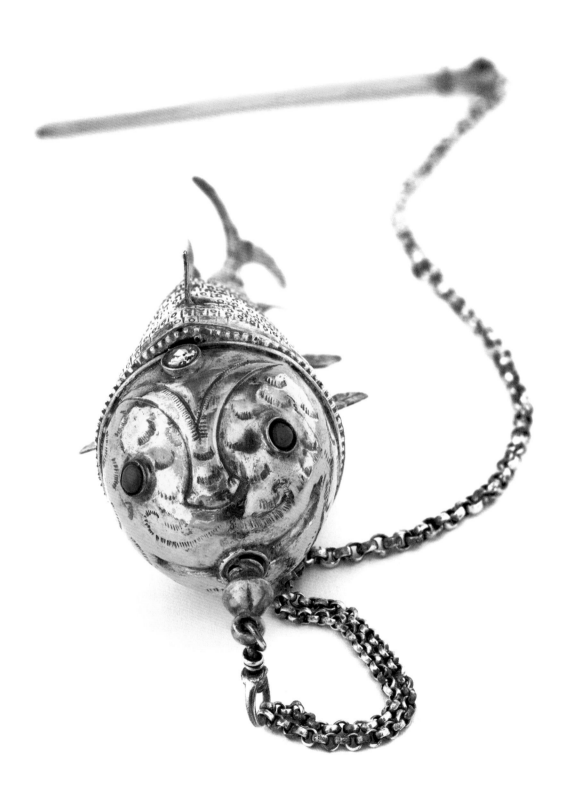

ORNAMENTAL FISH

Probably western India, *c*.1875
RCIN 11319
Gold, rubies and an emerald
20.2 × 6.1 × 3.6 cm
EXHIBITED: London 1982

This ornamental articulated fish was presented by Waghji 11 Rawaji, Thakur Sahib of Morvi (1858–1922), to the Prince of Wales at Bombay, in November 1875. It may have been inspired by the tale of the two twelfth-century competing goldsmiths, Nandu and Gangu (see RCIN 11475, pp. 96–7), in particular by Gangu, who produced a gold fish that could float and swim on water.

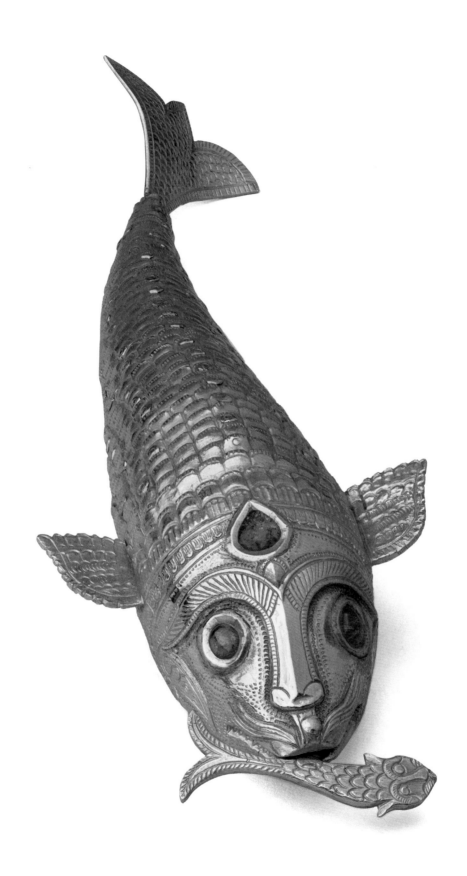

COSMETIC BOX

Jaipur, *c.*1870–75
RCIN 11507
Gold, enamel, diamonds and mirror glass
3.1 × 8.3 × 6.4 cm

This octagonal enamelled box was presented to the Prince by the Maharaja of Jaipur. The motifs, which show various animals in combat, relate to courtly entertainment practices. This box, which conceals a mirror in its base, may have been intended to be used as a container for cosmetics.

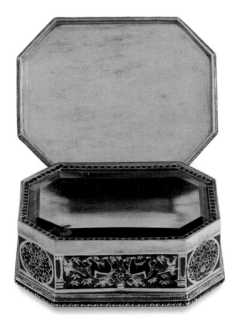

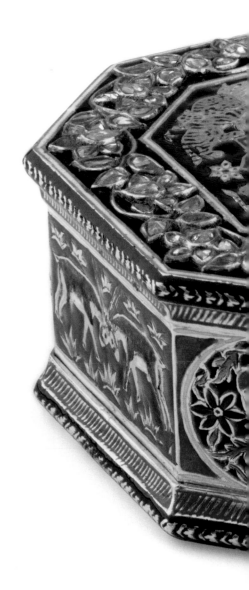

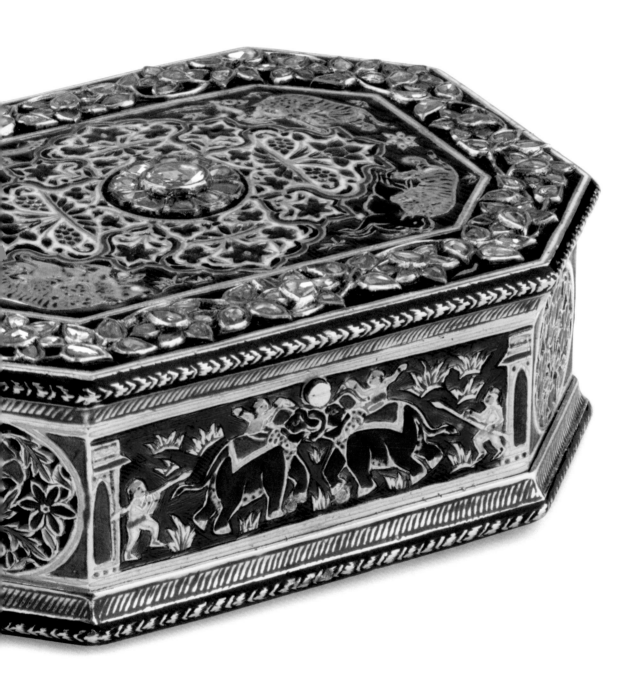

COURT SET OF 10 PIECES

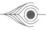

Mysore, c.1870–75

RCINS 11270, 11336, 11377, 11378, 11399.a–b, 11419, 11425.a–b, 11464, 11474.1–2.a–b, 11505.a–b

Gold

Plate 4.2 × 29.3 cm; plate 1.6 × 21.2 cm; salver 5.0 × 26.8 cm; perfume sprinkler 35.8 × 14.0 cm; box 7.6 × 11.7 × 7.8 cm; tray 5.0 × 29.0 × 21.6 cm; perfume holder 15.5 × 14.8 × 14.8 cm; paan holder 8.3 × 8.6 × 8.6 cm; pair of boxes 5.1 × 5.6 × 2.6 cm; perfume holder 21.7 × 15.5 × 15.5 cm

EXHIBITED: RCIN 11464 in Cardiff 1998; whole set in London 2009

Presented by Chamarajendra Wadiyar x to the Prince of Wales in November 1875, this gold service was praised by George Birdwood for its 'due sense of balance [...] between its beaten. and deeply graven ornamentation and its necessary unembellished, plain polished surfaces'.[1] During the tour of the Prince's gifts, this set – which includes ceremonial courtly objects such as perfume holders, *paan* holders and rosewater sprinklers – was often referred to as a 'Service of State'. The European perception that the set from the Maharaja of Mysore was 'authentically' Indian, and that it had a practical function within the Indian court, meant it was prized above the 'monstrous' tea sets of European form that the Prince was also given during the tour.[2]

1 *JIA* 1892, p. 94.
2 Birdwood 1878, p. 60.

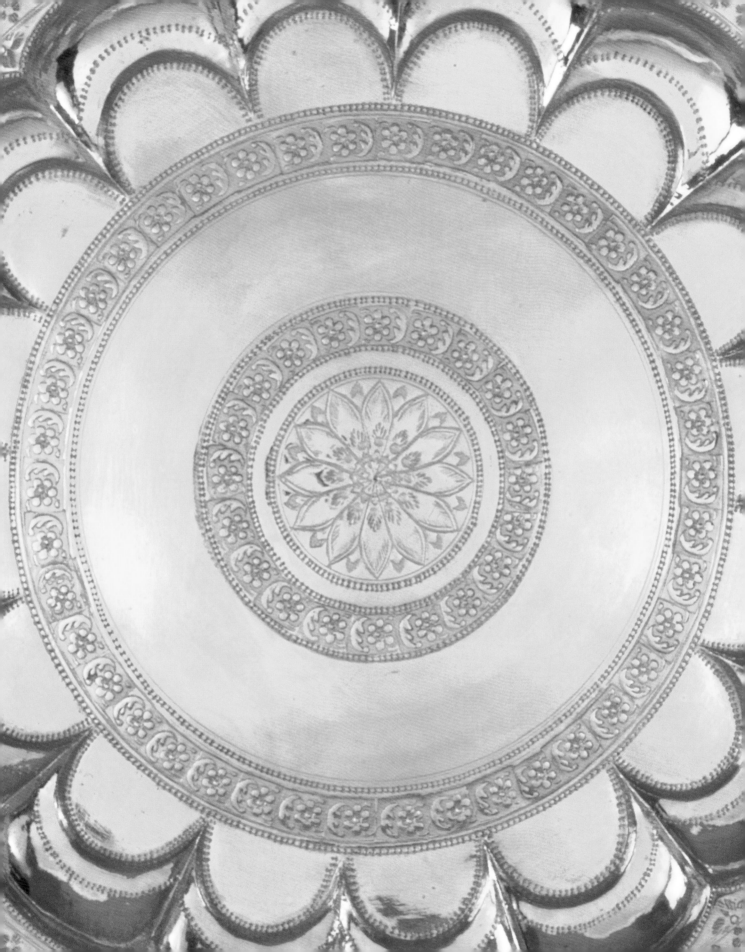

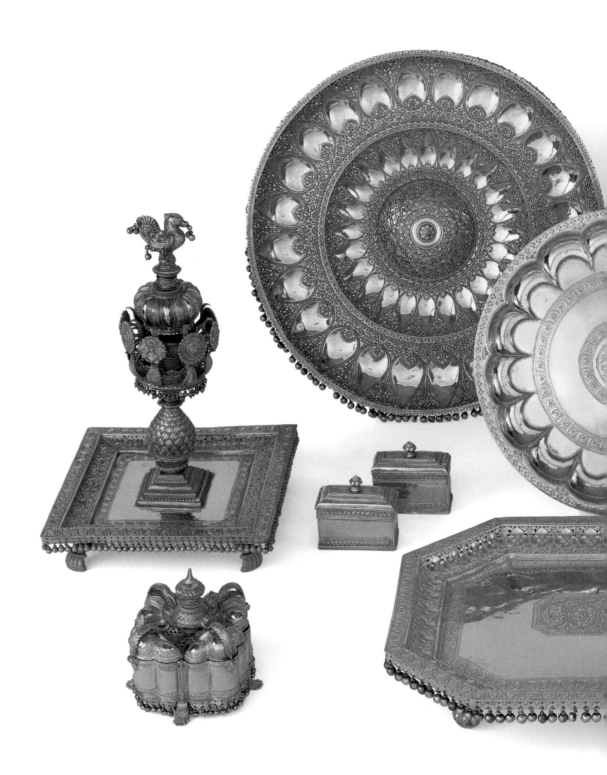

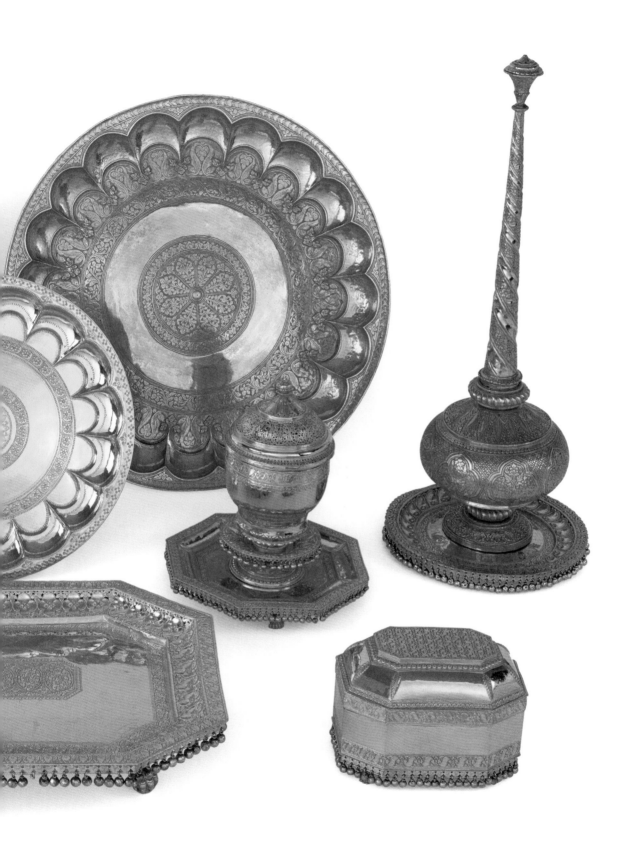

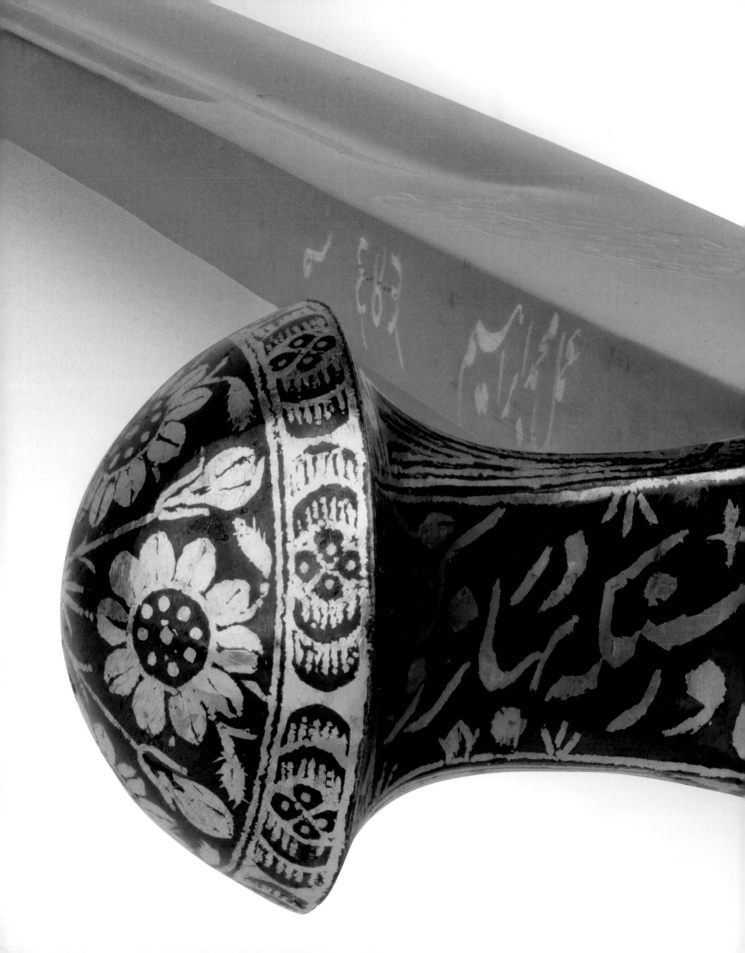

ARMS AND ARMOUR

DAGGER

Hilt Mughal Empire, eighteenth century with
associated Indian blade
RCIN 11361
Watered crucible steel, jade, gold and garnets
37.6 × 8.5 × 2.6 cm

This jade hilt dagger was presented by Bir Narsingh
Kunwar, Prime Minister of Nepal, when the Prince
visited Nepal as a guest of the Prime Minister from
21 February to 6 March 1876.

The form and style of the decoration of the hilt sug-
gest it was made within the Mughal Empire in the
late seventeenth century. Jade daggers became pop-
ular in the Mughal court during the reign of Alamgir
(r.1658–1707), when access to trade routes into Khotan
(in modern-day China) through Kashmir became acces-
sible.[1] The lapidaries working for the Mughal court were
accustomed to working with rock crystal and were able
to transfer this skill to jade, producing vessels, dagger
handles and jewellery inlaid with precious metals and
gemstones. This dagger may have reached Nepal as a
diplomatic gift from India.

1 London 2015, p. 70.

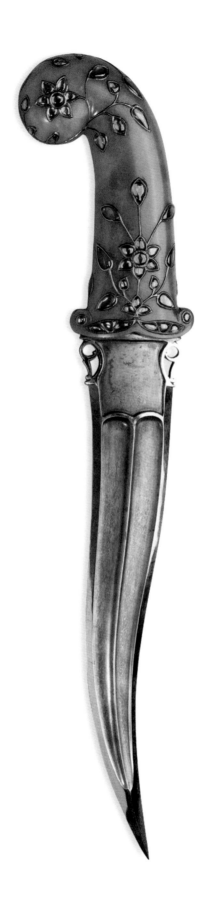

DAGGER AND SCABBARD

Mughal Empire, probably early eighteenth century
RCIN 11450.a–b
Watered crucible steel, gold, jade, lacquered wood,
glass and rubies
36.5 × 10.6 × 1.8 cm (overall)

This dagger was a gift to the Prince of Wales from Mahbub Ali Khan (1866–1911), Nizam of Hyderabad. Dagger hilts carved to resemble Arabian horses were popular in the Mughal court from the mid-seventeenth century, under which the Nizams served before establishing independence in 1724. The young Nizam, who was too ill to meet the Prince, sent his Prime Minister Salar Jung I to present the gift instead (fig. 29).

Mahbub Ali Khan was only two years old when he succeeded his father in 1866, and ruled under the guidance of Salar Jung I and the British Resident as joint regent.

Reforms under the Prime Minister led Hyderabad to prosper and enabled the young Nizam to gain renown as one of the richest men in the world.

Salar Jung I visited Queen Victoria shortly after the Prince's tour of India to try and reclaim the nearby province of Berar, which had been signed over to Britain in 1853. On 29 June 1876, the Queen recorded in her diary that Salar Jung I 'wore the ribbon & star of the Gd Cross of the Star of India & a large medal, given him by Bertie', presumably from this meeting in Bombay.[1]

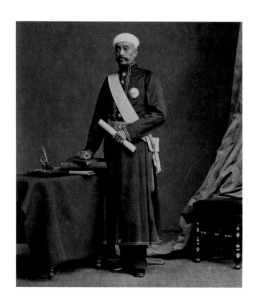

Fig. 29 Bourne and Shepherd, *Mir Turab Ali Khan, Salar Jung I (1829–83)*, 1875–6. RCIN 2114232

1 RA VIC/MAIN/QVJ (W) 29 June 1876 (Princess Beatrice's copies).

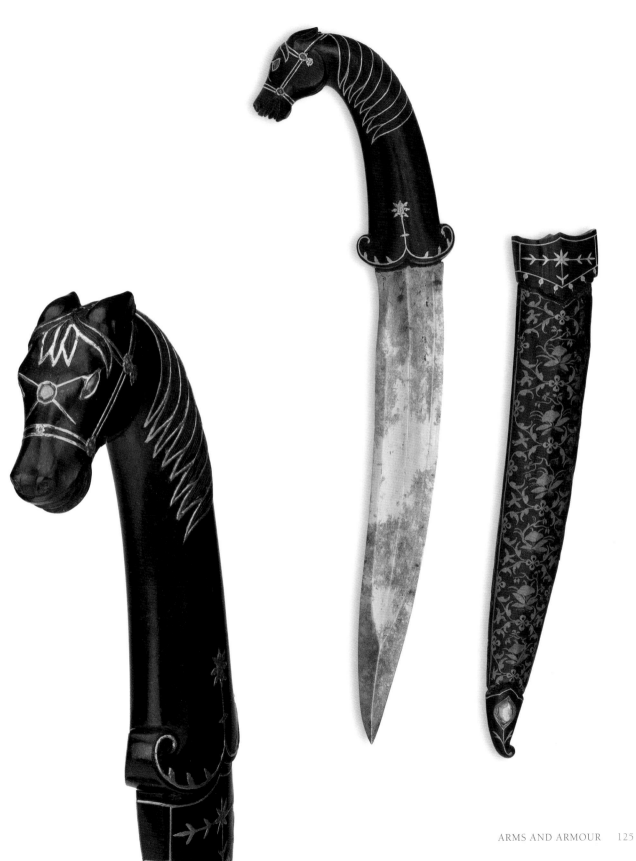

DAGGER AND SCABBARD

Dagger Mughal empire, late eighteenth or early nineteenth
century, scabbard western India, *c.1875*
RCIN 11346.a–b
Watered crucible steel, rock crystal, iron, gold and rubies
42.2 × 11.1 × 3.1 cm (overall)
MARKS: '*Sanglee*' inlaid in gold within cartouche
on top of both sides of scabbard

The Prince of Wales received this dagger when he met
Dhundirao Tatyasahib Patwardhan, Rao of Sangli (1832–
1901), in Bombay on 10 November. Rock crystal, a mate-
rial found across the subcontinent, had been used by
Indian lapidaries for centuries and was carved into dag-
gers and sword hilts as well as vessels.[1] Similar in form
to RCIN 11361 (pp. 122–3), it is likely that this dagger was
made in the Mughal Empire in the eighteenth century.
However, the steel scabbard, with overlaid gold pat-
terning and an English inscription, was made at a later
date, (probably in the late nineteenth century), and was
designed to make this object into a decorative presenta-
tion piece.

1 Watt 1903, p. 75.

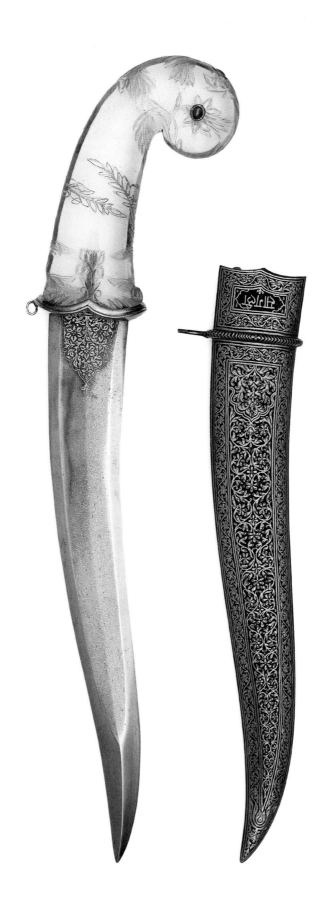

KNIFE AND SHEATH

Coorg, *c*.1870–5
RCIN 11297.a–b
Silver, gold, rubies and wood
31.0 × 8.5 × 3.3 cm (overall)

On 15 December the Prince of Wales met 'a picturesque deputation from Coorg' at the Guindy Park racecourse in Madras.[1] Here, William Howard Russell recorded that 'two gentlemen in their national costume, presented an address and offerings of Coorg knives and dresses'.[2] The ceremonial knife, known as a *pichangatti*, was carried by men in Coorg and was usually worn tucked into a waist sash (fig. 30). Intended to be useful for daily life, it is fitted with various grooming implements such as tweezers, file and ear scraper.

The knife is further decorated on the back edges with lines of floral designs and the blade is exceptional for being made of silver.

1 Russell 1877, p. 325.
2 Ibid.

Fig. 30 Amma Kodagi, or Kaveri Brahmins, in F. Watson, *The People of India. A series of photographic illustrations of the races and tribes of Hindustan*, vol. VIII, no. 425, 1875.

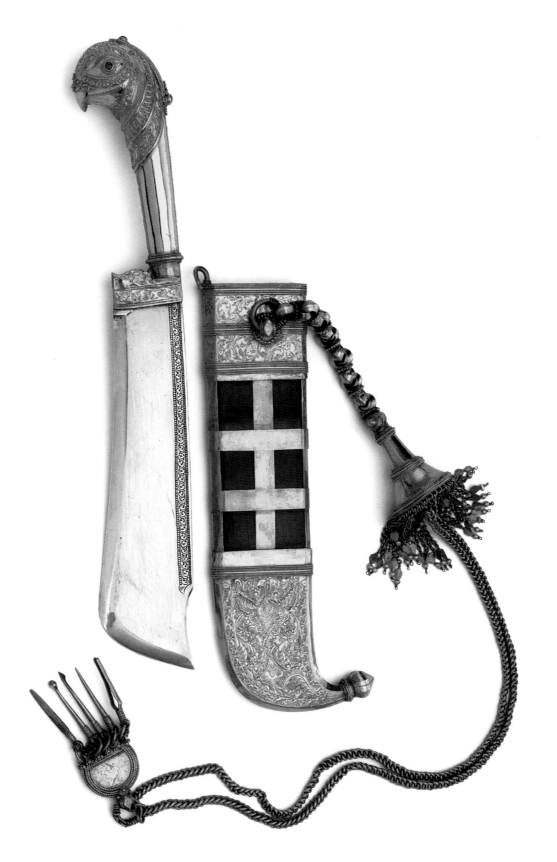

DAGGER AND SCABBARD

Dagger probably Yemen, scabbard probably South India, *c.*1870–5
RCIN 11302.a–b
Steel, gold, wood, emeralds and rubies
31.2 × 5.8 × 2.6 cm (overall)

Presented to Albert Edward by Mahbub Ali Khan, Nizam of Hyderabad, this hooked bladed dagger is known as a *jambiya*. This style of dagger was associated with parts of the Arabian Peninsula, in particular with Yemen.

From the early nineteenth century, the Nizam had employed mercenaries from Yemen, and the embellishments on the hilt of this dagger show stylistic elements typical of Yemeni craftsmen. By contrast the scabbard, with its *kundan*-set gemstones, was probably made by an Indian craftsman.

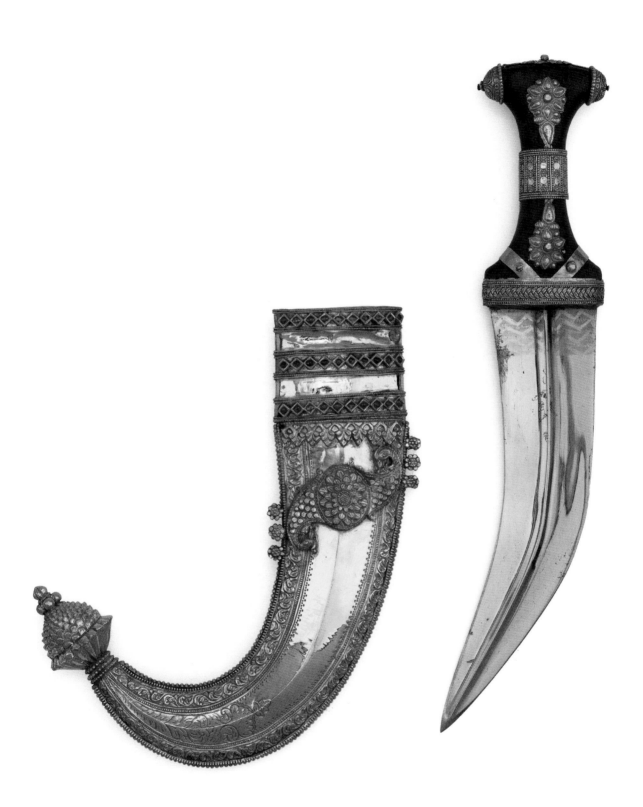

PUNCH DAGGER AND SCABBARD

Possibly South India, early nineteenth century, with jewelled embellishments added *c.*1875

RCIN 11487.a–b

Watered crucible steel, velvet, wood, diamonds and rubies

64.0 × 9.0 × 11.0 cm (overall)

MARKS: *'Heaven's Light Our Guide'* encircling Star of India, *'Ich Dien'* under Prince of Wales's crest

This punch dagger was presented to the Prince of Wales by Vijayarama III Gajapati, Maharaja of Vizianagaram (1826–79) (fig. 31). Having been made a Knight Commander of the Star of India in 1864, Vijayarama III had the scabbard embellished with the motto of the Order, 'Heaven's Light Our Guide'. The Prince of Wales's crest of three feathers has also been applied to the handguard.

The gold mounts chased with roses, thistles and shamrocks, the detailing of the lion's head on the handguard and the setting of the brilliant-cut diamonds suggest that parts of the scabbard were made by a European metalworker active in South India. From the early eighteenth century, individual British goldsmiths and silversmiths had become established in cities such as Bombay, Madras, Calcutta and Delhi, to cater for the many European communities based there. Here they produced jewellery and objects in a European style, alongside items intended for Indian patrons.[1] During the display of the Prince's gifts at South Kensington, these 'obtrusions of European design' were regarded as a negative consequence of British craftsmen working in India.[2]

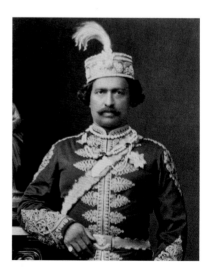

Fig. 31 Bourne and Shepherd, *The late Vijayarama III Gajapati, Maharaja of Vizianagaram (1826–79)*, *c.*1887. RCIN 2107655

1 London 2015, p. 103.
2 *The Times*, 22 June 1876; Birdwood 1884, p. 175.

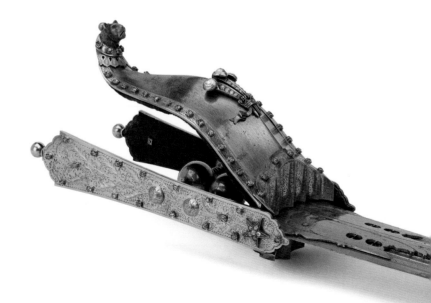

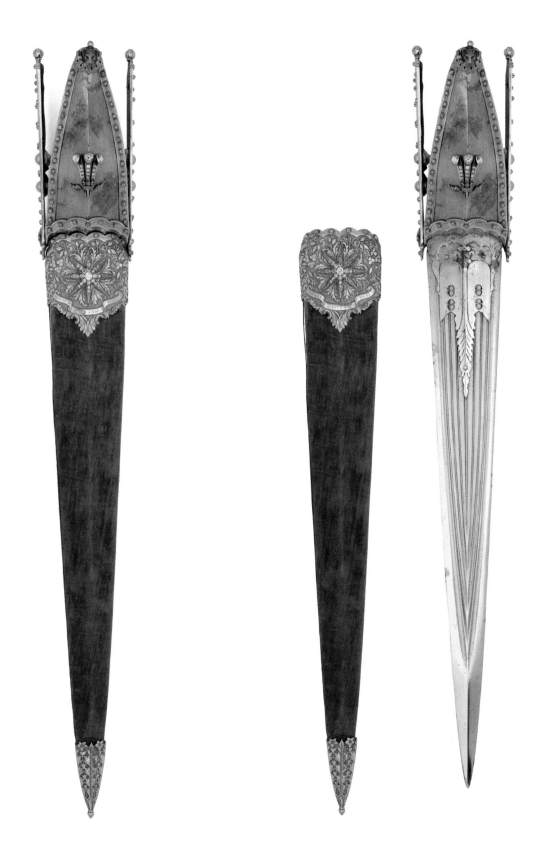

PUNCH DAGGER AND SCABBARD

India, *c*.1870–5
RCIN 11227.a–b
Steel, silver and gilded iron
39.8 × 8.8 × 1.8 cm (overall)

This intriguing punch dagger was presented to the Prince of Wales by Bijai Sen, Raja of Mandi (1848–1902), at a reception held for the rulers of Punjab in Lahore on 18 January 1876. Punch daggers, known as *katars*, were designed for close combat, and would usually have a single blade that would be gripped using the transverse crossbars. This example has been designed with a spring mechanism that is activated by applying pressure on the transverse bar closest to the hilt, causing the blade to split and reveal a further blade inside.

Punch daggers with such mechanisms were regarded as a display of the craftsman's skill. Some punch daggers were designed to split into five blades or equipped with pistols attached to the side guards (see RCIN 11455; pp. 136–7).

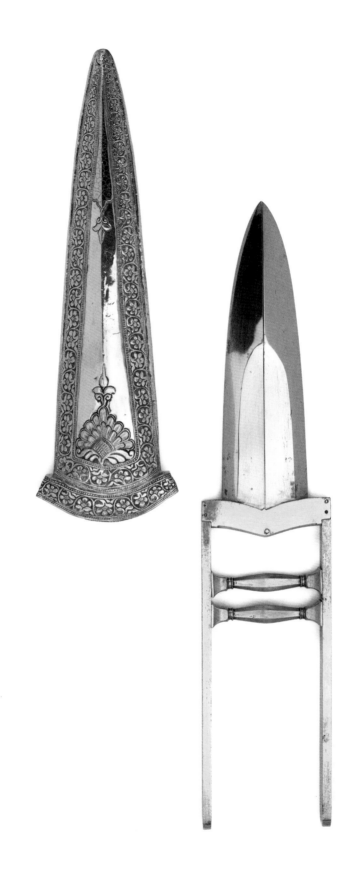

PUNCH DAGGER WITH PISTOLS

Blade possibly Mughal Empire, late seventeenth century,
hilt possibly Bundi, *c*.1870–5

RCIN 11455

Watered crucible steel, gold, rubies and emeralds

39.1 × 14.2 × 1.4 cm

This punch dagger was noted for its 'strangeness in form' in a review of the Prince's gifts, written for the *Illustrated London News* while they were on display at the South Kensington Museum.[1] The dagger incorporates two single flintlock pistols on the side guards parallel to the blade. The practical functionality of this weapon is questionable, and the embellishment of rubies and emeralds on the transverse grips suggests that this combination weapon was probably intended primarily as a presentation piece and a display of the craftsman's skill.

The donor of this punch dagger is not recorded; however, another dagger of similar design was presented by Ram Singh, Maharao of Bundi (1821–89), and it is possible that he may also have presented this one.

1 *ILN*, 8 July 1876.

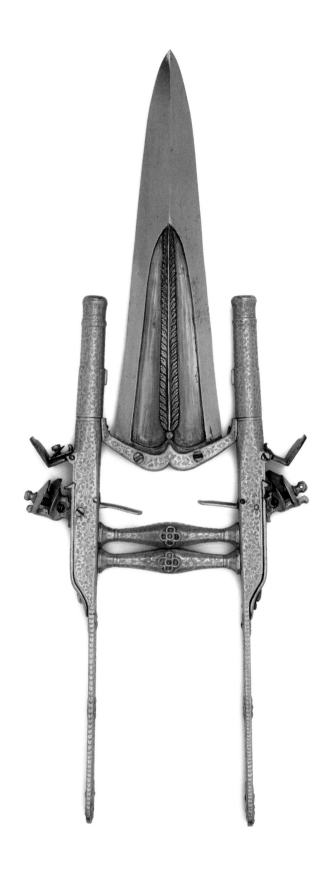

PARRYING HORNS

India, *c*.1870–5
RCIN 11416
Blackbuck horn and gold
36.2 × 8.1 × 3.7 cm
MARKS: '*HRH The Prince of Wales*' and '*Thakore Saheb of Wadhwan*'
chased around each cap

The Thakur Sahib of Wadhwan, Dajiraji Chandrasimhji
(1861–85), met the Prince of Wales on 10 November at
Bombay and presented this parrying weapon to him.
This weapon was usually associated with religious ascet-
ics and mendicants in India, making it an intriguing
gift for the ruler of Wadhwan to present to the Prince.
However, the use of gold mounts, instead of the typical
steel, and the dedication to the Prince, indicates that
this was intended as a virtuoso presentation piece.

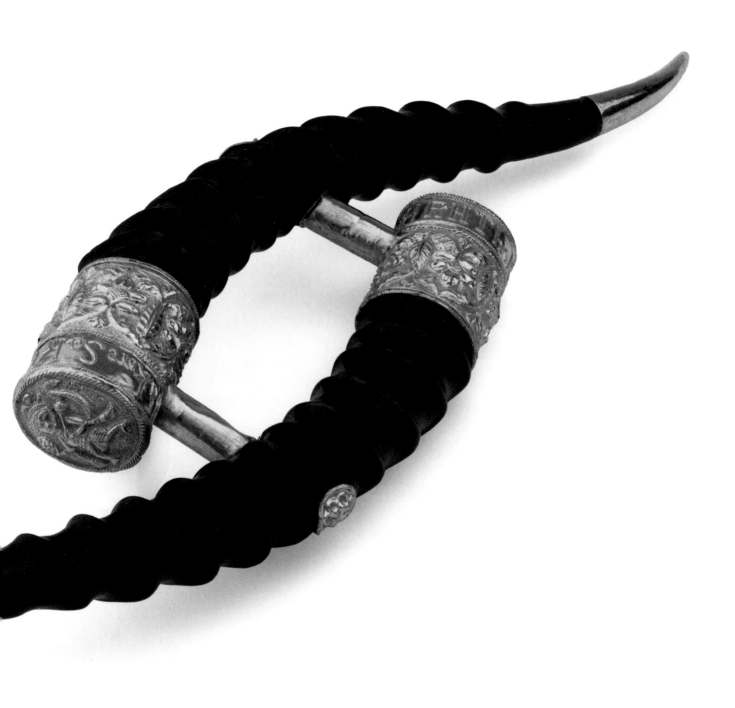

DAGGER AND SCABBARD

Possibly South India, early nineteenth century with
jewelled embellishments added *c*.1875
RCIN 11251.a–b
Watered crucible steel, gold, ivory, velvet, wood and diamonds
37.2 × 12.7 × 5.0 cm (overall)

This dagger was presented by Vijayarama III Gajapati, Maharaja of Vizianagaram at Benares in January 1876. It was specially commissioned as a presentation piece for the Prince of Wales and includes the Prince's feathers on the blue velvet-covered scabbard.

The gold overlay on the blade is incised with the ten *avatars* of the Hindu god Vishnu. The curved knuckle guard is incised with eight seated figures, possibly *vasus*, the eight attendant deities of Vishnu, and topped with a *yali*, a mythical creature, part elephant and part lion, often found in South Indian Hindu temple carvings.

As with the mounts of the punch dagger (RCIN 11487, pp. 132–3), also presented by the Maharaja of Vizianagaram, the chased foliage on the scabbard mounts appears to be a later addition by a European maker. The diamonds on the scabbard mounts and hilt are brilliant cuts, unusual in Indian pieces, which suggests that they were imported from Europe. The review of the Prince's gifts in *The Times* criticised the 'scant' use of brilliant-cut diamonds on this piece, suggesting that this resulted in 'all effect of splendour [being] lost'.[1]

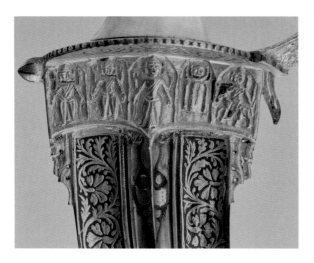

1 *The Times*, 22 June 1876.

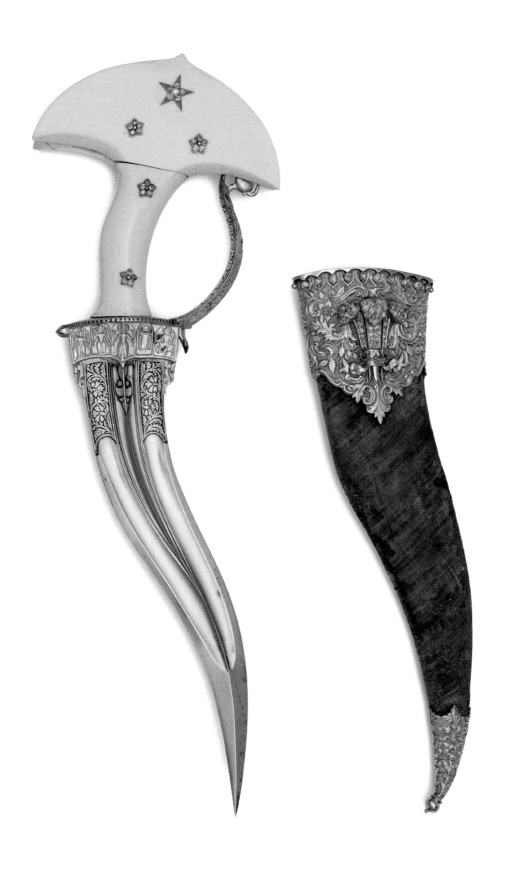

DAGGER AND SCABBARD

Ibrahim, Alwar, *c*.1877

RCIN 11289.a–b

Watered crucible steel, gold, enamel, wood, velvet, diamonds and pearls

40.6 × 4.5 × 3.7 cm (overall)

MARKS: '*Work of Ibrahim 1877*' in Persian damascened on the spine of the dagger blade

EXHIBITED: Cardiff 1998; London 2002

LITERATURE: Cardiff 1998, cat. no. 159; London 2002, cat. no. 306

This dagger was a late gift to the Prince of Wales from Mangal Singh, Maharaja of Alwar (1859–92), and was brought to England in July 1877 by Colonel Thomas Cadell (1835–1919), the British Resident at court. On receipt it was sent by the Prince to Bethnal Green Museum for display with the rest of his gifts.[1]

The dagger is remarkable for its ingenious blade. Made from crucible steel, the blade has a curved channel to reveal loose pearls that move along the passage when the dagger is tilted. The pearls are held in place by a rod that fits through the length of the hilt. The gold inscriptions and floral decoration on the blade have been overlaid using three different alloys of gold to subtly vary the colour. The enamelled hilt and scabbard mounts may have been made in Jaipur, although a branch of enamellers from Jaipur, are also recorded as working in Alwar.[2]

Mangal Singh and his successor, Jai Singh (1882–1937), were great patrons of the swordsmith 'Ibrahim', the maker of this dagger. They lent similarly designed swords and daggers with blades that had an open channel for free-moving pearls to the Colonial and Indian Exhibition (1886) and the Delhi Exhibition (1903).[3]

1 MA/1/R1940.

2 Hendley and Jacob 1886, p. 6.

3 Wardle 1886, Nos 4036 and 4044, p. 211; Watt 1903, pp. 471–2.

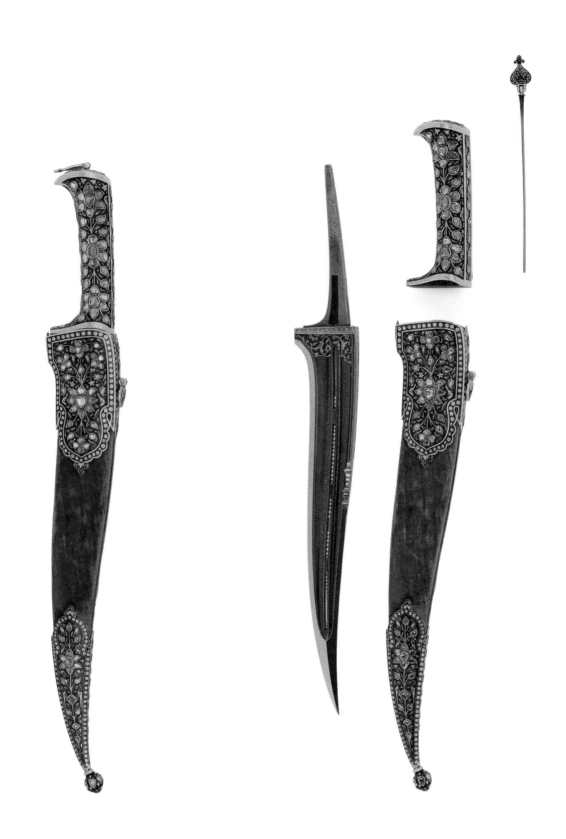

DAGGER AND SCABBARD

Rajasthan, probably early nineteenth century
RCIN 11309.a–b
Watered crucible steel, gold, jade, rubies and diamonds
41.4 × 5.0 × 2.4 cm (overall)

This dagger, with a parrot-shaped hilt, was presented to the Prince of Wales by Pratap Singh, Maharaja of Orchha (1854–1930) (fig. 32), at a reception in Agra on 26 January 1876.

Animal-headed hilts had become popular by the second half of the seventeenth century within the Mughal courts, where they were worn by rulers and senior nobles. By the early eighteenth century animal-headed daggers had also become popular in the neighbouring courts of Rajasthan, although here the animals were more stylised and less naturalistic – as with this example.[1]

When the dagger was catalogued in 1898, it was noted that a chain of large emeralds and pearls was attached to the hook of the parrot's beak.[2] These were subsequently removed, possibly for resetting in jewellery.

1 Topsfield 2014, p. 232.
2 Clarke 1898, p. 15.

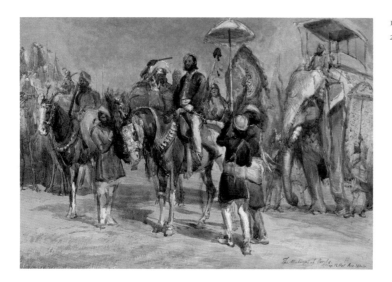

Fig. 32 Sydney Prior Hall, *The Maharaja of Orchha,*
26 January 1876. RCIN 923361

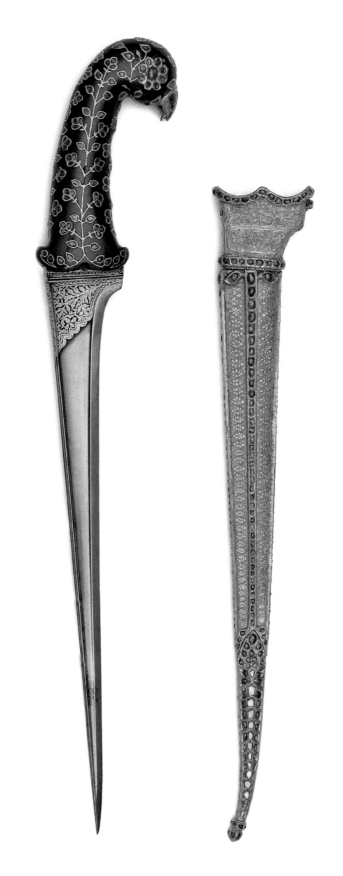

AXE KNIFE AND SHEATH

Bhuj, *c.*1870–5
RCIN 11434.a–*c*
Steel, copper, gold, silver and wood
61.8 × 6.3 × 3.7 cm (overall)

This axe knife was presented to the Prince of Wales by
Gambhirsinhji Verisalji, Raja of Rajpipla (1847–97),
who met the Prince in Bombay, on 10 November 1875.
This type of axe is thought to have originated in Cutch,
and was often refered to as a *bhuj*, after the capital of that
region. This weapon exhibits typical elements of axe
knives from Cutch, with the blade fixed to the top of the
sculptural elephant and a pommel on the handle which
unscrews to reveal a slender knife within.

SWORD AND SCABBARD

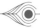

Blade possibly Iran, nineteenth century, hilt and
scabbard Sindh, c.1850–75

RCIN 11283.a–e

Watered crucible steel, gold, mother-of-pearl, iron, rubies,
emeralds, pearls, velvet and silver thread

127.6 × 8.6 × 6.0 cm (overall)

EXHIBITED: Cardiff 1998

LITERATURE: Cardiff 1998, cat. no. 156

This sword was presented to the Prince of Wales by Ali
Murad Khan, Amir of Khairpur (1815–94), in Bombay,
on 10 November 1875. The pink- and purple-hued enam-
elling on the scabbard is in a contemporary Iranian
style, a result of the court of Khairpur sharing close
artistic links with Iran and employing Iranian crafts-
men. The scabbard contains a knife with a mother-of-
pearl handle, a common feature of swords from this
region of India.

Sohrab Khan Bahadur Talpar (d. 1830), whose name
is inscribed on the blade in Persian, was the founder
of the Talpar dynasty that ruled over modern-day
Sind, Pakistan. The relationship between the rulers of
Khairpur and the British Government had been fraught
with political tensions and the Amirs had refused to
grant permission for British representatives to reside
within their court.[1]

In 1827, the court allowed James Burnes, a medical
officer, to treat Ali Murad Khan's illness, providing the
British doctor with a unique perspective from which
to record his observations in Khairpur. Burnes noted
that the Amirs had an immense collection of jewels,
many of which came from merchants selling stones
that had reputedly belonged to the deposed rulers of
Afghanistan. These were used by the Iranian craftsmen
employed in the Khairpur court for jewellery, as well as
for embellishing swords similar to that presented to the
Prince of Wales.[2]

1 Burnes 1831, p. 9.
2 Ibid., pp. 93–4.

SWORD AND SCABBARD

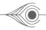

Blade possibly Iran, nineteenth century, hilt and
scabbard possibly Sind or western India, *c.*1870–75
RCIN 11413.a–b
Watered crucible steel, gold, diamonds, rubies, pearls,
velvet and wood
110.5 × 15.7 × 3.0 cm (excluding loop and tassel)

This sword, presented by the Amir of Khairpur, has a
fine watered crucible steel blade, inlaid with Persian
inscriptions in gold. The rulers of Khairpur greatly
admired watered crucible steel blades and sent agents
across Iran and Central Asia to procure swords on their
behalf. Consequently, by the early nineteenth century,
the Amirs were considered to possess 'a more valuable
collection of these articles than is probably to be met
with in any other part of the world'.[1]

While the blade of this sword predates the tour and
is likely to be from Iran, the decorations found on the
scabbard mount as well as the gemstone cut and setting
are European in style. It is most likely that these were
later additions undertaken by a European metalworker
based in western India.

1 Burnes 1831, p. 94.

SWORD AND SCABBARD

Sword probably Jaipur, scabbard probably Cutch, *c.*1870–5
RCIN 11350.a–b
Steel, gold, enamel and diamonds
89.2 × 11.1 cm (overall)

This sword, presented by Pragmalji II, Rao of Cutch, on 10 November 1875 at the start of the tour in Bombay, encapsulates the metalworking traditions for which that region had become known by the late nineteenth century.

Likened to European chasing, the design found on the scabbard is associated with Cutch's links to the Dutch maritime trade. The port of Mandvi in Cutch was a stopping point for Dutch ships before they continued on to Ceylon.[1]

The hilt of the sword is made of solid gold. The pommel and the ends of the crossguard of the hilt are in the form of cheetah heads enamelled and inlaid with *kundan*-set diamonds. This enamelling may have been undertaken in Jaipur, although by this period Bhuj, the capital of Cutch, had developed its own enamelling style, and the enamel work may have originated from there. In the Delhi Exhibition (1903), enamelling in Bhuj was described as having 'attained a higher proficiency in the art of enamelling than has been acquired in any other part of India, not even excepting Jaipur'.[2]

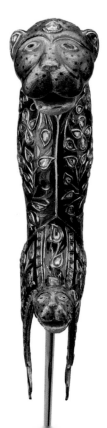

1 Postans 1839, p. 176; Wilkinson and Hawkins 2000, p. 138.
2 Watt 1903, p. 464.

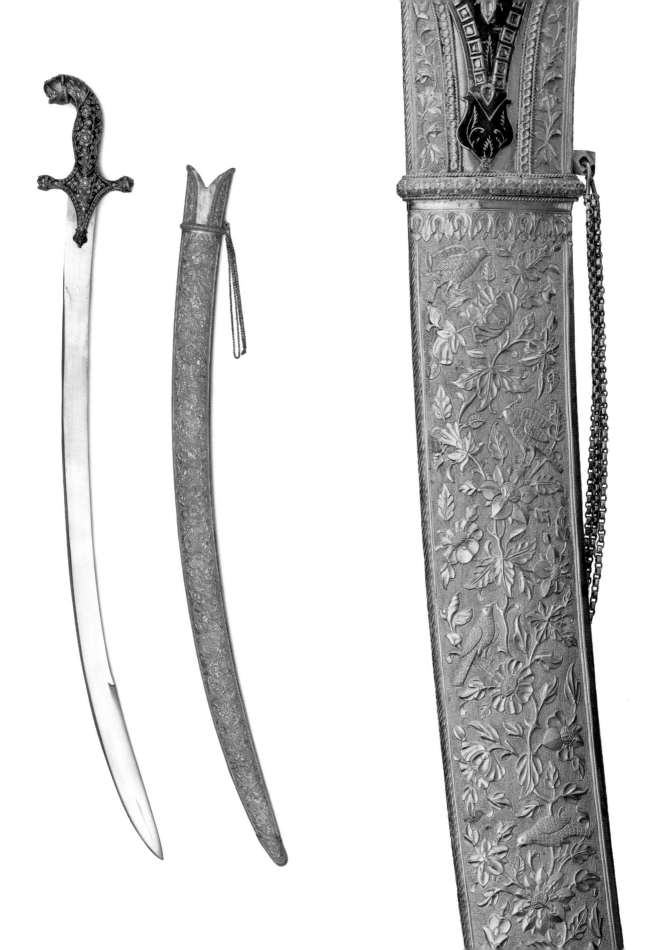

SWORD

Muhammad Ibrahim, Alwar, late eighteenth or early nineteenth
century with gold-inlaid inscriptions added to blade *c.1875*
RCIN 11238
Watered crucible steel and gold
87.0 × 12.2 × 7.5 cm
MARKS: the hilt is inlaid with gold and engraved in Persian
'Maharaja-rao Sawai Bakhtawar Singh Bahadur' and *'There is
no hero like Ali there is no sword like Zulfiqar 1223AH'*.
The blade inlaid with gold and engraved in Persian *'A gift from
Maharaja-rao Sawai Mangal Singh Bahadur Protector of Alwar'*,
'In the service of Albert Edward Prince of Wales' and *'Work of
Muhammad Ibrahim'*.

Described during the tour of the gifts as having a blade of
'curious finesse', this sword forged from watered cruci-
ble steel was presented to the Prince of Wales by Mangal
Singh, Maharaja of Alwar.[1] The blade is of exceptional
quality, with a very fine dark watered pattern, and the
gold inscriptions are inlaid.

According to the inscription, it appears that the hilt
of the sword predates the tour and was made in the late
eighteenth or early nineteenth century for a previous
ruler of Alwar, Bakhtawar Singh (1779–1815). The hilt
also includes an inscription referring to 'Zulfiqar', the
legendary sword that the Prophet Muhammad gave to
his son-in-law, Ali ibn Abi Talib.[2] The blade of the sword

is contemporaneous with the tour and includes a dedi-
cation to the Prince of Wales in Persian.

The Alwar armoury was described as containing
'swords, knives and shields of great beauty and excel-
lence'.[3] The craftsmen attached to the armoury were
noted as not being native to the region and may have
been invited to the court in the early nineteenth century
by the previous rulers of Alwar.[4] These rulers actively
collected arms and armour from important centres of
sword production across Iran and India.[5] The high status
enjoyed by the craftsmen in Alwar was reflected in the
rewards given for their work, for which they were reput-
edly given villages rather than monetary recompense.[6]

1 *Daily News*, 20 June 1876.
2 Stone 1934, p. 685.
3 Powlett 1878, p. 118.
4 Ibid., p. 118
5 Hendley 1888.
6 Powlett 1878, p. 118.

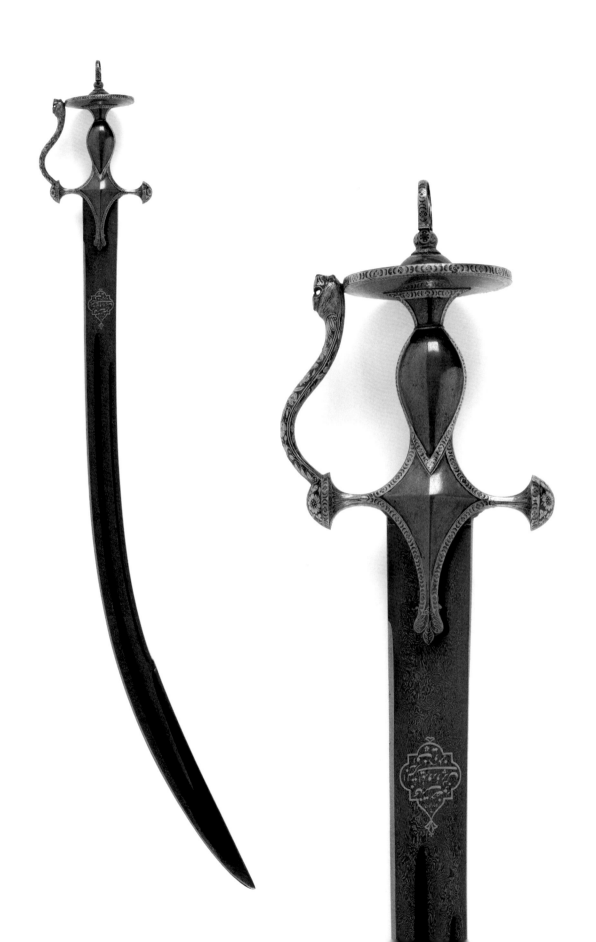

SPEARHEAD

South India, late sixteenth century
RCIN 37537
Steel
49.5 × 7.4 × 7.5 cm

On 10 December, en route to Madurai from Tuticorin, the Prince of Wales stopped briefly for lunch at Kovil- patty. Here the Prince met Jagadveera Rama Kumara Ettapa, Zamindar of Ettayapuram (1868–90), who presented him with what William Howard Russell de- scribed as 'some articles of trifling value as mementoes of his visit'.[1]

As it transpired, at least one of these 'trifling' memen- tos was in fact of of great historical importance. The finely cut, pierced and chiselled decoration on this late-sixteenth century spearhead has been linked with the Nayaka kingdom (1529–1736). At this time, art and architecture flourished in the region, now modern-day Tamil Nadu.[2]

1 Russell 1877, p. 300.
2 Elgood 2004, p. 194.

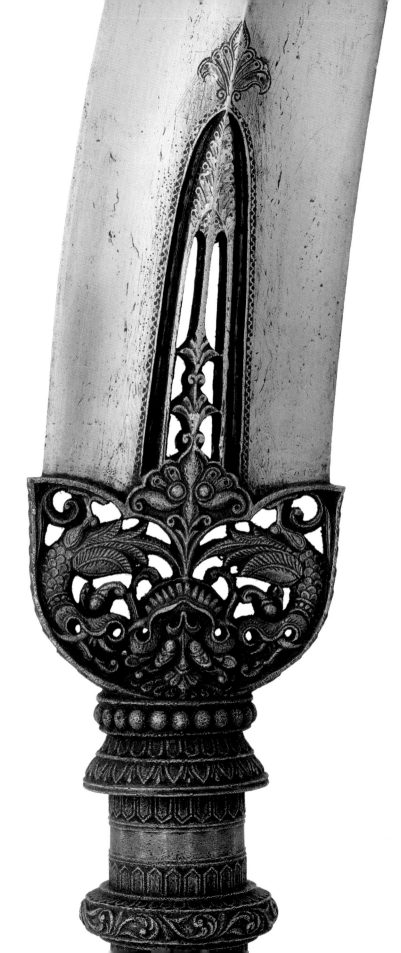
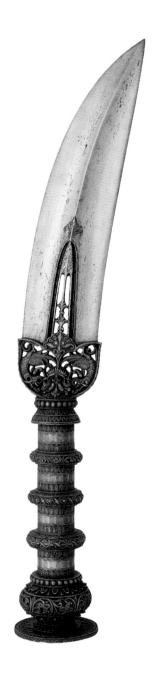

SWORD AND SCABBARD

Kandy, c.1800 with additional decoration c.1875
RCIN 11310.a–b
Tortoiseshell, horn (?) and copper alloy
62.6 × 9.4 × 3.2 cm (overall)
MARKS: inscribed on blade '*Presented to His Royal Highness*
Albert Edward the Prince of Wales by Don Cristoffel Henricues Dias
Bandarnaike Mudaliyr of the Siyane Korale Colombo Ceylon Dec. 1875'

This ceremonial sword, known as a *kastane*, was presented to the Prince of Wales by Don Cristoffel Henricues Dias Bandarnaike on 8 December 1975. The hilt and scabbard are made of tortoiseshell imported from the Straits of Malacca and the Maldives.[1] The pommel of the hilt and the crossguards terminate with the heads of a beast, possibly a *makara*, a mythical creature associated with Hindu iconography that has the combined features of an elephant and crocodile.

Bandarnaike was one of the Ceylonese Mudaliyars, a title created by Portuguese traders and settlers in the seventeenth century for Ceylonese people who acted as their intermediaries. The rank continued under Dutch, and later British, rule in the eighteenth and nineteenth centuries. The Mudaliyars would often act as ambassadors and translators to the Portuguese and Dutch within the Kandyan court.

This type of sword was associated with the court of the kingdom of Kandy where the workshops were known for their technical skills with metalworking. The decline of the kingdom in the early nineteenth century led to a dispersal of the craftsmen specialised in the production of these swords.

1 Jaffer 2001, p. 383.

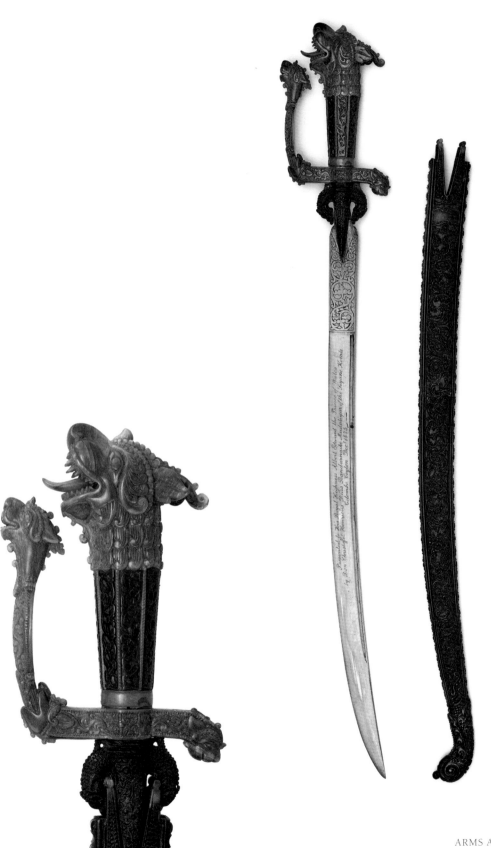

SWORD AND SCABBARD

Blade probably Iran, nineteenth century, hilt and
scabbard Kashmir, c.1850–75

RCIN 11410.a–b

Watered crucible steel, gold, wood, velvet, silk, emeralds and rubies

101.4 × 13.5 × 3.0 cm (overall)

EXHIBITED: Cardiff 1998; London 2001; London 2002; London
2005; London 2009; Edinburgh 2012

LITERATURE: Cardiff 1998, cat. no. 155; London 2002, cat. no.
305; London 2009 , cat. no. 305

On 20 January 1876, the Prince visited Jammu, the win-
ter capital of Ranbir Singh, the Maharaja of Kashmir. He
travelled to the Maharaja's palace on an elephant along a
route lined with crowds of people. The *Illustrated London
News* reported that, as Albert Edward left Jammu, 'the
Maharaja finally presented the Prince with this sword
worth at the lowest calculation £10,000. It is studded
with precious stones from hilt to point'.[1]

The hilt of this sword is made of solid gold. The cross-
guard is encrusted with impressive gemstones and on
each side are large emeralds, carved with floral motifs.
The blade is of very fine quality and the inscription on
the blade suggests that this was the personal sword of
the Maharaja.

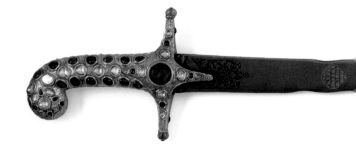

1 *ILN*, 26 February 1876.

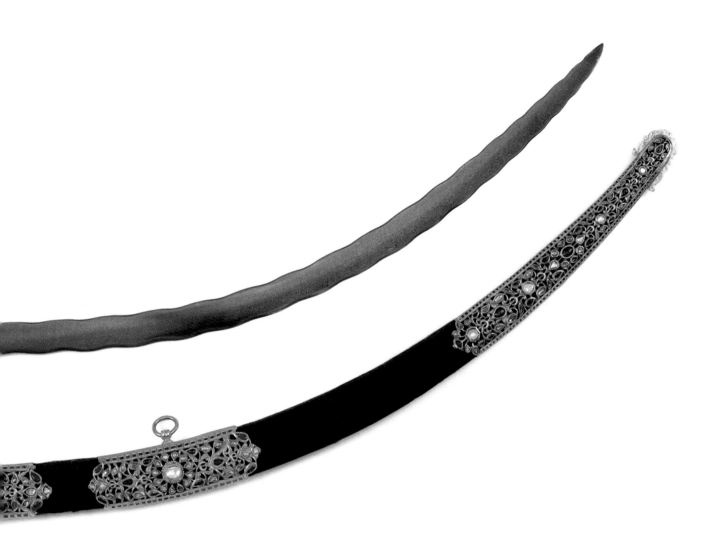

SWORD AND SCABBARD

Jaipur, late seventeenth century, enamelled scabbard
mounts, *c.*1870–75

RCIN 11421.a–b

Watered crucible steel, gold, wood, enamel and velvet
gilt threads

84.0 × 11.5 × 7.6 cm (overall)

During the tour the Prince of Wales was given a number
of gifts of historic significance. Among them was this
sword, presented by Ram Singh II, Maharaja of Jaipur.
The sword had belonged to Bishan Singh (1672–99),
the former ruler of Amber. Amber had been the seat of
the Kacchwaha rulers until 1727, when the capital was
moved by Bishan Singh's son, Jai Singh II (1688–1743)
to Jaipur, the city that was named after him.

The sword blade is overlaid in gold with a talismanic
square. These were applied to swords in the belief
that such symbols would provide protection from their
owners.

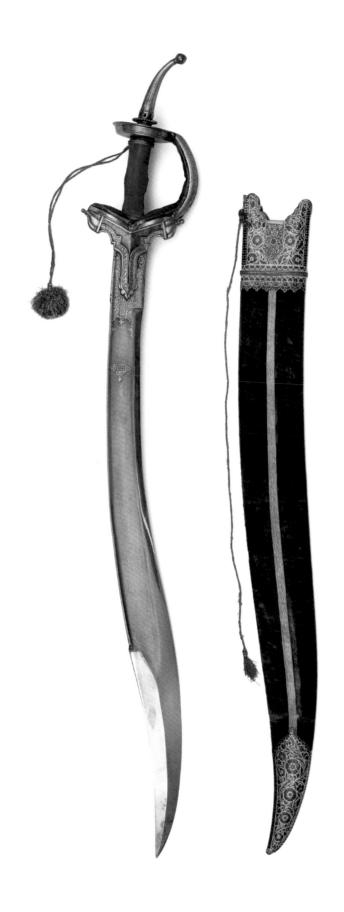

WALKING STICK GUN

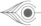

India, possibly Bundi, *c.*1870–5
RCIN 11484
Steel, gold, wood, emeralds, rubies and turquoise
103.4 × 6.6 × 2.6 cm (overall)

The Prince received several weapons that appear to be designed purely as a display of technical skill rather than for practical use. The gold handle of this walking stick gun is in the form of a *makara*, a mythological Indian sea creature popularly found in Hindu iconography. The stick is made of steel overlaid with gold. It transforms into a three-section gun, with a sprung percussion action deployed by a trigger, cocked by pulling the handle back. The barrel section unscrews to reveal a percussion nipple; the ferrule extends and is attached to a wooden ramrod fitted in the muzzle to conceal the barrel.

The donor of this extraordinary walking stick gun was not recorded in the *Indian Art at Marlborough House* catalogue; however, it may have been a gift from the Maharao Ram Singh of Bundi (fig. 33), who presented the Prince with punch daggers equipped with pistols and a walking stick containing an hourglass and overlaid with a gold calendar along its length.

Fig. 33 Bourne and Shepherd, *Maharao Raja Ram Singh of Bundi (1811–89), c.*1887. RCIN 2107601

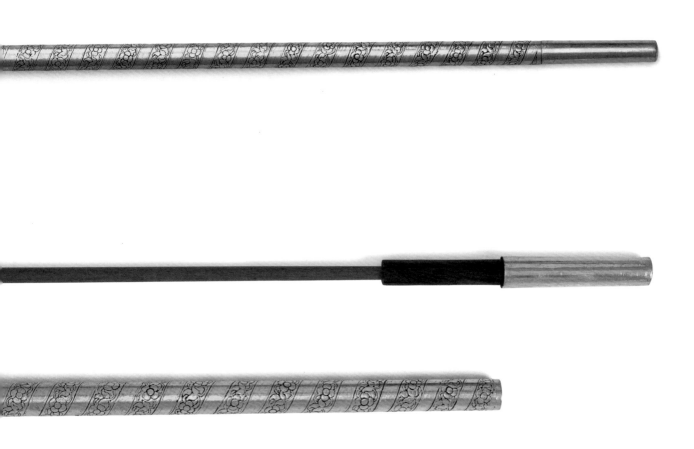

PAIR OF ARM GUARDS

Northern India, eighteenth century
RCIN 11496.1–2
Steel, gold, velvet, silk, pearls and diamonds
49.0 × 15.4 × 9.5 cm (each)

These ornate arm guards were presented by Jayajirao Scindia, Maharaja of Gwalior (fig. 34), to the Prince of Wales during his stay in Gwalior, from 31 January to 1 February 1876. The opulence of the Maharaja's court was recorded by William Howard Russell, who noted that many of the Maharaja's attendants wore jewel-encrusted armour. During the Prince's stay, the Maharaja took part in a military review and 'wore a scarlet tunic, with gold facings, diamonds and gems, [...] his cap blazing with jewels and ornamented with an egret plume rising from a diamond socket'.[1]

These arm guards with gauntlets made of silk, pearls and diamonds, and decorated with dense overlaid gold floral patterning, were designed to be conspicuous and for ceremonial wear.

1 Russell 1877, p. 450.

Fig. 34 Bourne and Shepherd, *Jayajirao Scindia, the late Maharaja of Gwalior (1835–86), c.1887.*
RCIN 2107587

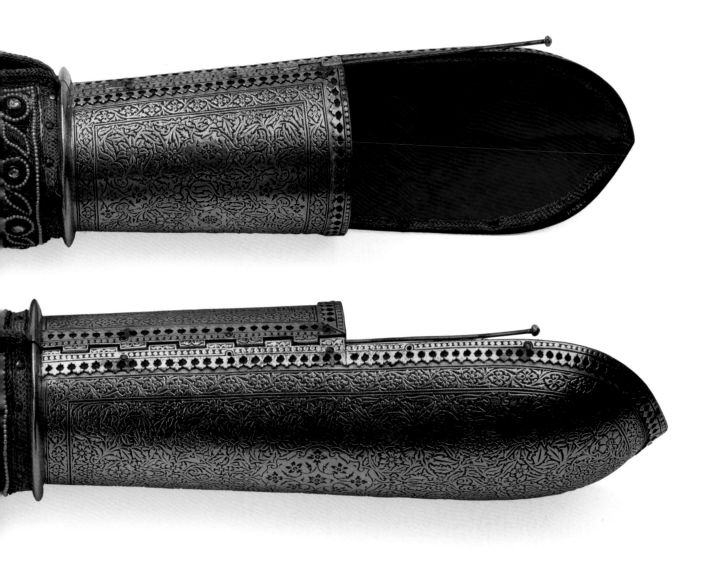

SHIELD

Rajasthan, *c.*1870–5, enamelled mounts Jaipur, *c.*1875
RCIN 11348
Rhinoceros hide, gold, velvet, enamel, diamonds, rubies
and emeralds
50.0 × 9.8 cm
EXHIBITED: London 2001

Mohammad Ibrahim Ali Kahn, the Nawab of Tonk, presented this shield to the Prince of Wales in Agra, where the Prince held a reception in January 1876. The floral designs are painted in gold, black and red, and certain sections of the pattern are applied with gesso to raise the motif from the surface of the shield. The entire surface is finished with a clear lacquer varnish.

The 'lacquered' effect on this rhinoceros hide shield shows Japanese influences. In the seventeenth century, Indian objects were taken by Portuguese merchants to Japan, where they would be decorated. They were subsequently brought back to India for presentation as diplomatic gifts. This decorative design and method appears to have been reinterpreted by Indian craftsmen.[1]

The Prince received several shields with very similar designs from Rajasthan, suggesting that they were produced by one workshop.

1 Weston 2014, pp. 45–56.

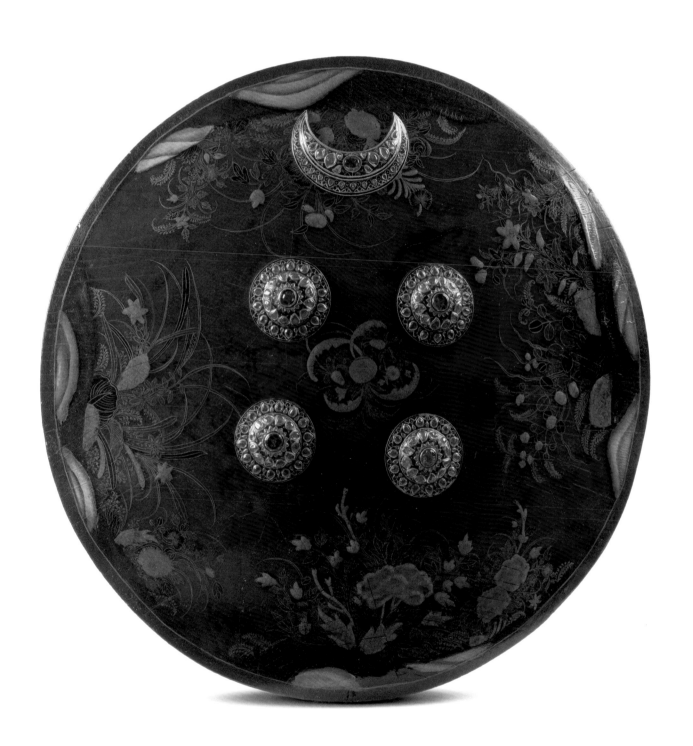

SHIELD

Western India, probably late eighteenth century or early
nineteenth century
RCIN 11458
Rhinoceros hide, lacquer, gold, emeralds, rubies, diamonds,
velvet, gold and silver thread and gold sequin
Shield 39.5 × 9.0 cm; sash 105.0 × 7.0 cm

This ornate shield was presented by Vibhaji II Ranmalji, Jam Sahib of Nawanagar (1827–95), in Bombay in November 1875. The translucent hide is decorated with four large ornate bosses, and painted on the central reserve is the face of Chandra, the Hindu lunar deity to represent the lunar dynasty, from which the Nawanagar rulers descended.

The purple velvet sash is embellished with *zardozi* (gold embroidery) and is attached to a padded, embroidered cushion on the back of the shield, also made of purple velvet with silver and gold thread decoration. This cushion would have served to protect the hand of the wearer. The dimensions of the shield are significantly smaller than others presented to the Prince, and, with its conspicuous bosses, it is likely that this shield was designed for use in processions and ceremonies rather than in battle.

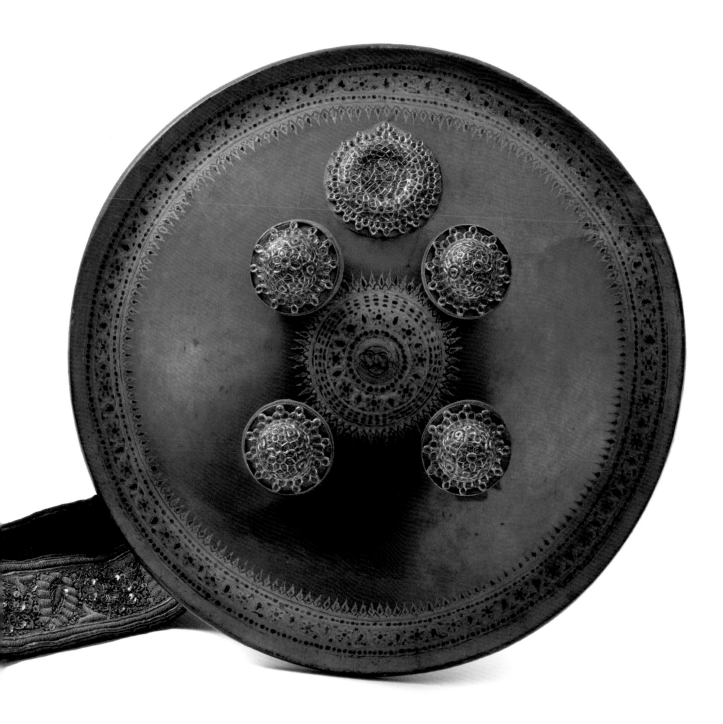

SHIELD

India, possibly Punjab, nineteenth century
RCIN 11411
Rhinoceros hide, gold, diamonds, emeralds,
pearls, enamel and silk
55.7 × 11.5 cm

The most striking feature of this shield, presented to the Prince by Mahendra Singh, Maharaja of Patiala, is the enamelled and diamond inlaid bosses in the form of curled-up cheetahs. It appears that the front of the shield had originally been lacquered, but by the time of its presentation to the Prince of Wales this finish had worn away, leaving a speckled surface. This would suggest that the shield predated the tour and came from the Maharaja's armoury.

Diamond-shaped openwork ornaments, similar to the one in the centre of the shield, were usually attached to ornate sashes worn as belts.[1] This ornament was described in the *Illustrated London News* as a brooch, suggesting that it was a later addition to the shield.[2]

1 See London 2015, p. 116.
2 *ILN*, 12 August 1876.

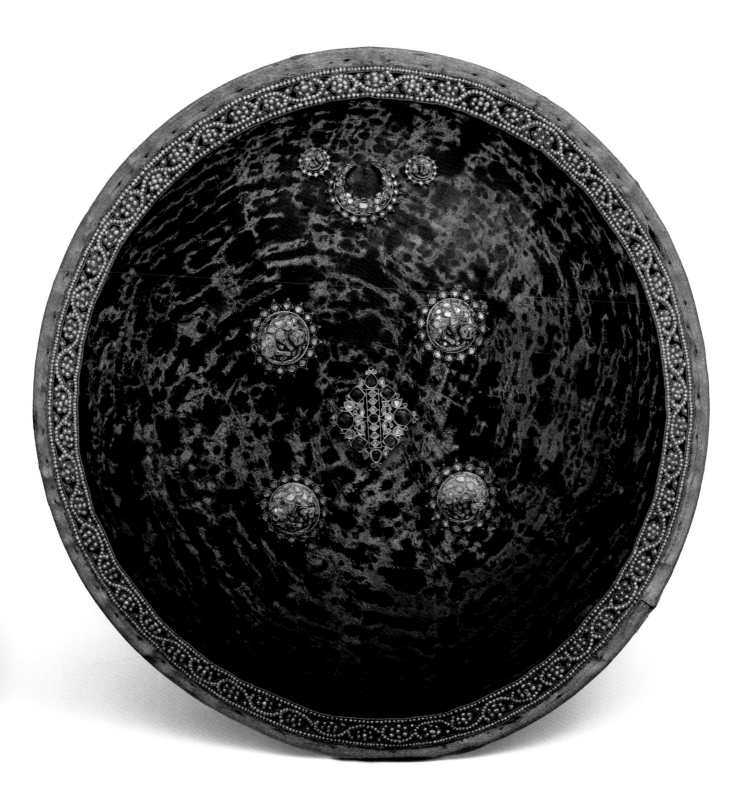

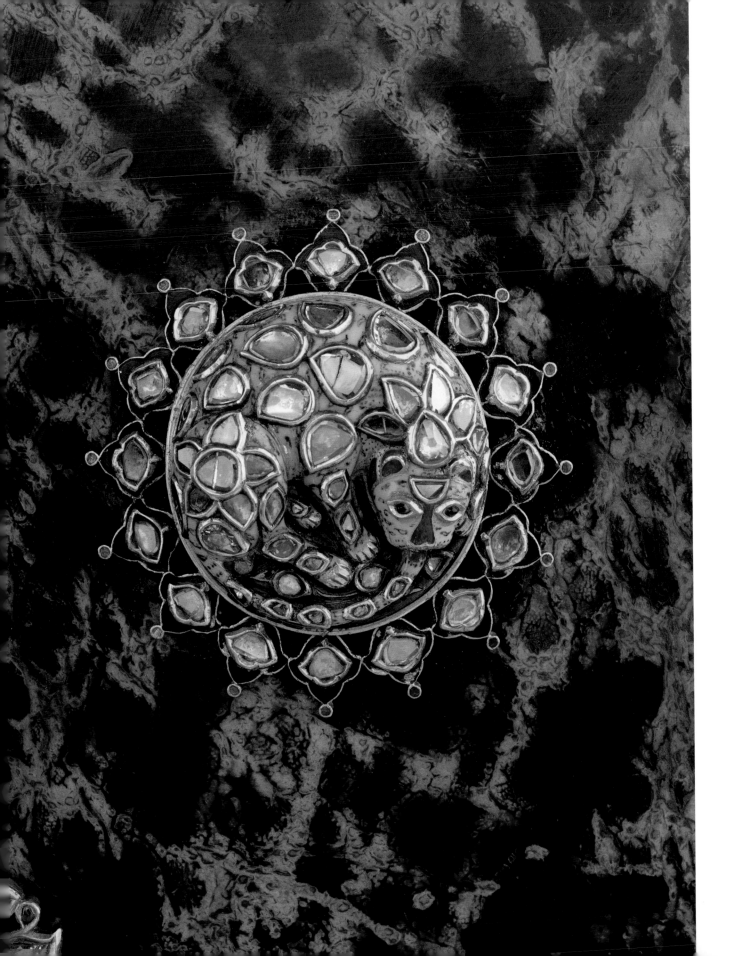

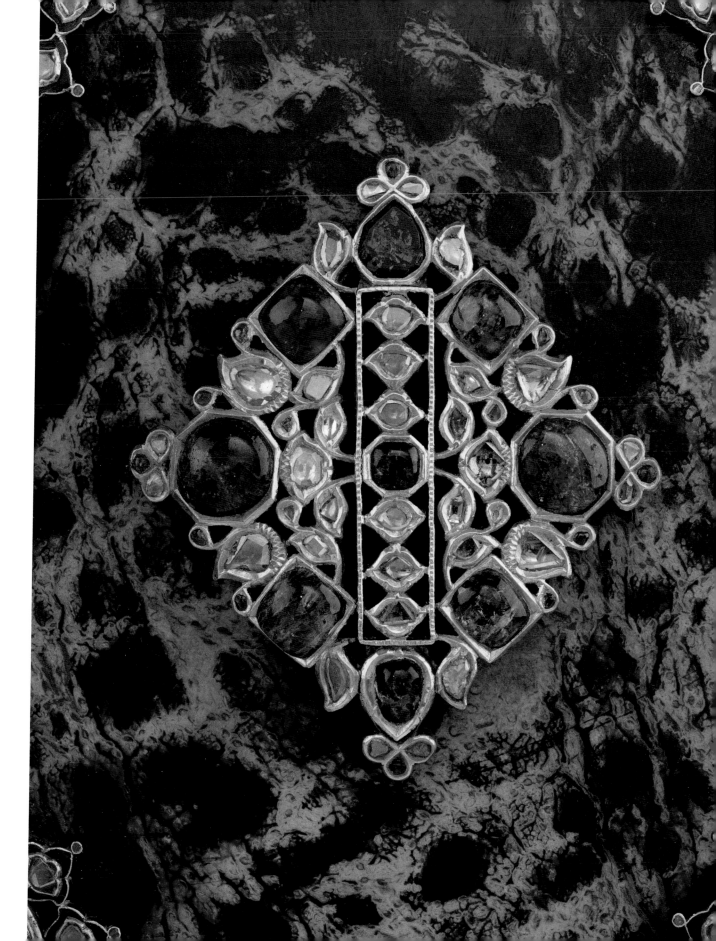

SHIELD AND WAIST SASH

Shield Lucknow, sash possibly France and embroidered in
Punjab, *c*.1870–5
RCINS 11278, 11412
Silver-gilt, enamel, diamonds, silk, gold thread and pearls
Shield 48.0 × 6.7 cm; sash 199.5 × 25.2 cm
MARKS: stamped on sash in ink '*octroi 678*'
EXHIBITED: RCIN 11278 in Cardiff 1998; London 2002; London
2005; Edinburgh 2012
LITERATURE: Cardiff 1998, cat. no. 160; London 2002,
cat. no. 308

In addition to presenting a jewel-encrusted sword, Ranbir Singh, Maharaja of Kashmir, also presented the Prince with a jewel-encrusted, silver-gilt shield during the Prince's stay at Jammu, in January 1876.

The shield was made purely for ceremonial purposes, its weight of 5.89 kilograms rendering it ineffective for combat. Furthermore, it is inlaid with more than 800 diamonds. The surface of the shield, showing animals in combat, was made in Lucknow, where green and blue enamelling on silver was typical.

The woven motifs on the pink and green waist sash and the tax stamp suggest that the textile was produced in Europe, possibly France, and imported to Kashmir, which began to levy a tax, called the 'octroi', on imported goods. The sash was later embroidered in the Punjab region, where the *zardozi* (gold embroidery) technique was prominent.

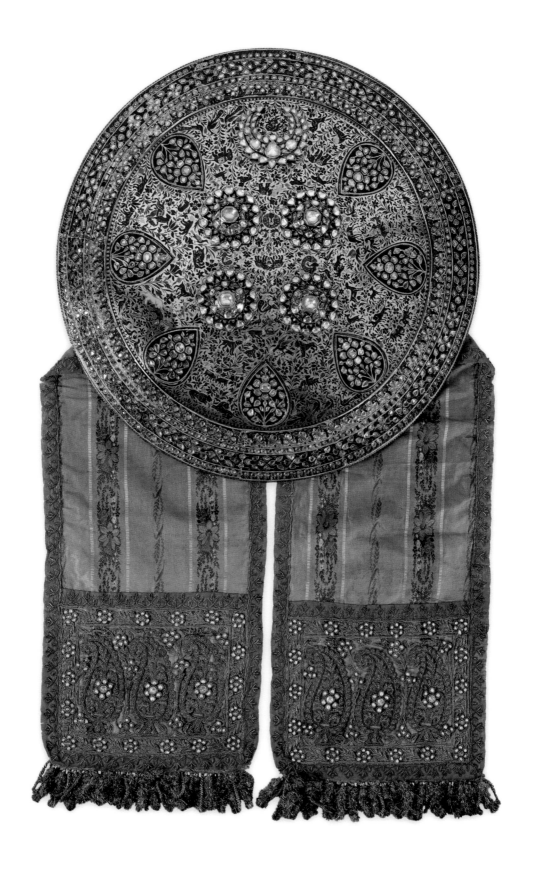

SCALE ARMOUR

Datia, *c.*1875
RCINS 38058, 38059
Gilt copper, pangolin scale, turquoise, rubies, velvet, gold and pearls
Helmet 33.0 × 20.5 × 24.5 cm; coat 123.0 × 90.0 × 6.0 cm
MARKS: '*PRESENTED TO H.R.H. THE PRINCE OF WALES BY MAHARAJAH BHAWANI SINGH OF DUTTIA AS A TOKEN OF LOYALTY AND ATTACHMENT*' painted across the scales on the front left portion of the coat.

This extraordinary armour, made of pangolin scales, was presented by Bhavani Singh, Maharaja of Datia, to the Prince of Wales in Agra, January 1876, and was only the second armour of pangolin scales to be given to the British Royal Family.[1] The two coats are the only known published examples of such armour in the world.

Each individual scale of the coat and helmet is painted with gold flowers, and those on the edges of the coat are inset with turquoises and rubies.

This suit is formed from the pangolin species *Manis pentadactyla*, predominantly found in parts of north-eastern India, Nepal and Bangladesh. Scales from several pangolins are likely to have been used in the construction of the armour, and a small number of the scales have a different applied decoration, suggesting that they may be replacements.

1 The first coat of scales was presented to George IV by Francis Rawdon-Hastings, then Governor-General of India in 1820.

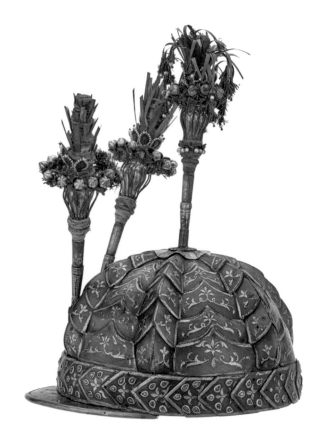

CURIOS

MILITARY FIGURES

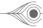

Vizagapatam or Peddapuram, late eighteenth century

RCINS 10838–10848

Brass

Camel 19.7 × 9.5 × 7.8 cm; elephant and driver 16.0 × 8.0 × 16.5 cm; soldier on camel 17.8 × 4.5 × 7.5 cm; elephant and drummer 12.3 × 9.5 × 14.0 cm; African soldier 12.5 × 4.2 × 9.5 cm; soldier on horseback 12.1 × 3.3 × 8.1 cm; spear-man on horseback 17.5 × 3.4 × 7.6 cm; sepoy 8.8 × 2.5 × 2.4 cm; soldier on horseback 10.7 × 3.3 × 6.4 cm; horse 9.0 × 3.4 × 6.5 cm; archer on horseback 12.5 × 3.4 × 6.5 cm

EXHIBITED: London 1982; London 2001

This set of eighteenth-century brass military figures consists of a camel, two caparisoned elephants and their mahouts, a horse, an infantry soldier, a mounted African soldier, an East India Company carabineer, a Maharatta spearman, an East India Company sepoy and a mounted archer – all carrying various weapons and wearing different headdresses. The set of 11 figures was presented during the tour by 'G.L. Narsinga Rao', whose identity is obscure.[1] The figures were originally part of a larger set, reportedly belonging to Timma Razu, Raja of Peddapuram (d. 1796). They were commissioned on the advice of his astrologer to enable the Raja to review his troops daily without the need for bloodshed. The set was dispersed in the early nineteenth century.

The figures are individually modelled and cast using the lost wax process, a technique used in many parts of South India to produce brass sculptures of deities. Some debate exists as to whether these expressive and amusing figures, with their disproportionately sized weapons and headdresses, were modelled by an Indian or European maker, the latter being proposed due to their comical nature.[2]

George Birdwood praised them for their skilful modelling and felt that 'they graphically illustrate[d] the whole gamut of military swagger in men and beast'.[3] When they were displayed at the Paris International Exhibition in 1878, the figures with their 'irresistible grotesqueness of expression' led Birdwood to claim that the craftsman appeared to have been inspired by Gustave Doré's illustration of Don Quixote.[4]

1 Francis 1907, p. 220 records that 'G.L. Narsinga Rao' was married to the daughter of the prominent Godey family in Anakapalle, Vizagapatam, but offers very little other information as to the identity of the donor.

2 Digby and Harle 1982, p. 6.

3 Birdwood 1884, p. 194.

4 Birdwood 1878, p. 62.

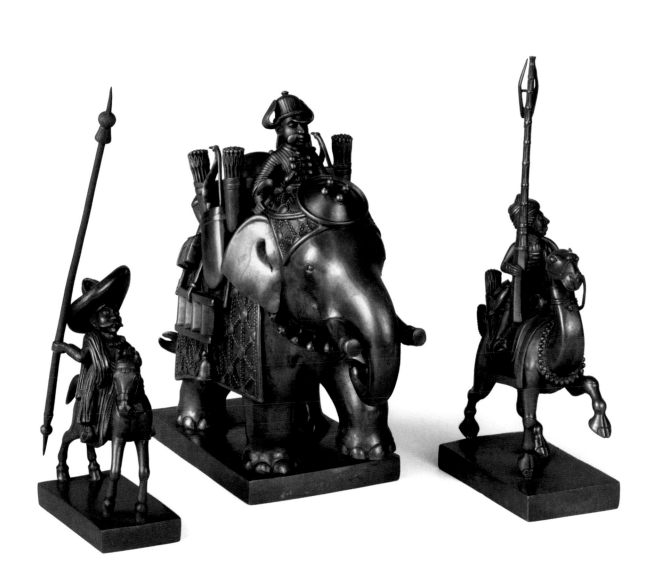

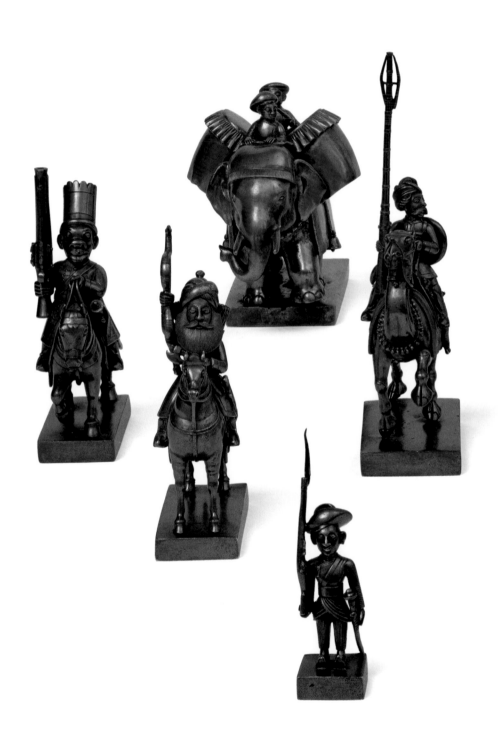

PEACOCK INKSTAND

Jaipur, *c.*1870–5

RCIN 11444.a–s

Gold, enamel, rubies, sapphires, diamonds, silver and pearl

17.5 × 5.7 × 39.3 cm (overall)

MARKS: '*Presented to H.R.H The Prince of Wales by
H.H. The Maharaja of Benares 1876*' engraved on mast

EXHIBITED: London 2001

The Prince of Wales visited Benares, where he was
presented with this inkstand by Ishwari Narayan Prasad
Singh, Maharaja of Benares. The inkstand is modelled
on a state barge known as the *Maurpankhi*. The Prince
travelled on a similar barge along the Ganges at dusk on
5 January 1876 (fig. 35).[1]

The prow, modelled as a peacock, has been engraved
with radiating lines that can be glimpsed through the
blue enamel. The Benares crest of two fishes can be seen
on the small triangular gold flag, and the mast is inscribed
with a dedication to the Prince of Wales. The stern is
shaped as the head of a *makara*, a mythological Hindu
creature that is the *vahana* (mount) of the personified
Hindu god, Ganga. The canopy, woven of silver thread,
surmounts the *palki* (lotus flower-shaped seat), which
was usually the seat reserved for high-status individuals.
The inkstand is formed of 19 pieces that include a pen-
knife, two inkwells, two pen nibs and a pair of scissors.

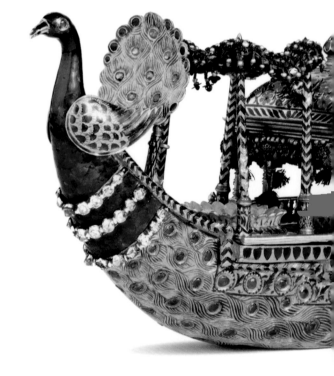

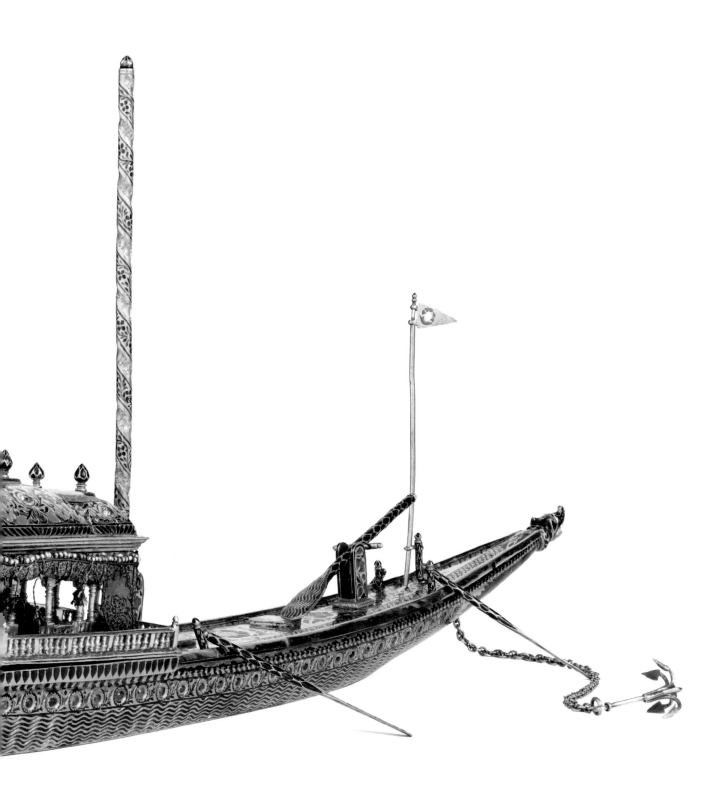

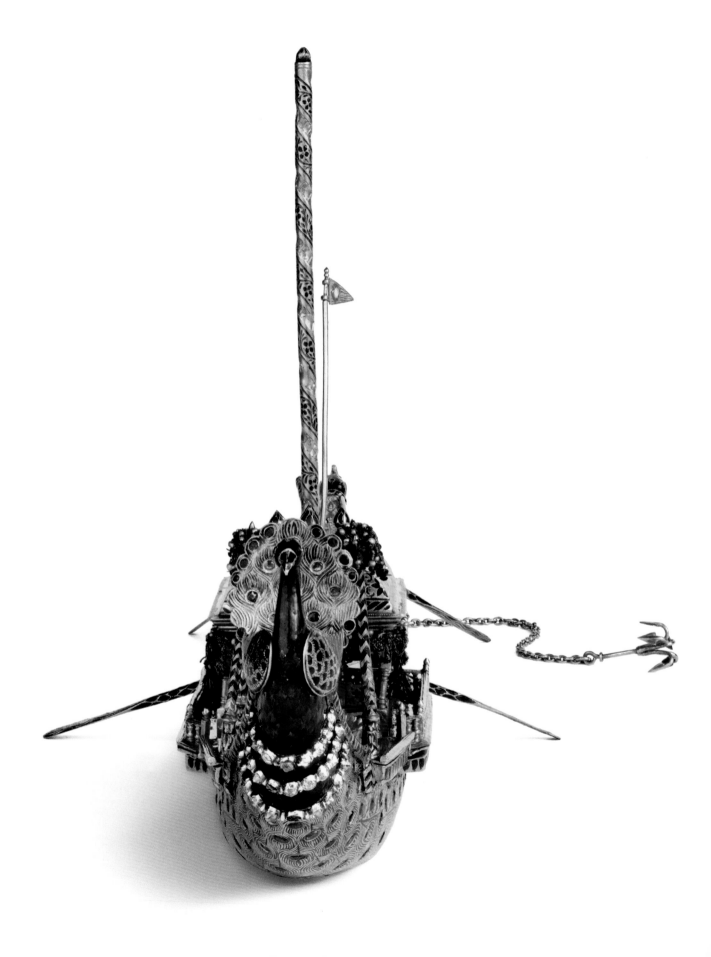

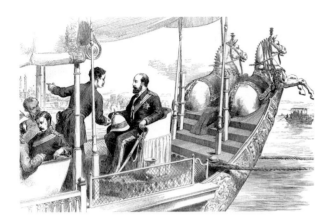

Fig. 35 The Prince of Wales on board the state barge of the Maharajah at Benares during his tour of India, 1876. Illustrated London News

Thomas Holbein Hendley, author of the *Handbook to the Jeypore Museum* (1895), noted that along with the pair of peacock feather fans (RCIN 11409, pp. 82–3) and salver (RCIN 11423, pp. 84–5), the barge inkstand was an example of the 'largest and the most valuable pieces of Jeypore enamel now in existence'.[2] The handbook illustrates an enamelled silver inkstand similar to the one presented to the Prince of Wales but states that the 'Jeypore artist does not care to work on a less valuable substance than gold, alleging that the colours will not adhere to the baser material'.[3]

George Birdwood, who had become an authority on Indian decorative arts, held the belief that the Indian enameller had surpassed his European counterpart, proclaiming that 'even Paris cannot paint gold with the ruby and coral reds, emerald green, and turquoise and sapphire blues of the enamels of Jaipur, Lahore, Benares, and Lucknow'.[4]

1 Russell 1877, p. 616.
2 Hendley 1895, p. 21.
3 Ibid.
4 Birdwood 1878, p. 64.

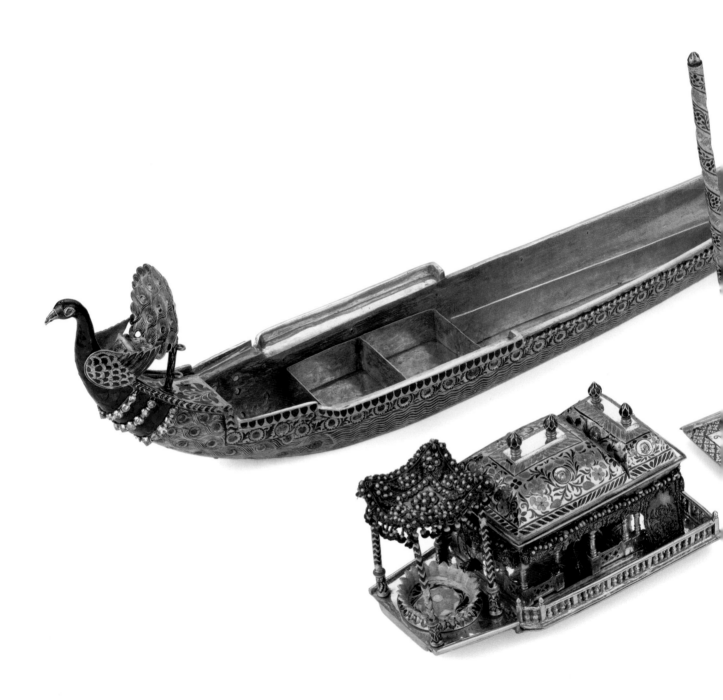

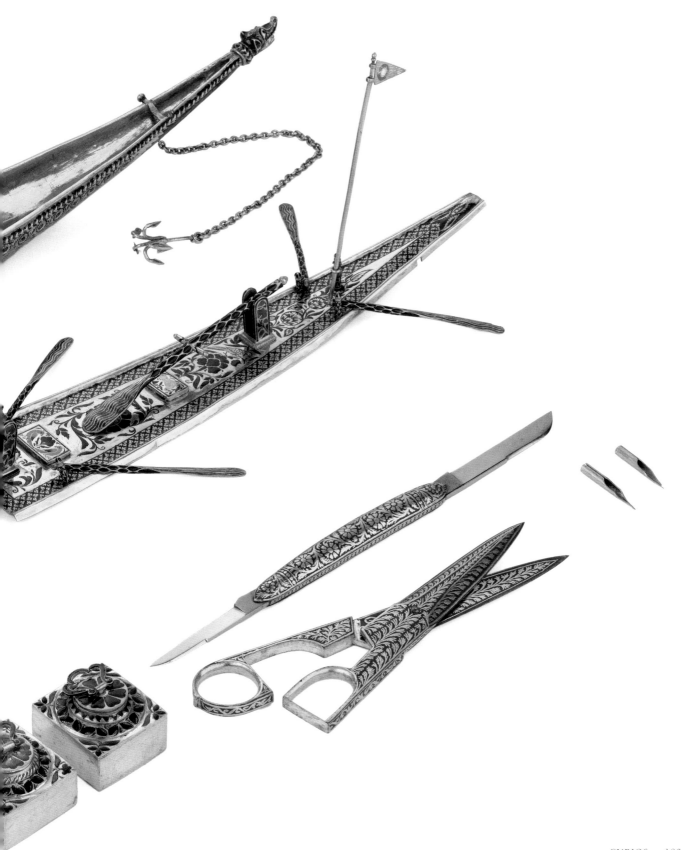

EQUATORIAL SUNDIAL

Ram Charan and Mangaran, Patna, 1875–6

RCIN 11215

Silver and steel

16.2 × 15.0 × 11.3 cm

MARKS: engraved in Persian on base of stand '*The year 1292 Hijri*'.

Engraved on the front of sundial '*The maker of this compass Mangaran very capable student of Lala Makhan Lal Ram Charan student of Mangaran*'.

Engraved on back of sundial in English '*Presented to HRH the Prince of Wales by Syud Lootfi Ali Khan Zemindor and Banker. Patna 4th Jany. 1876*'

The Prince of Wales briefly met Syed Lutf Ali Khan, Zamindar of Patna on 4 January 1876, on his way to Benares, where he was presented with an equatorial sundial. The rectangular silver sheet, bent to form a semi-circular trough, contains two timescales, one that can measure 60-minute hours and the other which measures 24-minute *ghatis*, an Indian measure of time. The sundial appears to be a presentation piece constructed entirely of silver (as opposed to the usual brass) with the exception of the compass, which is made of blued steel. The bearings, hung on silver wire, do not hang straight and are ineffective in ensuring that the ground is level. The reflective silver sheet also makes it difficult to obtain a precise reading.

The maker, Mangaran (*fl.*1859–76), made several examples of this sundial, all of which he signed as being a pupil of Lala Makhan Lal, although no examples of instruments made by this master are known to survive.[1]

1 Sarma 2010, p. 92.

ASTROLABE

Jaipur, *c.*1875
RCIN 11209
Silver and steel
37.3 × 24.8 × 3.8 cm
MARKS: on throne, obverse engraved '*PRESENTED TO H.R.H. THE PRINCE OF WALES BY H.H.THE MAHARAJAH OF JEYPOOR*' and verso '*LAT.51-28'-38*'.
EXHIBITED: London 2001

The silver astrolabe, presented to the Prince by Maharaja Ram Singh II, has a tubular eye-piece that was a common feature of astrolabes produced in India, notably Jaipur. In size, however, this example was markedly larger than many astrolabes being produced at the time in India and elsewhere. The instrument was specially made for the occasion of the Prince of Wales's tour and includes a presentation inscription and the co-ordinates for Greenwich on the reverse of the top section, known as the throne.

Jaipur became a centre for the production of astrolabes in the eighteenth century in response to Maharaja Jai Singh II's avid interest in astronomy. This led him to construct astronomical observatories in Jaipur, Delhi, Mathura, Ujjain and Benares.

William Howard Russell noted upon entering the city of Jaipur with the Prince on 4 February 1876, 'the world knows very little of its great men; and the number of people who are acquainted with the deeds of the

Maharaja Jey Singh, who founded "the City of Victory" in 1728, is probably very small indeed, although astronomers must be acquainted with the name, at least, of the man who reformed the Calendar, and constructed the remarkable observatories at Benares, Jeypoor, and elsewhere'.[1] An enlightened ruler, Maharaja Jai Singh II was influenced by Indian, Arabian and European sources of scientific research.

Referred to, in Sanskrit, as the *yantraraja*, or 'king of instruments', the earliest treatise on the astrolabe was written in the fourteenth century by Jain monk Mahendra Suri (1340–1410), although no instruments of this period appear to have survived. The astrolabe is thought to have been introduced into South Asia by travelling Iranian scholars, and the production of astrolabes was fostered by the Tughluq Sultans (1320–1413) in Delhi, and by the Mughals from the mid-sixteenth century in Lahore.

1 Russell 1877, pp. 455–6.

SCEPTRE

China, eighteenth century
RCIN 11328
Nephrite and silk
45.0 × 10.2 × 5.9 cm
LITERATURE: Ayers 2016, Vol. III, cat. no. 1773

The sceptre, known as a *ruyi*, was a Chinese ceremonial symbol of power and good fortune and would often feature Chinese motifs associated with these themes, such as dragons and bats.

This example was made in China in the eighteenth century and given to the Prince of Wales by the Prime Minister of Nepal. In June 1850, the Prime Minister had visited Queen Victoria at Buckingham Palace and presented her with a *ruyi*, together with some jade bowls.[1]

1 Ayers 2016, Vol. III, p. 746.

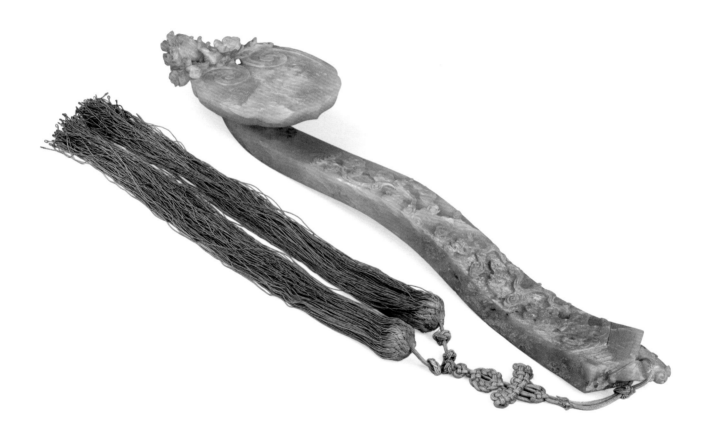

MOUNTED MOTHER-OF-PEARL TRAY

Shell Canton (China), mount western India,
possibly Ahmedabad, *c*.1870–5
RCIN 11391
Mother-of-pearl shell and gold
4.5 × 25.2 × 24.0 cm

This gold-mounted mother-of-pearl shell carved with scenes of Chinese villagers and dragons was presented by Janoji II Yashwantrao Bhonsle, Raja of Deor (d. 1881).

The shell was carved in Canton, modern-day Guangdong, in the mid-nineteenth century. Finely carved shells were produced for the Western export market, decorated with typical Chinese scenes and supplied with hardwood stands to allow for display. The mount of this tray was made in gold in India. An inscription in Gujarati on one of the feet suggests that the mount was produced in western India, possibly Ahmedabad, where mounted mother-of-pearl objects had been produced since the sixteenth century.[1]

1 Jaffer 2002, p. 22.

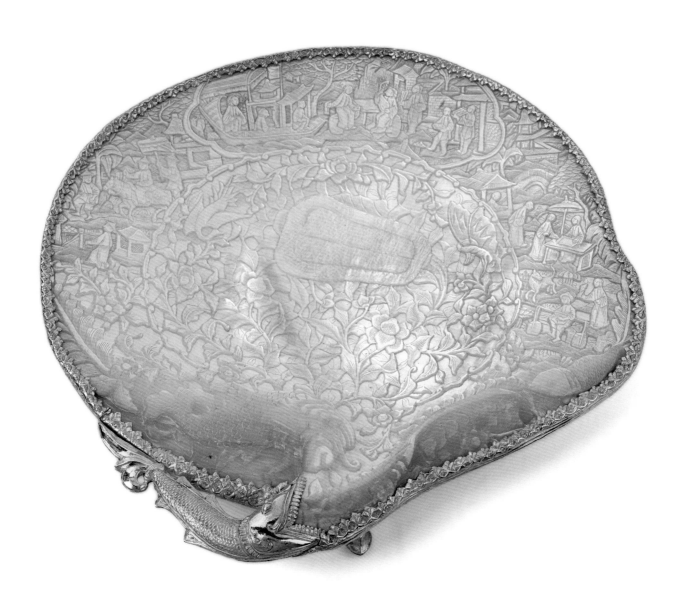

ALBUM CASE

Mysore, early nineteenth century
RCIN 90629
Sandalwood and silver
61.0 × 56.3 × 10.5 cm

This impressive sandalwood album case was presented by Chamarajendra Wadiyar X, Maharaja of Mysore. Mysore specialised in sandalwood carving, a wood that was abundantly found in the region. The rulers of Mysore had historically presented articles of carved sandalwood as diplomatic gifts and in 1862, when Maharaja Krishnaraja Wadiyar III of Mysore presented items to Queen Victoria, they included fans and flywhisks carved out of sandalwood.[1]

The spine of the album case is intricately carved with Hindu deities and their *vahana* (mounts). The silver studs depict the ten avatars of Vishnu: Matsya, Kurma, Varaha, Narasimha, Vamana, Parashurama, Rama, Krishna, Buddha and Kalki. The panels are carved with depictions of Shiva as Gangadhara, bearer of the Ganges, Indra and his consort Shachi, on Indra's white elephant mount, Airavata. Rama, the seventh avatar of Vishnu and the protagonist of the Hindu epic, *Ramayana*, with his consort Sita on horseback are also shown. Shiva is depicted with his consort Parvati, and son Ganesh, sitting on Shiva's *vahana*, the bull Nandi. Shiva as the dancing god, Nataraja, is depicted, as are Vayu and Vishvakarma, gods of the wind and artisans and architecture respectively. Vishnu is also depicted on his mount, Garuda, a mythical bird.

The popularity of carved sandalwood from Mysore grew in the late nineteenth century, possibly due to the rulers of Mysore being great patrons of the tradition. As well as using elaborately carved panels to decorate their palaces, the Maharajas of Mysore sent examples to international exhibitions, where they were described as the 'most perfect samples'.[2]

1 IOR/L/P45/6/511 *ff.* 4–5
2 Watt 1903, p. 150.

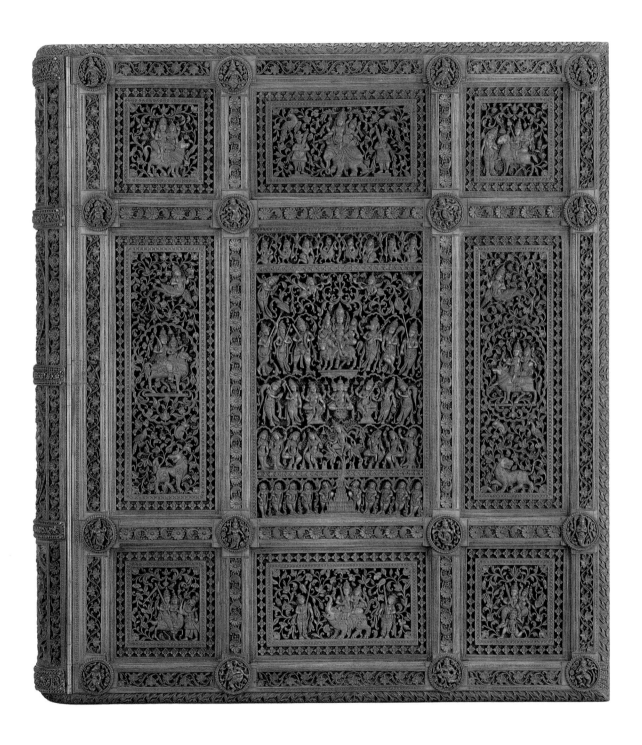

MODEL OF RAMNAGAR PALACE

Benares, *c.*1875
RCIN 42378
Ivory, mirror glass and silk
83.6 × 58.0 × 46.1 cm
MARKS: '*PRESENTED TO H.R.H. THE PRINCE OF WALES BY H.H. THE
MAHARAJA BENARES*' and '*SIVAPRASAD IN THE SERVICE OF H.H.
MAHARAJA BENARES*'

The form of this ivory workbox is based on the central portion of the Ramnagar Palace in Benares, which the Prince of Wales visited on 5 January 1876 (fig. 36). The palace, constructed out of sandstone, was built by Raja Balwant Singh (1711–70) in 1750. In the model palace, steps lead from a mirrored panel up to the palace, mimicking the *ghats*, or steps, leading up from the Ganges to the palace in Benares. The top of the box is hinged, and the body contains three drawers lined with yellow silk and embroidered with silver and red floral motifs.

Ivory carvers at Benares may have been inspired by the workboxes of Vizagapatam, where the crafts-

men had been producing extraordinary examples based on European buildings since the late eighteenth century.[1] There is little information regarding the ivory craftsman, Sivaprasad, who signed this work. It appears that he was held in high esteem by the Maharajas of Benares, who historically retained carvers at their court.[2] Another model in ivory of a *ghat* and temple at Benares, possibly by the same maker, was in the India Museum collection at South Kensington but was destroyed in the 1880 fire.[3]

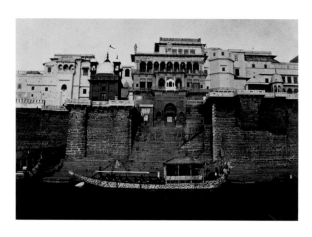

Fig. 36 Bourne and Shepherd, *Ramnagar Palace,
Benares*, 1875–6. RCIN 2701724

1 See in Victoria and Albert Museum collection
 W 20-1951; Jaffer 2001, p. 206.
2 An ivory casket signed by the same maker dates to
 1878 (Amir Mohtashemi auction house); Watt 1903,
 p. 178.
3 *JIA* 1894, p. 7.

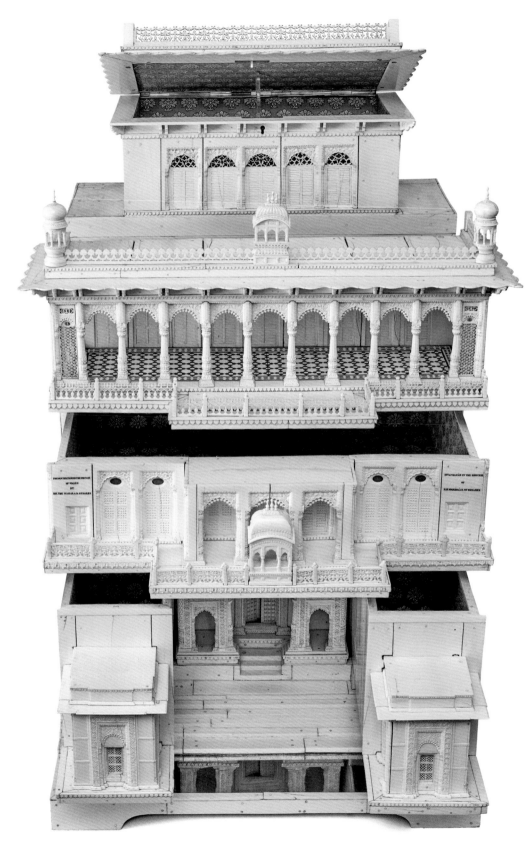

MODEL OF A JAIPUR HOUSE

Jaipur, *c.*1866–76
RCIN 42376
Plaster, paint and gold
57.8 × 49.5 × 54.4 cm

Ram Singh II established the Jaipur School of Art in 1866, where this plaster model was constructed by its students. The model is based on an eighteenth-century *haveli* (townhouse) of the region.

Generously supported by Maharaja Ram Singh, there had been a flurry of building projects. The architect Sir Samuel Swinton Jacob (1841–1917) was based in the Public Works Department in Jaipur and designed many buildings in the 'Indo-Saracenic Style', which combined elements of Hindu temple architecture and Mughal architecture. Architectural models based on secular buildings were largely the production of art schools

established in India by the Public Works Department of the British Indian Government, or were commissioned by European patrons from Indian craftsmen as souvenirs. The successor of Ram Singh II, Madho Singh II (1862–1922), also sent several architectural models based on the buildings of Jaipur for the Colonial and Indian Exhibition (1886).[1]

This model and the ivory model of Ramnagar Palace (RCIN 42378, pp. 208–9) were sent to Osborne House in 1904, when the Durbar Room was opened to visitors and were displayed alongside Queen Victoria's Golden and Diamond Jubilee gifts from India.

1 Wardle 1886, p. 197.

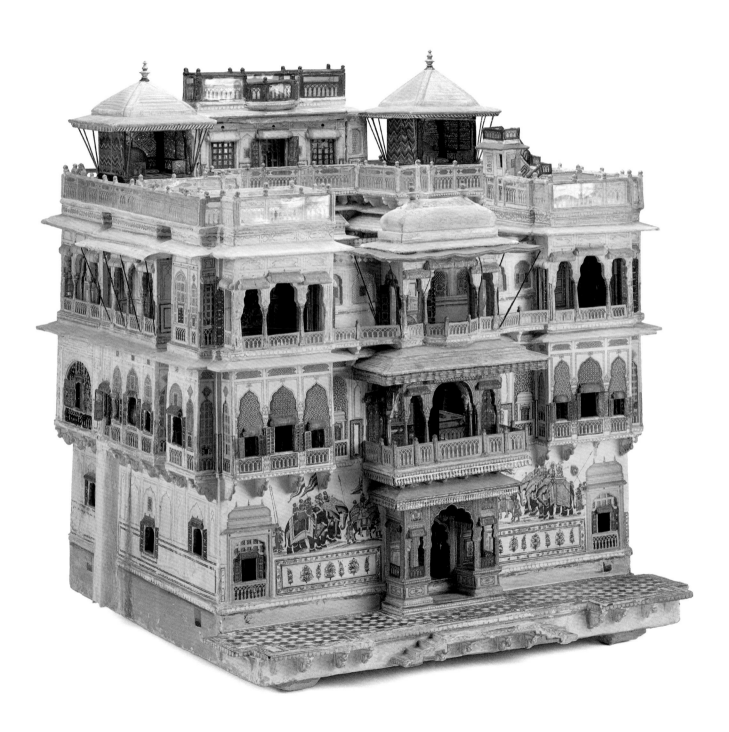

BIBLIOGRAPHY

Abbreviations

RA	Royal Archives
QVJ	Queen Victoria's Journal
IOR	India Office Records
ILN	Illustrated London News
JIA	Journal of Indian Art [and Industry]

Archival Sources

Royal Archives (RA)

RA VIC/ADDA5/503
RA VIC/MAIN/Z/468/98 14 November 1875
RA VIC/MAIN/QVJ (W) 10 March 1875 (Princess Beatrice's copies)
RA VIC/MAIN/QVJ (W) 18 April 1875 (Princess Beatrice's copies)
RA VIC/MAIN/QVJ (W) 25 April 1875 (Princess Beatrice's copies)
RA VIC/MAIN/QVJ (W) 24 May 1876 (Princess Beatrice's copies)
RA VIC/MAIN/QVJ (W) 29 June 1876 (Princess Beatrice's copies)
RA VIC/MAIN/QVJ (W) 28 February 1878 (Princess Beatrice's copies)
'List of jewellery belonging to Her Majesty The Queen Victoria, 1819–1901', vol. 3, c.1917–27. RCIN 1170221

India Office Records (IOR)

IOR/L/P45/6/511 ff. 4–5
IOR/C/138 f. 66
IOR/R/2/167/258

Victoria and Albert Museum Archives (V&A)

MA/1/R1940

Published Sources

Aberigh-Mackay 1875
G. Aberigh-Mackay, *The Prince's Guide Book: The Times of India Handbook of Hindustan*, Bombay and London, 1875

Alexander et al. 2015
D. Alexander et al., *Islamic Arms and Armor in the Metropolitan Museum of Art*, New York, 2015

Ayers 2016
J. Ayers, *Chinese and Japanese Works of Art*, 3 vols, London, 2016

Barnard 2008
N. Barnard, *Indian Jewellery: The V&A Collection*, London, 2008

Beavan 1896
A.H. Beavan, *Marlborough House and its Occupants Present and Past*, London, 1896

Birdwood 1878
G. Birdwood, *Paris Universal Exhibition of 1878: Handbook to the British Indian Section*, London, 1878

Birdwood 1881
G. Birdwood, *The Arts of India as Illustrated by the Collection of H.R.H. the Prince of Wales* (exh. cat.), Yorkshire Fine Art and Industrial Institution, York, 1881

Birdwood 1884
G. Birdwood, *The Industrial Arts of India*, vol. 2, London, 1884

Bradford 1988
S. Stronge, N. Smith and J.C. Harle, *A Golden Treasury: Jewellery from the Indian Subcontinent* (exh. cat.), Cartwright Hall, Bradford, 1988

Bradford 1991
K. Singh, *Warm and Rich and Fearless: A Brief Survey of Sikh Culture* (exh. cat.), Bradford Art Galleries and Museums, Bradford, 1991

Burnes 1831
J. Burnes, *A Narrative of a Visit to the Court of Sinde: A Sketch of the History of Cutch*, Edinburgh and London, 1831

Cardiff 1998
M. Evans (ed.), *Princes as Patrons: The Art Collections of the Princes of Wales from the Renaissance to the Present Day* (exh. cat.), National Museum and Gallery of Wales, Cardiff, 1998

Clarke 1878
C.P. Clarke in Birdwood 1878, pp. iii–iv

Clarke 1898
C.P. Clarke, *Indian Art at Marlborough House: a catalogue of the collection of Indian arms and objects of art presented by the princes and nobles of India to H.R.H. the Prince of Wales...*, London, 1898

Clarke 1910
C.P. Clarke, *Arms and Armour at Sandringham: the Indian collection presented by the princes, chiefs and nobles of India to His Majesty King Edward VII when Prince of Wales, on the occasion of his visit to India in 1875–1876*, London, 1910

Corbet 1880
M.E. Corbet, *A pleasure trip to India, during the visit of the Prince of Wales and afterwards to Ceylon*, London, 1880

Crill 2010
R. Crill, 'Textiles and dress in Lucknow in the eighteenth and nineteenth centuries', in Markel et al. 2010, pp. 227–41

Crill 2015
R. Crill (ed.), *The Fabric of India*, London, 2015

Cundall 1886
F. Cundall (ed.), *Reminiscences of the Colonial and Indian Exhibition*, London, 1886

Daily News, 20 June 1876
'The Prince of Wales Indian presents', *Daily News*, London, 20 June 1876

Dehejia et al. 2008
V. Dehejia et al., *Delight in Design: Indian Silver for the Raj* (exh. cat.), Miriam and Ira D. Wallach Art Gallery, Columbia University, New York, 2008

Digby and Harle 1982
S. Digby and J.C. Harle, *Toy Soldiers and Ceremonial in Post-Mughal India*, Oxford, 1982

Edinburgh 2012
'Treasures from the Queen's Palaces', The Queen's Gallery, Palace of Holyroodhouse, 16 March–4 November 2012 (exh. only)

Egerton 2002
Lord Egerton, *Indian and Oriental Arms and Armour*, Dover, 2002

Elgood 2004
R. Elgood, *Hindu Arms and Ritual: Arms and Armour from India 1400–1865*, Delft, 2004

Elgood 2008a
R. Elgood, 'Introduction', in C.P. Clarke, *Indian Art at Marlborough House*, Huntingdon, 2008

Elgood 2008b
R. Elgood 'Introduction', in C.P. Clarke, *Arms and Armour at Sandringham*, Huntingdon, 2008

Ferguson 1888
M. Ferguson and J. Ferguson, *All about Gold, Gems, and Pearls in Ceylon and Southern India*, Columbo, 1888

Francis 1907
W. Francis, *Vizagapatam District Gazetteer*, Madras, 1907

Gay 1877
J.D. Gay, *The Prince of Wales in India; or, From Pall Mall to the Punjab*, New York, 1877

The Graphic, 7 January 1882
'Scraps', *The Graphic*, London, 7 January 1882

Harle and Topsfield 1987
J.C. Harle and A. Topsfield, *Indian Art at the Ashmolean Museum*, Oxford, 1987

Hendley 1888
T.H. Hendley, *Ulwar and its Art Treasures*, London, 1888

Hendley 1895
T.H. Hendley, *Handbook to the Jeypore Museum*, Calcutta, 1895

Hendley and Jacob 1886
T.H. Hendley and S.S. Jacob, *Jeypore Enamels*, London, 1886

Hibbert 2007
C. Hibbert, *Edward VII: The Last Victorian King*, New York, 2007

ILN, 2 October 1875
'The Prince of Wales's voyage to India', *Illustrated London News*, London, 2 October 1875

ILN, 4 December 1875
'Visit of the Prince of Wales to India', *Illustrated London News*, London, 4 December 1875

ILN, 26 February 1876
'Our sketches from India', *Illustrated London News*, London, 26 February 1876

ILN, 1 July 1876
'The Prince of Wales's presents', *Illustrated London News*, London, 1 July 1876

ILN, 8 July 1876
'The Prince of Wales's presents', *Illustrated London News*, London, 8 July 1876

ILN, 12 August 1876
'The Prince of Wales's Indian gifts', *Illustrated London News*, London, 12 August 1876

ILN, 2 October 1880
'Fine Arts', *Illustrated London News*, London, 2 October 1880

ILN, 9 July 1887
'The Queen at the Imperial Institute', *Illustrated London News*, London, 9 July 1887

Jaffer 2001
A. Jaffer, *Furniture from British India and Ceylon*, London, 2001

Jaffer 2002
A. Jaffer, *Luxury Goods from India: The Art of the Indian Cabinet Maker*, London, 2002

Jaffer 2004
A. Jaffer, 'Diplomatic encounters: Europe and South Asia', in A. Jackson and A. Jaffer (eds), *Encounters: The Meeting of Asia and Europe 1500–1800* (exh. cat.), Victoria and Albert Museum, London, 2004, pp. 74–87

Jaffer 2013
A. Jaffer (ed.), *Beyond Extravagance: A Royal Collection of Gems and Jewels*, New York, 2013

JIA 1886a
T.H. Hendley, 'Minakari-enamels', *Journal of Indian Art*, vol. I, no. 2, London, 1886, pp. 1–5

JIA 1886b
T.H. Hendley, 'Silver plate', *Journal of Indian Art*, vol. I, no. 2, London, 1886, pp. 6–7

JIA 1886c
'Fire at the India Museum', *Journal of Indian Art*, vol. I, no. 7, 1886, p. 7

JIA 1886d
T. Wardle, 'The Indian Silk Culture Court at the Colonial and Indian Exhibition', *Journal of Indian Art*, vol. I, no. 15, London, 1886, pp. 115–23

JIA 1892
G. Birdwood, 'The collection of Indian Art in Marlborough House and at Sandringham Hall', *Journal of Indian Art*, vol. 4, nos 36–7, London, 1892, pp. 93–129

JIA 1894
B.H. Baden-Powell, 'The silver workers of Cutch (Western India)', *Journal of Indian Art and Industry*, vol. 5, no. 45, London, 1894, pp. 59–62

Leeds Mercury, 16 May 1881
'The Prince of Wales's Indian presents at York', *The Leeds Mercury*, 16 May 1881

Lethbridge 1900
Sir R. Lethbridge, *The Golden Book of India: a genealogical and biographical dictionary of the ruling princes, chiefs, nobles, and other personages, title or decorated, of the Indian empire*, London, 1900

London 1877
The British Almanac of the Society for the diffusion of useful knowledge for the year of Our Lord 1876, and 1877, London, 1877

London 1879
Twenty-sixth Report of the Science and Art Department of the Committee of Council on Education, with appendices, London, 1879

London 1886
Colonial and Indian Exhibition, 1886: Official Catalogue, London, 1886

London 1982
'Aditi: Festival of India', Barbican Centre, London, July–August 1982

London 1999
S. Stronge, *The Arts of the Sikh Kingdoms* (exh. cat.), Victoria and Albert Museum, London, 1999

London 2001
'The Victorian Vision: Inventing New Britain', Victoria and Albert Museum, London, 5 April–29 July 2001

London 2002
J. Roberts (ed.), *Royal Treasures: A Golden Jubilee Celebration* (exh. cat.), The Queen's Gallery, London, 2002

London 2005
'Treasures from the Royal Collection', The Queen's Gallery, Buckingham Palace, 11 February 2005–8 January 2006 (exh. only)

London 2009
A. Jackson and A. Jaffer (eds), *Maharaja: The Splendour of India's Royal Courts* (exh. cat.), Victoria and Albert Museum, London, 2009

London 2013
S. Gordon et al., *Cairo to Constantinople: Francis Bedford's Photographs of the Middle East* (exh. cat.), The Queen's Gallery, London, 2013

London 2015
S. Stronge, *Bejewelled Treasures* (exh. cat.), Victoria and Albert Museum, London, 2015

London Gazette, 2 September 1873
'Vienna Universal Exhibition', *The London Gazette*, London, 2 September 1873, pp. 4048–53

Markel et al. 2010
S. Markel et al., *India's Fabled City: The Arts of Courtly Lucknow*, Munich and London, 2010

Morning Post, 22 December 1882
'Art Exhibition at Penzance', *The Morning Post*, London, 22 December 1882

Newnes 1893
G. Newnes (ed.), 'The Prince of Wales at Sandringham', *Strand Magazine: An Illustrated Monthly*, London, 1893, vol. 5, pp. 326–39

Nottinghamshire Guardian, 13 January 1882
'The Prince of Wales's Indian presents', *Nottinghamshire Guardian*, Nottingham, 13 January 1882

Nottinghamshire Guardian, 10 March 1882
'Local and District News', *Nottinghamshire Guardian*, Nottingham, 10 March 1882

Orr and Sons 1877
P. Orr and Sons, *Manufacturing Jewellers, Gold and Silversmiths, to His Royal Highness the Prince of Wales by Special Appointment* (Swami Catalogue), Madras, 1877

Postans 1839
M. Postans, *Cutch; or, Random sketches taken during a residence in one of the northern provinces of western India*, London, 1839

Powlett 1878
P.W. Powlett, *Gazetteer of Ulwar*, London, 1878

Robinson 1967
H.R. Robinson, *Oriental Armour*, London, 1967

Russell 1877
W.H. Russell, *The Prince of Wales' Tour: a diary in India; with some account of the visits of His Royal Highness to the courts of Greece, Egypt, Spain, and Portugal*, London, 1877

Sarma 2010
S.R. Sarma, 'The makers, designers and patrons of Sanskrit astronomical instruments – an alphabetical directory of names and related inscriptions', *Journal of the Oriental Institute*, vol. 60, nos 1–2, 2010, pp. 75–108

Stone 1934
G. C. Stone, *A Glossary of the Construction, Decoration and Use of Arms and Armour in all countries and in all times*, New York 1934

Scherbina et al. 2014
E. Scherbina, U.R. Bala Krishnan, D. Scarisbrick, L. Peshekhonova and A. Popov, *India: Jewels that Enchanted the World*, London, 2014

Stronge, Smith and Harle 1988
S. Stronge, N. Smith and J.C. Harle, *A Golden Treasury: Jewellery from the Indian Subcontinent* (exh. cat.), Cartwright Hall, Bradford, 1988

Stronge 1995
S. Stronge (ed.), *The Jewels of India*, Bombay, 1995

Stronge 2011
S. Stronge, 'Imperial Gifts at the Court of Hindustan', in L. Komaroff et al., *Gifts of the Sultan: The Art of Giving at the Islamic Courts*, Los Angeles, 2011, pp. 171–87

The Times, 23 March 1875
'The proposed visit of the Prince of Wales to India', *The Times*, London, 23 March 1875

The Times, 21 July 1875
'India Museum – His Royal Highness the Prince', *The Times*, 21 July 1875

The Times, 22 June 1876
'The Prince's Indian collection', *The Times*, London, 22 June 1876

Topsfield 2013
A. Topsfield (ed.), *In the Realm of Gods and Kings: Arts of India*, London, 2013

Trivedi 2010
M. Trivedi, *The Making of the Awadh Culture*, Delhi, 2010

Untracht 1997
O. Untracht, *Traditional Jewelry of India*, New York and London, 1997

Walker 1880
A. Walker, *Guide to the Collection of Indian Presents belonging to His Royal Highness the Prince of Wales, graciously lent by him to the City of Aberdeen for public exhibition in the Municipal Buildings*, Aberdeen, 1880

Wardle 1886
T. Wardle, *Colonial and Indian Exhibition 1886: Empire of India*, London, 1886

Watt 1903
Sir G. Watt, *Indian Art at Delhi, being the official catalogue of the Delhi Exhibition, 1902–1903*, Calcutta, 1903

Weston 2013
V. Weston (ed.) *Portugal, Jesuits and Japan: spiritual Beliefs and Earthly Goods*, Boston, 2013

Wheeler 1876
G.P. Wheeler, *India in 1875–76: The Visit of the Prince of Wales*, London, 1876

Wilkinson and Hawkins 2000
W. Wilkinson and M.-L. Hawkins, 'Kutchi silver', in C.W. London (ed.), *The Arts of Kutch*, London, 2000

York 1881
G. Birdwood, *The Arts of India as Illustrated by the Collection of H.R.H. the Prince of Wales* (exh. cat.), Yorkshire Fine Art and Industrial Institution, York, 1881

York Herald, 6 May 1881
'Opening of the Yorkshire Fine Art Institution', *York Herald*, York, 6 May 1881

York Herald, 4 June 1881
'Local and District', *York Herald*, York, 4 June 1881

York Herald, 29 December 1881
'The Trade and Progress of York in 1881', *York Herald*, York, 29 December 1881

Index

Acknowledgements

Within the Royal Collection, I am very grateful to Rufus Bird, Caroline de Guitaut and Elizabeth Silverton for their advice and comments on the catalogue. I thank Simon Metcalf and Sophy Wills for their expertise and sharing their observations on the gifts, the catalogue entries have considerably benefited from both Simon and Sophy's knowledge and I am greatly indebted to them. I also thank Emily Hannam for providing translations of Persian and Devanagari inscriptions and Alexandra Campbell-Ricketts for verifying the gemstones.

I am very grateful to Susan Stronge, Senior Curator of the South Asian Department at the Victoria and Albert Museum, for her generous advice and suggestions on the catalogue and to Joanna Whalley, Senior Metals Conservator at the Victoria and Albert Museum, for her insights on Indian gemstones and gem setting. I thank Rajmata Padmini Devi of Jaipur and Pankaj Sharma, Senior Curator at the Maharaja Sawai Man Singh II Museum, for supplying information about the Prince's gifts from Jaipur. I am grateful to Paul Sloman, Sarah Kane and Debbie Wayment for their involvement in the design and production of the catalogue.

In addition, a number of colleagues have been crucial in developing this catalogue and I acknowledge their expertise, assistance and support with many thanks: Tjeerd Bakker, Stephen Chapman, Paul Cradock, John Davis, Allison Derrett, Tamsin Douglas, Sophie Gordon, Sally Goodsir, Jacky Colliss Harvey, Kate Heard, Kathryn Jones, Indra Jutlla, Tung Tsin Lam, Karen Lawson, Jonathan Marsden, Will Miller, Nick Moss, Alessandro Nassini, Fiona Norbury, Daniel Partridge, Shruti Patel, Stephen Patterson, Rachel Peat, Deborah Phipps, Richard Shellabear, Rachael Smith, Emma Stuart, David Tibbs, Shaun Turner, Dee Vianna, Jane Wallis, David Wheeler and Eva Zielinska-Millar.

Explore the Royal Collection at www.royalcollection.org.uk

Published 2017 by Royal Collection Trust
York House, St James's Palace
London SW1A 1BQ

ISBN 978 1 909741 42 3
100961

British Library Cataloguing in Publication data:
A catalogue record of this book is available from the British Library

Designer Paul Sloman | +SUBTRACT
Jacket design Adrian Hunt
Project Manager Elizabeth Silverton
Production Manager Debbie Wayment
Edited by Sophie Kullmann and Sarah Kane
Colour reproduction Tag publishing
Printed and bound in Ghent by Graphius

Front cover: Peacock inkstand, RCIN 11444.a–s, pp. 188–9.
Back cover: Ornamental fish, RCIN 11319, pp. 112–3.